THE GRAND TOUR

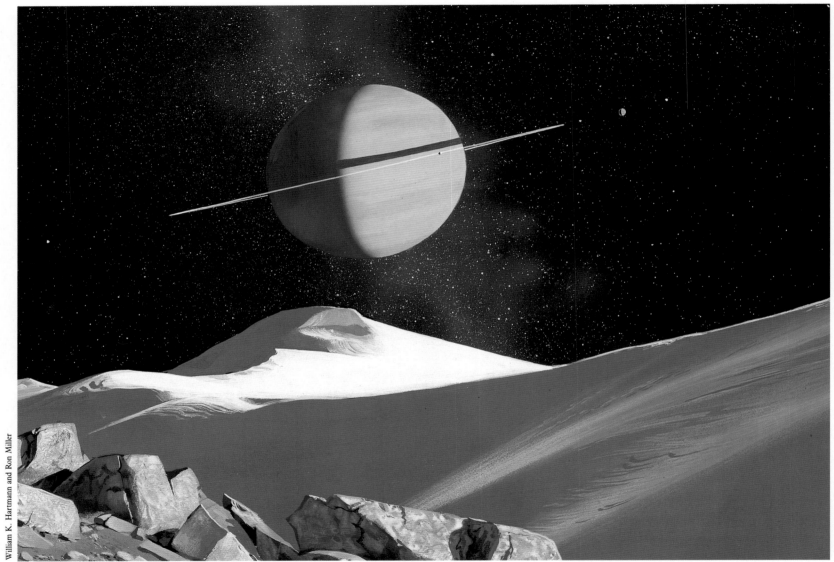

Viewing Saturn from its icy moon, Rhea.

THE GRAND TOUR

A · TRAVELER'S · GUIDE · TO · THE · SOLAR · SYSTEM

THE REVISED EDITION

By Ron Miller & William K. Hartmann

WORKMAN PUBLISHING · NEW YORK

Library of Congress Cataloging in Publication Data
Miller, Ron, 1947–
 The grand tour.

 Bibliography: p.
 Includes index.
 1. Solar system. I. Hartmann,
 William K.
II. Title.
QB501.2.M54 523.2 80-54620
ISBN 1-56305-511-2 AACR2
ISBN 1-56305-031-5 (pbk.)

Workman books are available at special discounts when purchased in bulk for premiums and sales promotions as well as for fundraising or educational use. Special editions or book excerpts can also be created to specification. For details, contact the Special Sales Director at the address below.

Workman Publishing
708 Broadway
New York, NY 10003

Manufactured in Hong Kong
Revised Edition
First printing October 1993
10 9 8 7 6 5 4 3 2 1

Cover: On the surface of Neptune's mysterious moon Triton. Triton, the fifteenth largest world in the solar system, astonished scientists in 1989 when *Voyager II* discovered geyser-like volcanic vents erupting on this cold, frozen world. The foreground vent has plastered the icy scene with reddish organic compounds. The plume in the distance, like many smoke plumes from these vents, rises 8 kilometers (26,000 feet) and then is sheared off by high-altitude jet stream winds. The blue planet Neptune, marked by cloud belts and storm patterns, presides over the scene.
Illustration: Ron Miller and William K. Hartmann

Pages 14–15: Jupiter rises above an ice ridge on its moon Ganymede. From this location near the equator, Jupiter's thin ring appears in a vertical orientation, bisecting the planet. *Illustration:* Ron Miller

Pages 134–135: Uranus glows like a huge ice-blue Christmas tree ornament above the surface of its rugged and icy moon, Oberon. The frigid planet is just over half a million kilometers distant.
Illustration: Ron Miller

Acknowledgments

The authors are indebted to many individuals for their help. At the U.S. Geological Survey we thank Jay Inge and R.A. Batson for providing shaded relief maps of the planets and moons, and Alfred McEwen for processing old mission photos into splendid new color mosaics. We also thank Les Gaver and other personnel at NASA headquarters, and Jurrie Van der Woude and other personnel at the Jet Propulsion Lab's Public Information Office for providing photographs from NASA missions. For assistance with photography of paintings in this book we thank Maria Schuchardt of the Lunar and Planetary Laboratory, Brian Sullivan and Dennis Mammana at Flandrau Planetarium, and Chris Spielmann of Advanced Images, Inc. Judith A. Miller, Gayle Hartmann, Trish McFarren, and Amy Hartmann gave advice, critiques, and support. We also thank Pamela Lee and other fellow artists of the International Association of Astronomical Artists for inspiration and support, and Floyd Herbert, the staff at the Planetary Science Institute of Science Applications International Corporation, and many other scientific colleagues for technical discussion and suggestions. We are grateful to Ian Summers, Peter Workman, Sally Kovalchick, and the design team and staff at Workman Publishing Company for their faith, support, and enthusiasm.

Dedication

Without Chesley Bonestell (1888–1987), the father of astronomical painting in America, this work, in many ways, would not have been realized. With trepidation based on his crusty but encouraging critiques of some of our early work, we dedicated the first edition of this book to him with the words "whether he likes it or not." Fortunately he lived to see it, and liked it well enough that we dedicate this second edition to his memory with no caveats. The cycle of his work won't be really complete until the day when the first artist lands on asteroid 3129 Bonestell and takes out his or her sketch pad . . .

CONTENTS

On the volcanic surface of Venus.

INTRODUCING THE TERRITORY

A NEW LOOK AT THE SOLAR SYSTEM

Imagine that we are cruising far out in interstellar space, our ship flying among millions of stars strewn along one curving arm of a spiral galaxy. We are looking carefully at each star. We pick out an average star, which turns out to be the sun. We discover that it has not only planets but many other bodies circling around it. Each *planet* is a large nonluminous body that shines by reflected sunlight. Countless smaller examples of such bodies (smaller than about 1,000 km, or 620 miles, across) are traditionally divided into three categories that we will discuss in a moment: *asteroids, comets,* and tiny *meteoroids.* We set out to explore those bodies, one by one.

Such is the goal of our book: to see our own planetary system as a new visitor might perceive it, not centered around Earth, but with Earth as only one planet out of many. Like Charles Darwin voyaging indiscriminately from island to island, we want to see what all these places are like. What grandeur, desolation, power, silence, resources, or loneliness does each offer?

We scrutinize the approaching star. At first we can see no planets at all, because the sun is vastly brighter and more massive than any of them. The planets are lost in the sun's glare.

We try our radio. It picks up faint signals at radio, TV, and other wavelengths. These signals might not necessarily reveal intelligent life in the system: they might be network TV broadcasts, or the random snaps, crackles, and pops of electrical activity such as lightning in the atmospheres of Jupiter, Venus, and Earth. But they at least suggest the presence of planets.

We can also search for planets at this distance by looking for their gravitational effects. As they orbit around the sun, the planets tug it slightly to and fro. Sensitive instruments can pick up this "wiggle" in the sun's position. The major wiggle is due to the largest planet, massive Jupiter. Jupiter has more mass, hence gravity, than all the other planets put together. So at first we notice only Jupiter's effect and conclude that the sun is essentially a double system. The largest object in our system— the sun—is said to have 1 solar mass. The second largest object—Jupiter—has about

0.001 solar mass. The rest of the planets put together have only 0.0004 solar mass—easy to overlook from our perch out in space.

With both radio and gravity data indicating planets in this system, we come in for a closer look. When we first catch sight of a planet, it is again Jupiter, five times as far from the glaring sun as Earth is. Astronomers, following the Earth-chauvinist tradition of our forebears, defined the standard unit of distance in the solar system as the distance from the sun to Earth: 150 million kilometers, or 93 million miles. This is called one *astronomical unit.* So we say that Earth is 1 AU from the sun; Jupiter is 5.2 AU from the sun.

Most stars have companions orbiting around them. Usually these companions are smaller stars, not planets. As we catch sight of Jupiter, we wonder whether this object should be classified as a planet or a small companion star to the sun. What is the difference? Stars shine by means of nuclear reactions inside them. Planets are not big enough to generate the heat and pressure necessary to cause nuclear reactions in their centers, so planets don't shine. You might

think it is obvious that Jupiter is a planet, but telescopic observers discovered in the 1960s that Jupiter radiates several times more energy than it receives from the sun. This means that energy *is* being created somehow inside Jupiter, and in this sense Jupiter is like a star. But theoretical work shows that the energy is not coming from nuclear reactions. Instead, it is being generated by a slow contraction that has been going on since Jupiter formed. Jupiter's gravity is so strong that it keeps pulling itself inward, liberating a modest amount of heat at the same time.

The theoretical work also indicates that a body must be about eighty times as massive as Jupiter in order to generate enough central heat and pressure to initiate nuclear reactions and become a true star. Thus, we can say that the solar system has only one star. Jupiter has not nearly enough material to become a star. If more material had been available to proto-Jupiter during the ancient days of planet formation, the solar system might have had two suns, making our astronomical climate strikingly different.

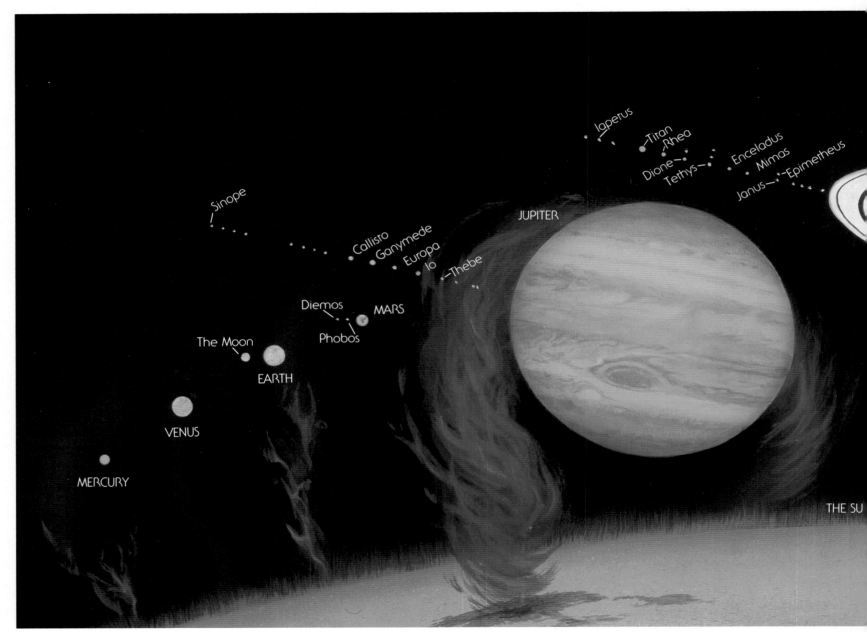

Iaperus
Tiran
Rhea
Dione
Tethys
Enceladus
Mimas
Janus
Epimetheus

Sinope

JUPITER

Callisto
Ganymede
Europa
Io
Thebe

Diemos
MARS
Phobos

The Moon
EARTH

VENUS

MERCURY

THE SU

Family portrait of the sun, planets, and moons.

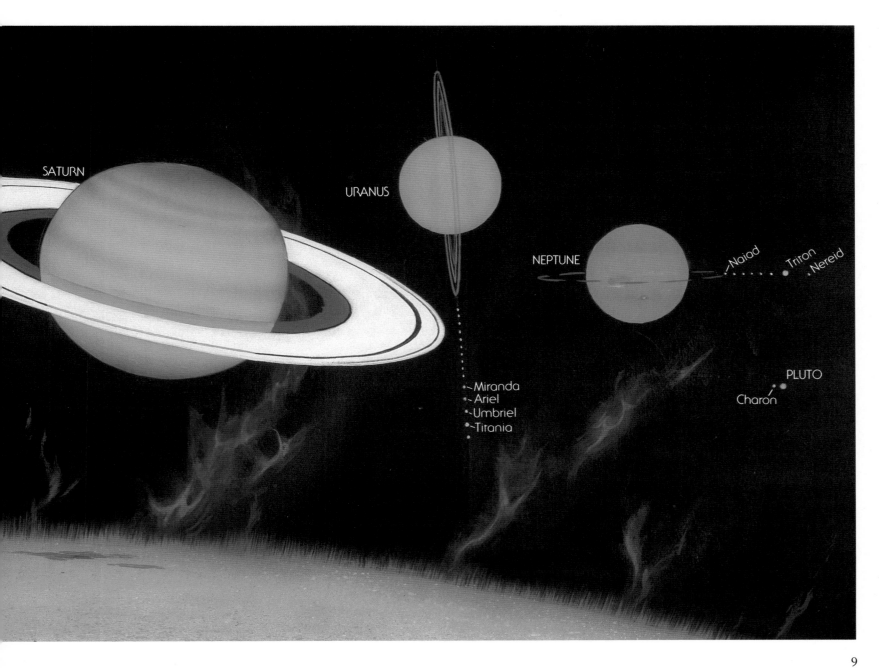

SATURN

URANUS

NEPTUNE Naiad Triton Nereid

Miranda
Ariel
Umbriel
Titania

PLUTO

Charon

NINE PLANETS?

If you study the sky from night to night, you will find that the planets—such as diamond-bright Venus or ruddy Mars—move among the stars. This is why the Greeks gave them the name *planētēs*, or "wanderers." They thought that the planets moved around Earth in complicated loops. In 1543, the Polish astronomer Nicolaus Copernicus showed that the planets' movements could be better understood by postulating that they moved around the sun. Acceptance of this idea came to be called the Copernican revolution.

It was an epoch-making breakthrough because it affected how we think about ourselves in relation to the universe. For the first time, we were forced to face the idea that the universe doesn't revolve around us. We are just a part of it.

Many people seem to assume that the Copernican revolution was the one and only revolution in our view of the solar system, and that things have been stable since then. More planets have been discovered in more or less circular orbits around the sun, of course. And more moons have been found in orbits around planets. But for years, textbooks have reported that there are nine planets, and most people have the impression that the hierarchy of planets, moons, and interplanetary debris is very clear-cut, with the planets being the big, important objects, the moons lesser, and so on.

Today, we are beginning to look at the solar system in a new way, a break from the "nine planets paradigm." Our recent spacecraft voyages have made us realize that the solar system has many more than nine large worlds. Most planets, for example, are orbited by moons—also called satellites (from a Latin word for "companions"). Some moons are bigger than some of the planets. There are about two dozen worlds larger than a thousand kilometers, or 620 miles, across. These are bodies big enough to have their own, distinctive geologic "personalities." We will visit these worlds. Thousands more interplanetary bodies, neither planets nor moons, range up to a thousand kilometers across. We will visit the most interesting of these smaller worlds. These are traditionally classified as *asteroids, comets,* and *meteoroids.* According to the traditional observational distinctions, asteroids are stony bodies ranging from about 100 meters (100 yards) to a thousand kilometers in size, situated mostly between Mars and Jupiter. Comets, one to a few hundred kilometers in size, are icy bodies that are mostly located in the outermost solar system, but sometimes drop into the inner solar system, where the sun melts off some of their ices and releases the gas and dust that streams out to form a cometary tail. Meteoroids are fragments of asteroids and comets, typically microscopic to a hundred meters in size. Meteoroids that strike planetary surfaces are called *meteorites* and are composed of various types of stone or nickel-iron metal.

Interplanetary bodies are too numerous to count. Catalogs of objects with well-defined orbits include over four thousand asteroids and several hundred comets. The solar system contains thousands of bodies big enough to land on, though the gravity of the small ones is so weak that you might wish to tether your spacecraft so as not to have it drift off. And you should be careful not to launch *yourself* off such a body by an overenthusiastic jump.

Data from the 1980s and '90s make us realize that the traditional practice of categorizing each object as a planet, moon, asteroid, comet, or meteoroid is misleading. It blurs compositional relationships by setting up different pigeonholes, obscuring the unique nature of each. Spectral observations, for instance, show a wide range of different rock types among different asteroids. Some asteroids may have enough ice content that they mark transitional objects between ordinary asteroids and full-fledged iceball comets. Moons and planets also show a range of densities, compositions, and surface types. Some moons seem more closely related to some asteroids than to other moons. Scientific arguments have been fought over whether certain "asteroids" are really asteroids at all, or simply burnt-out comets. Other research focuses on whether meteorites are pieces of comets, asteroids, or a mixture of fragments from both sources.

If we reject the distinct categories that were made in the past, we begin to see the variety and relationships of planetary bodies more clearly.

A COMPOSITIONAL SEQUENCE

One relationship we find among major planetary bodies is a sequence of compositions that varies primarily with their different distances from the sun. The planets were formed by an aggregation of dust grains condensed out of cooling gases that surrounded the newly formed sun. These gases were hottest near the sun and coolest away from the sun.

Mineral grains requiring low temperatures to condense could not do so near the sun; those that condense at higher temperatures were the only ones to solidify in the inner solar system. These included metal

grains and particles of various silicate minerals like those found in Earth rocks, lunar rocks, and meteorites. Farther from the sun, such grains were accompanied by lower-temperature compounds, such as sooty black, carbon-rich minerals and hydrated minerals (minerals that contain water molecules within their crystal structure). Beyond the asteroid belt, the gas was cold enough for frozen water, frozen carbon dioxide, and other ices to form. Thus, the bodies that began to form in the outermost solar system were combinations of three materials: silicate/metals, black carbonaceous minerals, and ices.

We can now recognize three compositional zones in the solar system. The inner zone, sometimes called the zone of terrestrial planets, extends out to the middle of the asteroid belt and has light-colored bodies made of familiar silicate minerals and rocks. The middle zone, which includes the outer asteroid belt, has black bodies rich in soot-like carbonaceous material. The outer zone, from Jupiter outward, has bodies that originally contained much ice.

Now we see a new way to perceive the asteroid/comet distinction. Asteroids are the small, rocky objects and black carbonaceous objects that originally formed in the inner two zones. Comets are the ice-rich bodies that formed in the outer zone. Gravitational perturbations by the massive planets threw many of these small bodies into parts of the solar system far from where they first formed. Thus, some stony stragglers may be found today in the outer solar system, while icy comets drop into Earth's vicinity for an occasional visit.

Current data suggest that large satellite systems, like Jupiter's, may have formed like miniature solar systems, and also may share the same compositional patterns. From the measured densities of Jupiter's large moons, we know that the inner ones have mostly rocky interiors, while the outer ones have icy interiors. Jupiter's radiation was probably a significant heat source during the formation of satellites around it, just as the sun heated the inner solar system.

When an inner planet experiences internal melting (generally due to radioactivity heating its interior), it produces silicate lavas like those of Earth and its moon. But when an outer world melts, the erupted "lava" may well be water, and the "frozen lava flows" sheets of ice. This probably explains why many worlds in the outer solar system have icy surfaces. In particular, some of the inner moons of giant planets, though they may have stone-rich interiors, seem to have been heated enough to produce watery eruptions that left ice on their surfaces.

Evidence from meteorites and the moon shows that planets aggregated from cool, solid material 4.5 billion years ago. Evidence from lunar rocks indicates that they had molten layers at their surfaces almost as soon as they formed, but that these so-called magma oceans cooled quickly, by about 4.4 or 4.3 billion years ago. All rocky planetary material contained small amounts of radioactive minerals, which produced small amounts of heat. The smallest planets could radiate this heat easily and cool quickly. Therefore, planetary bodies smaller than a few hundred kilometers across probably never melted or developed volcanoes; their surfaces are much the same as they were when they were formed, still preserving the impact scars of the meteorites that fell on them and helped mold them.

The larger worlds could not shed their heat so easily, because planetary bulk insulated their hot centers. These centers got hotter and hotter. In the zone of terrestrial planets, the insides of worlds larger than 1,000 kilometers (620 miles) melted around 4 billion years ago, allowing heavy molten iron to sink into them, forming metal cores. The light "slag" of silicates and watery material floated to the top. These planets thus gained crusts of silicate-rich rocks that tend to have low densities and light coloration.

Volcanism broke through these crusts, covering parts of the surfaces with lava flows. On the smaller worlds, interiors soon cooled and volcanism declined. Volcanism continued for a longer period of time on larger worlds.

Often, the last eruptions were from deeper in the planet and produced rocks poorer in silicates and darker in color than the crustal rocks. On the moon (3,476 kilometers, or 2,155 miles, in diameter), such eruptions formed dark lava plains covering about 15 percent of its surface. They ended about 3 billion years ago, as the moon's interior cooled. On Mars (diameter 6,795 kilometers, or 4,212 miles), internal heat lasted longer, promoting volcanic eruptions as recently as 1 billion years ago or less. These eruptions resurfaced about half the planet. On Venus (diameter 12,100 kilometers, or 7,500 miles), continuing eruptions have resurfaced the entire planet within the last 0.5 to 0.8 billion years (500 to 800 million years). On Earth (12,756 kilometers, or 7,908 miles), the eruptions have continued through geologic time. The primeval crust has been totally destroyed, and volcanoes continue to erupt.

In addition to internal evolution, atmospheric evolution also depends on the size of the planet. Small planets have

too little gravity to retain atmospheres. Gases released by small planets' volcanoes escape into space. Worlds larger than 4,000 to 6,000 kilometers (2,490 to 3,720 miles), depending on their temperature, have enough gravity to hold down the heavier volcanic gases such as carbon dioxide. Mars, for instance, has a thin atmosphere of carbon dioxide; some of the molecules escape into space, one at a time. Venus has a thick carbon dioxide atmosphere. Earth has a more complex atmosphere, in which much of the carbon dioxide has been broken down by plants, thus releasing oxygen. Light gases, such as hydrogen, have mostly risen to the top of our atmosphere and leaked into space, while only heavier gases have been retained. Giant Jupiter, 143,000 kilometers (88,660 miles) across (11 times bigger than Earth), has a deep, dense atmosphere. Even hydrogen, the most abundant but lightest element in the solar system, is retained by Jupiter. Because the larger planets have denser atmospheres, their surfaces are more modified by erosion. Earth has lost virtually all of its meteorite impact craters to erosion and tectonics; Mars has dust dunes and dry streambeds. Only airless bodies like the moon preserve surfaces saturated with craters formed during the early days of the solar system.

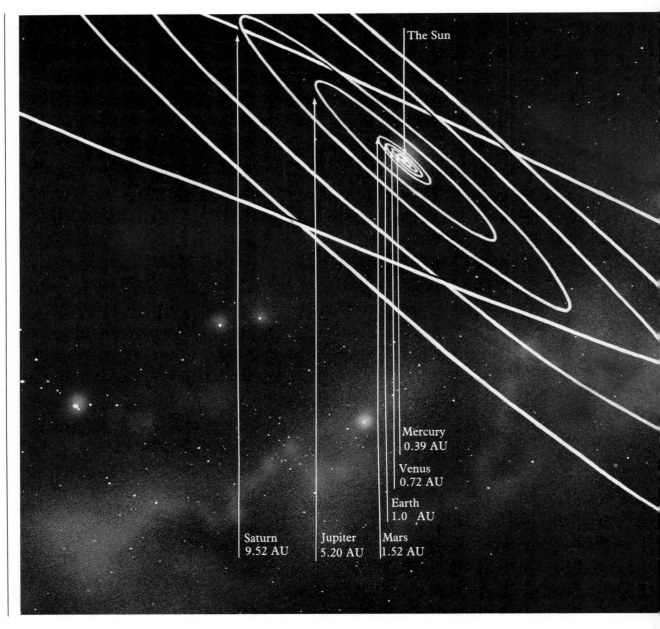

The Sun

Mercury
0.39 AU

Venus
0.72 AU

Earth
1.0 AU

Saturn
9.52 AU

Jupiter
5.20 AU

Mars
1.52 AU

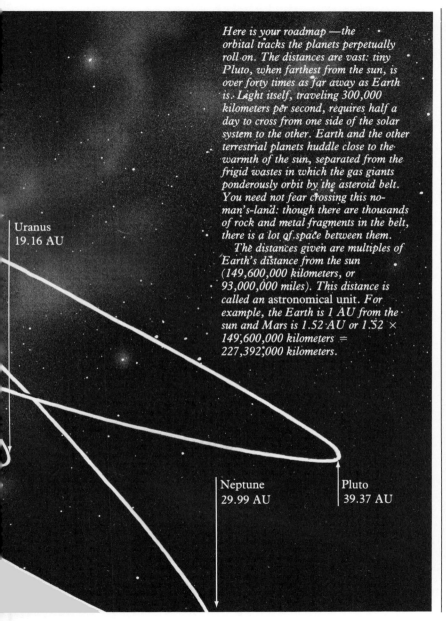

Here is your roadmap — the orbital tracks the planets perpetually roll on. The distances are vast: tiny Pluto, when farthest from the sun, is over forty times as far away as Earth is. Light itself, traveling 300,000 kilometers per second, requires half a day to cross from one side of the solar system to the other. Earth and the other terrestrial planets huddle close to the warmth of the sun, separated from the frigid wastes in which the gas giants ponderously orbit by the asteroid belt. You need not fear crossing this no-man's-land: though there are thousands of rock and metal fragments in the belt, there is a lot of space between them.

The distances given are multiples of Earth's distance from the sun (149,600,000 kilometers, or 93,000,000 miles). This distance is called an astronomical unit. For example, the Earth is 1 AU from the sun and Mars is 1.52 AU or 1.52 × 149,600,000 kilometers = 227,392,000 kilometers.

Uranus
19.16 AU

Neptune
29.99 AU

Pluto
39.37 AU

A PLAN FOR OUR GRAND TOUR

If we organized our tour of the solar system according to tradition, we might start close to the sun and work our way outward. But then we would go from moonlike Mercury to cloud-shrouded Venus; from tiny asteroids to massive Jupiter. The scenery would be a chaotic hodgepodge, because scenery is controlled by the evolutionary state of a world, and evolutionary state is controlled largely by size.

So we propose to take a new kind of tour: a tour in order of size. First comes massive Jupiter, the sun's principal companion. Next is the second most massive planet, Saturn; and so on. This approach allows us to progress from energetic, massive, active, evolved worlds to dormant, small, primitive worlds with empty craters that seem to echo with the explosions of meteorite impacts billions of years old.

There is a second advantage of touring our solar system in this order. It will soon become clear that our planetary neighborhood does *not* consist of the traditional nine planets and insignificant, smaller worlds. We will visit all 25 worlds larger than a thousand kilometers across, of which 18 are planets or moons bigger than the planet Pluto.

WHAT TO LOOK FOR

We are about to embark on a tour of worlds—a tour that will enable us to change our ways of thinking about planets. We are going to try to see each world on its own terms, one at a time.

What we are really looking for is a new perspective on our solar system, and a new sense of the fantastic variety of wilderness areas that surround us, waiting just over the horizon . . .

13

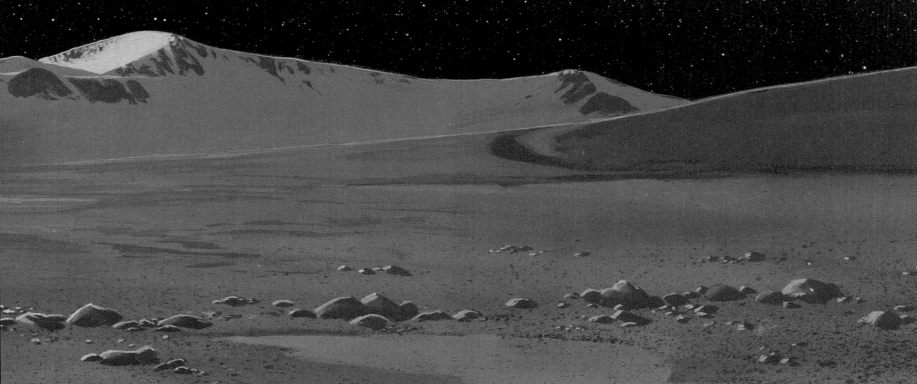

PART 1.
THE 15 LARGEST WORLDS

JUPITER PLANET OF THE GODS

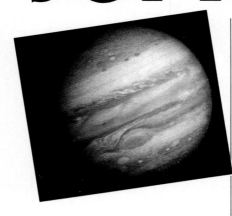

LARGEST PLANET
Average distance from the sun:
 778,300,000 km
Length of year: 11.86 years
Length of day: 9 hours 55 minutes
Diameter: 142,984 km
Surface gravity (Earth = 1): 2.3
Composition: hydrogen; ices; hydrogen
 atmosphere

Jupiter was the giant among gods, and it is also the giant among planets. It has about two and a half times the mass of all other planets combined, and therefore has the strongest gravitational pull, affecting the motions of many other planets and interplanetary bodies. The second largest planet, Saturn, has only 84 percent the diameter of Jupiter and less than one-third its mass. Earth would comfortably nest inside the largest oval storm system that swirls in Jupiter's skies.

Jupiter is covered with dense clouds of different colors that stretch in ragged belts parallel to its equator, broken here and there by oval storm systems. The atmosphere is much thicker than Earth's. About 90 percent of its molecules are hydrogen, and nearly 10 percent are helium. Minor constituents include methane, ammonia, water, and other compounds. All the planets originally formed in a nebula made up of these gases. Jupiter grew so big that its strong gravity trapped and held the nebular hydrogen and helium, while on Earth the light, fast-moving hydrogen and helium molecules escaped into space. Earth's atmosphere thus thinned and evolved in composition; Jupiter's remained in nearly its original state.

Many of Jupiter's hydrogen atoms, which are chemically active, have combined with less abundant elements to form exotic, brightly colored compounds. These lend their vivid hues to the clouds, which are composed primarily of ammonia "snowflakes," water "snowflakes," and "snowflakes" of compounds such as ammonium hydrosulfide. Red and orange clouds that formed at certain altitudes and latitudes swirl into white and tan clouds formed in other regions. Jupiter rotates more quickly than Earth, in about 10 hours, and its rotational dynamics shear the cloud patterns out into long bands and zones that run around the planet parallel to its equator. The two most prominent dark bands of clouds are the North and South Equatorial Belts, a few degrees on either side of a lighter Equatorial Zone. Additional dark belts and light zones also ring the planet.

When we plunge into Jupiter's atmosphere, the sky turns lighter and bluer as we approach the cloudtops because of scattered sunlight in the air—the same process that makes the sky blue on Earth. We begin to encounter high clouds at a level where the pressure is almost equal to that on Earth's surface, but the temperature is only around −123 degrees Centigrade (C), or −189 degrees Fahrenheit (F). As we descend into the clouds, the air grows warmer and denser, reaching room temperature among cloud layers with an air pressure perhaps five times greater than that on Earth. As we keep going downward, what do we find? Is there an alien, hidden surface lurking far below the clouds at warm temperatures?

Unfortunately, the answer is no. Jupiter's thick clouds obscure the deep layers, but theoreticians have calculated conditions as we drop below the clouds. Their studies suggest that the atmosphere simply gets denser and denser, turning into a thick, dark fog that grades imperceptibly into a sluggish ocean of liquid hydrogen, tainted by other trace compounds. The *Galileo* spacecraft may reveal some of the conditions below the clouds when it parachutes a probe into Jupiter's atmosphere—an exciting experiment targeted for late 1995.

Jupiter's atmosphere is restless. Atmospheric dynamics depend partly on the amount of heat flowing through an atmosphere. On Earth, this heat comes almost entirely from the sun, entering the atmosphere from above and reradiating off the ground. Jupiter and the other giant planets are very different. In the 1960s, astronomers were surprised to

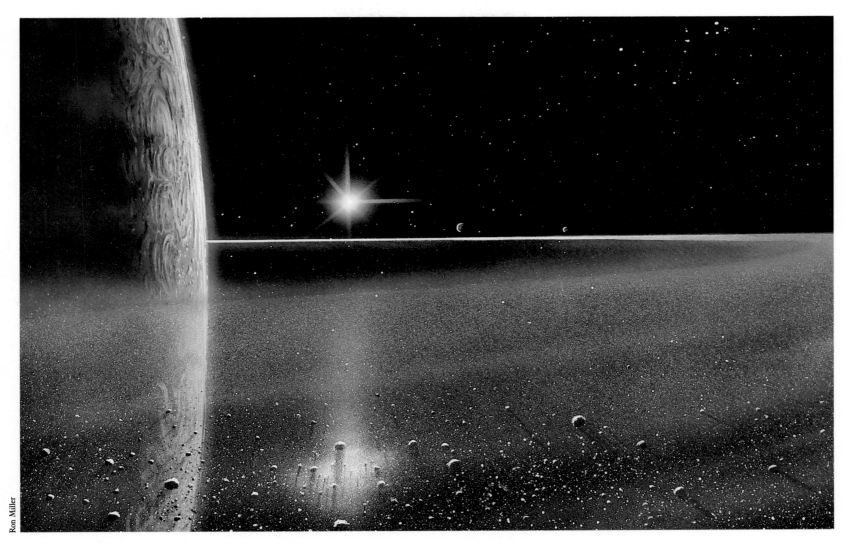

Above: *Jupiter's ring surrounds the planet like an enormous smoke ring, visible only when the sun is shining directly behind it. With the exception of some small rubble, Jupiter's ring is composed of particles no bigger than* *those in cigarette smoke—literally microscopic dust. The ring is material slowly spiraling into Jupiter, but may be constantly being replenished by the erosion of a small moon that sits on the ring's outer edge. The distant sun (only* *one-fifth its diameter as seen from Earth) illuminates Jupiter and two of its large moons in narrow crescent phases.*

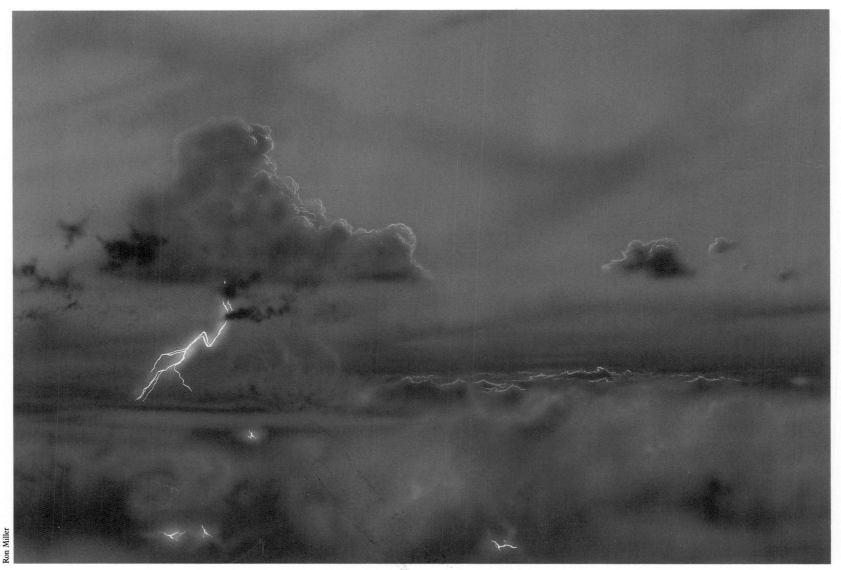

Ron Miller

Scores of miles beneath the visible cloudtops, the deep atmosphere of Jupiter is a murky abyss lit occasionally only by lightning. The atmosphere at deeper levels grows as dense as liquid, and gets denser as one descends. There may in fact be no solid surface to Jupiter, only an increasingly dense atmosphere that merges into liquid material.

JUPITER

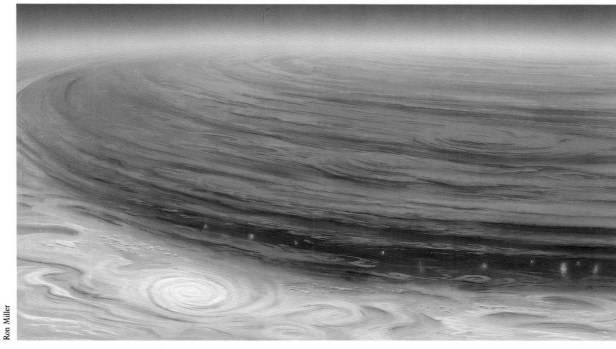

Ron Miller

Above: *Jupiter's Great Red Spot is an enormous hurricane large enough to engulf Earth.*

discover that Jupiter radiates several times more energy than it absorbs from sunlight. The extra energy must be coming from Jupiter's interior. Further theoretical studies showed that this energy release probably involves a slow contraction of the planet—a long-term process that began as Jupiter formed, creating heat by compressing the inside of the planet. Some of the heat that was initially produced is still leaking out, and new heat is constantly being generated.

This extra energy contributes a certain amount of warmth from below Jupiter's clouds and increases activity in the cloud layer. If you heat a pan of water or cooking oil on the stove, you will note that the material begins to circulate long before any boiling starts. This thermally created movement is called a *convection current.* Similarly, convection due to the heat from below the clouds stirs giant, rapidly moving masses of gas in the atmosphere. This may bring colored material up from below and initiate condensation of new clouds, just as water condenses into thick clouds in updrafts in

Earth's atmosphere.

Generally, the dark brownish and bluish belts and spots on Jupiter are relatively low, with bright cloud zones, red clouds, and wispy white ammonia clouds being higher.

The most famous cloud feature is the Great Red Spot, a relatively high, cool, brick-red cloud system larger in diameter than all of Earth. *Voyager* observations showed vigorous circulation in the Red Spot. Smaller clouds passing nearby get sucked into it, circulate in it for several hours, and finally get torn apart. Other clouds are almost sucked in, circulate

Overleaf: *We are hovering deep within a vast canyon of clouds. Curving walls dozens of kilometers high sweep away from us toward a horizon that, even though we are high in the atmosphere, and can see for hundreds of kilometers, is still straight and level. The higher the cloud-cliffs soar, the colder and whiter they get. The deeper, warmer clouds glow with orange, red, yellow, and brown chemical compounds. At this level, the air is as thick as Earth's and the sky has the same familiar blue color. But the sun is a brilliant point only a fifth its size as seen from Earth, and the clear blue atmosphere is hydrogen, helium, and ammonia. The dark clouds in front of us are made of ammonium hydrosulfide, a substance that smells like both ammonia and rotten eggs. Wispy tendrils and graceful cirrus clouds are actually icy crystals of ammonia. Below us, lightning bolts powerful enough to incinerate a city flash in the gloom.*

19

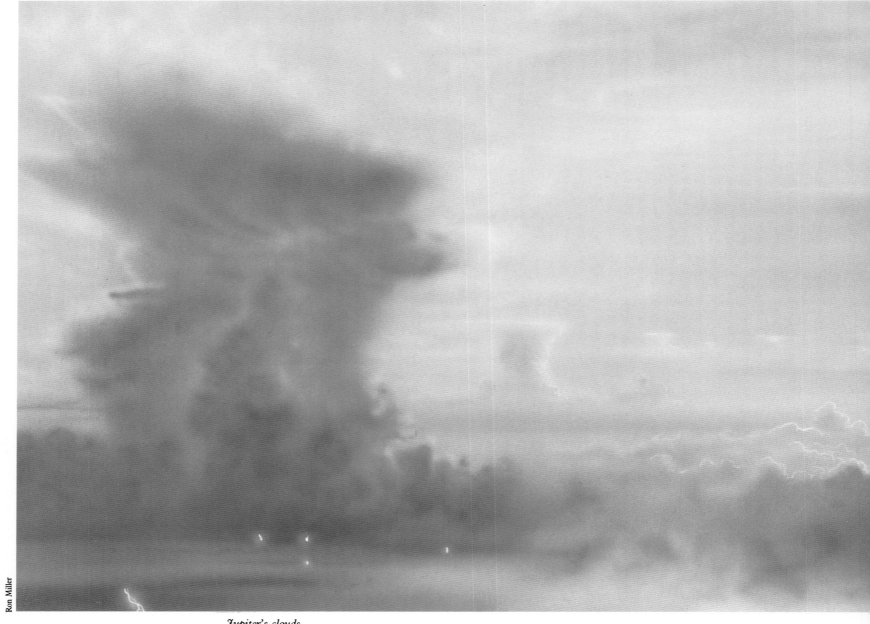

Ron Miller

Jupiter's clouds.

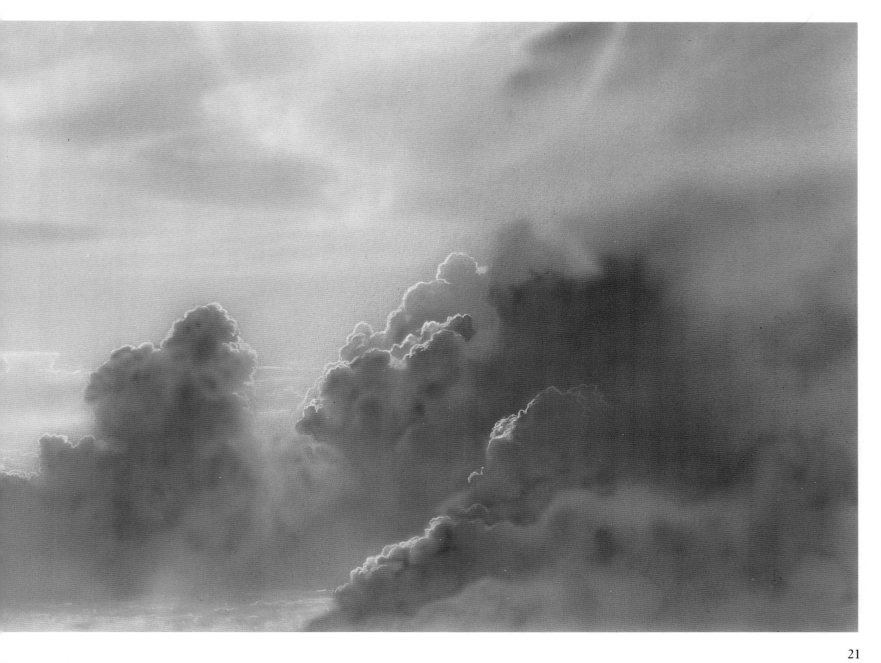

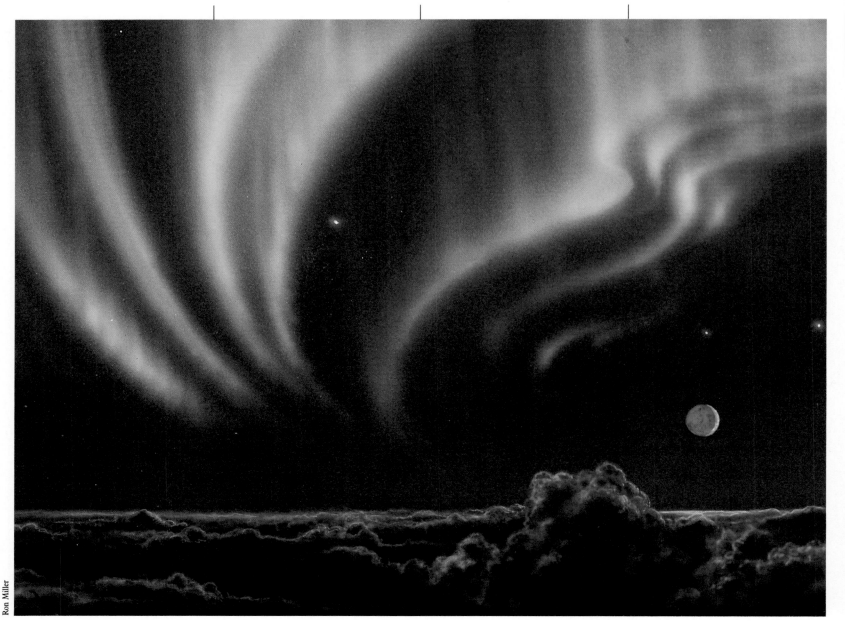

around the periphery, and are then spit out into adjacent zones. The Red Spot has existed for at least several centuries. Other disturbances, not quite as large, may last for many years. The huge mass and size of Jupiter's storm systems probably contribute to the enormous momentum that keeps them defined for long periods of time, though the Red Spot may be associated with some source of disturbance below the clouds that would explain its longevity.

Jupiter probably has a central core of rocky material resembling an oversized Earth, overlaid by an enormous mantle of a form of high-pressure liquid hydrogen called *liquid metallic hydrogen,* which can conduct electric current and may be involved in producing Jupiter's very strong magnetic field. Covering this is an ocean of liquid hydrogen in an ordinary molecular state. Whether the surface of this ocean is clearly defined is uncertain. It may simply blend into the nearly liquid atmosphere.

As *Voyagers 1* and *2* flew close to Jupiter in 1979, they discovered two interesting luminous phenomena in Jupiter's atmosphere. First, ghostly auroras play high over Jupiter's polar regions. Like Earth, Jupiter has Van Allen belts of ions, or charged particles from the sun, trapped in its magnetic field. These can't easily escape, but can move along the magnetic field toward either the north or south magnetic pole of Jupiter. As a result, swarms of ions sometimes crash into the upper atmosphere, colliding with air atoms and molecules and making them glow with strange colors. These colors depend upon the types of atoms involved and energies of their collision. The auroras of both Jupiter and Earth are formed in the same manner.

The second discovery was of a pattern of bright glimmers on time-exposure photos of Jupiter's night side. These are believed to be lightning blasts in the clouds. As on Earth, turbulent cloud motions probably cause atmospheric charges, leading to eventual discharges in stupendous lightning bolts.

Decades before the *Voyager* fly-bys in 1979, a few astronomers had raised the possibility that Jupiter might have a slight ring, too thin and faint to show up from Earth. Generally, this idea was ignored because it couldn't be proven at that time and wasn't required by any proposed theories of planet formation. Nonetheless, as *Voyager* approached Jupiter, NASA scientists planned to take some pictures of the region near Jupiter to check for possible rings of faint inner moons. It was a long shot, but it paid off beyond their wildest dreams. The first pictures, and several subsequent views, revealed a beautiful narrow ring, brightest at its outer edge. It is clearest when viewed from the far side of Jupiter, backlit, with sunlight coming through it toward the cameras. Primarily composed of a swarm of microscopic particles, it looks rather like a thin cloud of cigarette smoke—dim in the middle of a room with the light behind you, but bright where it hangs in front of a lamp with light shining through it.

The same photos also showed a small satellite, previously unknown, at the outer edge of the newly discovered ring. The implication is that the ring is fed by tiny particles that get blasted off this moon by small meteorites. Dynamical studies show that these particles spiral in toward Jupiter, thus augmenting the ring. The ring seems, then, to be not a static feature, like a rock or a hill, but rather dynamic, like a river. The ring we will see years from now will be different from the one we see today, because new material is constantly flowing through it.

Jupiter remains one of the most alien wildernesses in the solar system—a reminder of the awesome environments that nature can create.

Jupiter's satellite system to scale. Left to right: Sinope, Pasiphae, Carne, Ananke, Lysithea, Elara, Himalia, Callisto, Ganymede, Europa, Io, Amalthea.

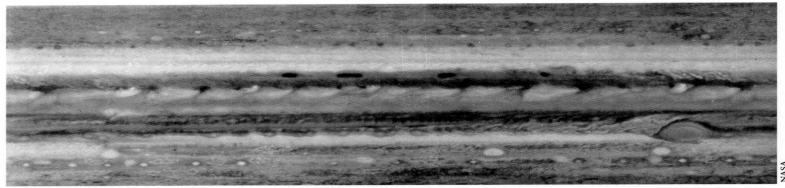

NPR
NTZ
NTB
NTrZ
NTrB
EqZ
STrB
STrZ
STB
STZ
SPR

NASA

Above: *Jupiter, which has no permanent features, is divided into horizontal zones and belts. From top to bottom: North Polar Region, North Temperate Zone, North Temperate Belt, North Tropical Zone, North Tropical Belt, Equatorial Zone, South Tropical Belt, South Tropical Zone, South Temperate Belt, South Temperate Zone, South Polar Region.*

Right: *Little Sinope is the moon with the greatest average distance from Jupiter. It is in an noncircular orbit and reaches a distance of 30 million kilometers from the planet. At this distance, mighty Jupiter looks only half the angular size of our moon as seen from Earth. The four major moons, the Galilean satellites, are easily seen. Sinope is an estimated 40 kilometers (25 miles) across. Its small size, dark surface, retrograde (backward) motion, and high orbit inclination and eccentricity all suggest that it originated not as part of Jupiter's system but as a wandering asteroid that was captured by Jupiter's gravity.*

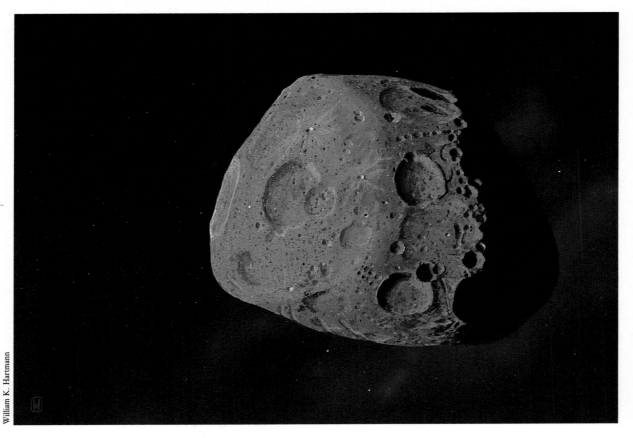

William K. Hartmann

SATURN LORD OF THE RINGS

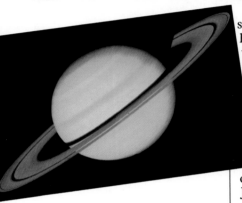

PLANET
Average distance from the sun:
1,427,000,000 km
Length of year: 29.46 years
Length of day: 10 hours 40 minutes
Diameter: 120,660 km
Surface gravity (Earth = 1): 0.93
Composition: hydrogen; ices; hydrogen
atmosphere

Saturn is a smaller-scale, colder, and calmer version of Jupiter, and is most famous for its rings. We are so used to the verbal and visual picture of "Saturn, the ringed planet" that it is hard to focus on the planet itself—the yellowish-tan ball that floats in the center of the ring system.

A brief examination of the size and mass of Saturn reveals that it is the least dense planet in the solar system. In fact, it is less dense than water; if there were a large enough ocean, Saturn could float in it. As on Jupiter, the atmosphere is mostly hydrogen. *Voyager* spacecraft measurements indicate that 97 percent of the molecules are hydrogen. About 3 percent are helium, with a smattering of methane and other gases. Also following Jupiter, the cold upper atmosphere warms below the clouds and grades into hot liquid hydrogen, and the center is occupied by a rocky core with an estimated mass 10 to 15 times the mass of Earth.

Saturn's clouds, viewed from space, lack the vivid colors and contrasting swirls of Jupiter's, but they do have the same general arrangement of dark bands and lighter zones paralleling the equator. Close-up photos by *Voyagers 1* and *2* in 1980 and 1981, respectively, showed some turbulent swirls, and telescopic observers from Earth see occasional dark and light disturbances that erupt for some months before fading. As on Jupiter, the main two dark bands straddle a lighter equatorial region.

Saturn, like Jupiter, radiates measurably more heat from its interior than it receives from the sun. This heat flow may help stir the clouds. As on Jupiter, the main clouds are composed of ammonia crystals, with water ice clouds lying far below. Saturn's clouds look less colorful than Jupiter's, the colors perhaps muted by high haze overlying the main cloud decks.

Saturn has the grandest ring system of all the planets. Unlike Jupiter's, Saturn's rings are very prominent even as seen from Earth through small telescopes. The particles of Saturn's rings are larger than those in Jupiter's rings.

Below: *Saturn's rings swing around the crescent planet (overexposed here to bring out ring detail). The transparency of the C and A rings is easy to see, as well as the opaque areas of the B ring.*

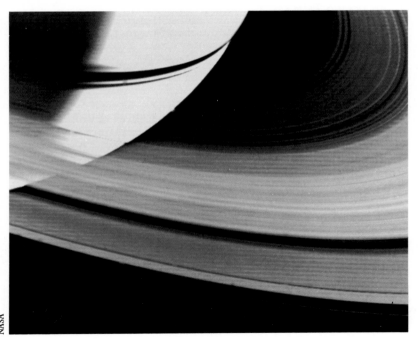

NASA

25

SATURN

Spectroscopic observations in the 1960s proved that the ring particles are composed of (or at least coated with) frozen water. And other testing methods, such as the bouncing of radar signals off the rings, indicate that the dominant particles range from marble size to the size of basketballs; larger ones, though more rare, may reach sizes of 1 to 100 kilometers (.6 to 60 miles) in diameter. These larger particles (or moonlets) orbit among the swarm of smaller particles and may possibly determine the distances between them. Observations from Earth and space vehicles between 1969 and 1980 revealed several small moons, on the order of 40 to 200 kilometers across, orbiting at the very edge of the ring. Gravitational forces from these moons and also from the more distant satellites of Saturn are important in further control of the edges and divisions of the rings.

Although early observers had little physical information about Saturn and its rings, they were able to perform many interesting geometric studies of the ring configuration. As early as 1865,

Above: *Mysterious dark spokes appear in these* Voyager 1 *photographs. They were taken in sequence, from upper left to lower right.*

the British observer Richard Proctor realized that the sky of Saturn, at least from the level of the cloudtops, must present an extraordinary sight, with the ring system arching through the firmament like a midnight rainbow.

The rings are tipped relative to Earth's position, and as Saturn orbits around the sun we see them from different angles. This varying perspective reveals that they are extremely thin and flat; they are about 275,000 kilometers (170,500 miles) in diameter, but their thickness is

Above: *The enigmatic F ring and its inexplicable lumps and braids.*

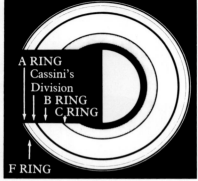

A RING
Cassini's Division
B RING
C RING
F RING

probably less than 1 kilometer and may be only a few hundred meters. Visiting the rings is quite a feat. If we fly into the Saturn ring system at normal spacecraft speeds (i.e., on an unpowered orbit falling toward or around Saturn), we will pass through the rings in less than a tenth of a second unless we approach at a very shallow angle to the ring plane. And if we do that, we will be within the rings for a long time and stand a fairly good chance of hitting a dangerously large body.

But if we slow down, using retro-rockets, and move into the rings, what a sight we'll see! In the most heavily populated parts of the rings, much of the sunlight is blocked out by whirling bodies that cause a thousand twinkling eclipses. Clouds of hailstones spin by, snow-white and glittering. And the sky is filled with passing bodies stretching off to a strange horizon, the distant vanishing

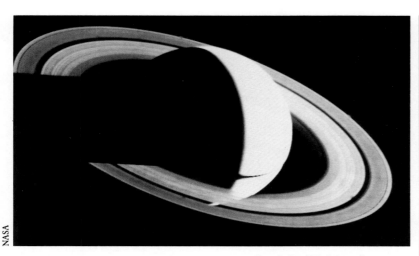

NASA

Above: A view never seen from Earth: a crescent Saturn photographed by Voyager 1.

Saturn's satellite system to scale. Left to right: Phoebe, Iapetus, Hyperion, Titan, Rhea, Dione, Tethys, Enceladus, Mimas. There are several small moons between Mimas and Saturn's rings.

point defined by the ring plane—a virtual highway in the sky.

Earthbound telescopic observers have long known that the rings were structured. In the 1600s, French astronomer Jean Dominique Cassini discovered a prominent gap. Other finer gaps, called *divisions*, have also been

seen. Cassini's Division forms the boundary between the outer ring, called the *A ring*, and the inner *B ring*, which is somewhat brighter than its counterpart. Inside the B ring is a much fainter division of rings called the *C ring*. Other ring portions have been tentatively identified by various observers, including the so-called D, E, and F rings.

But when *Voyager 1* flew by in 1980, it revealed a vastly more intricate structure than was explained by the old theories. For example, in one of the obscure divisions inside the rings, a very narrow ring was found that was not circular but rather elliptical in profile. On one side of Saturn it seemed to be centered in its division, but

on the other side it was well off-center, toward the edge of the division. This finding may help explain some very puzzling observations: various telescopic observers have drawn pictures of divisions in different positions in the rings at different times. Perhaps changing configurations of satellites actually change positions of ring divisions. Or perhaps rotation of the rings brings different structures into view.

This last possibility seemed to be established by the *Voyagers* when they discovered strange, radial streaks in the rings that could be seen rotating around Saturn in time-lapse movies made by the probes' cameras. These spokes, similar to markings sketched by observers as long ago as the 1880s, have never been explained. Since the particles in any ring system move at different speeds (those closer to a planet move more rapidly than those farther from it), it seems impossible for a radial pattern to be maintained, since the part of the spoke closer to Saturn should be moving more rapidly than its outer end.

The complexity of the rings was further made apparent by the *Voyagers*' discovery of an intricate structure of filaments, seemingly braided in appearance,

Overleaf: *Saturn is a world of genuine magic, circumscribed by the compass of a mythic draftsman. Hovering above dark, wind-torn clouds at a latitude that, on Earth, would put us over Mexico City, the great rings cover the southern sky like the rainbow bridge Viking heroes took to Valhalla. In this nearly 180-degree view, they sweep from the east, at our extreme left, to the west, where the shadow of Saturn itself has bitten off a reddened mouthful.*

The sun will be rising soon. For all its enormous size (nine and a half times the diameter of Earth), Saturn rotates in only slightly more than 10 hours—so rapidly that the planet bulges strikingly at its equator and objects there weigh one-sixth less than they do at the poles. The night has lasted scarcely 5 hours, Saturn's shadow sweeping across the rings like the hand of a clock.

Although softened by the atmosphere, much of the fine detail that makes the rings look like a phonograph record still comes through. Many of the largest features—Cassini's Division, the dark band at the top, or the French Division between the bright B ring and the inner C ring—are fairly stable and permanent. Observations over the past 150 years or so would seem to imply changes in many of the finer details: they come and go, passing through the rings like ripples in a circular pond.

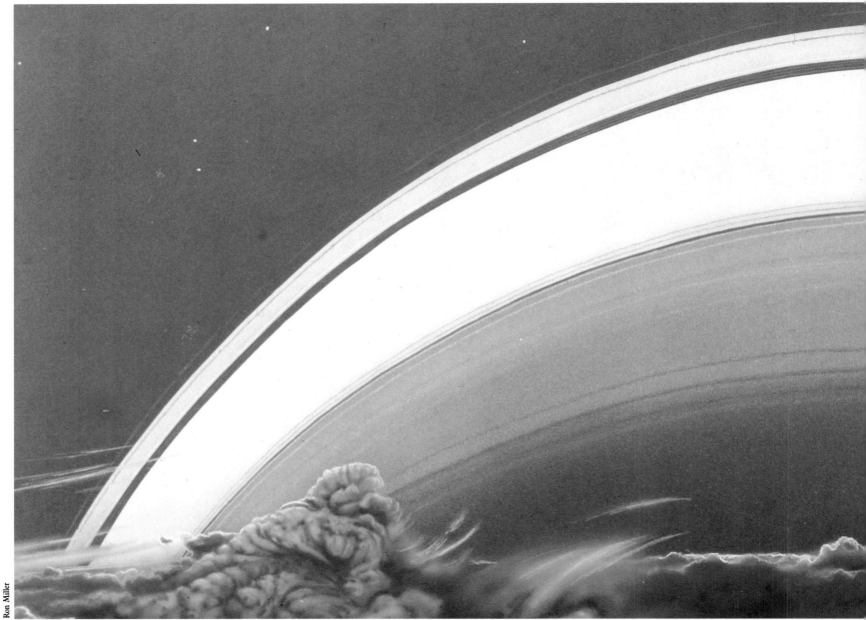

Saturn's ring panorama.

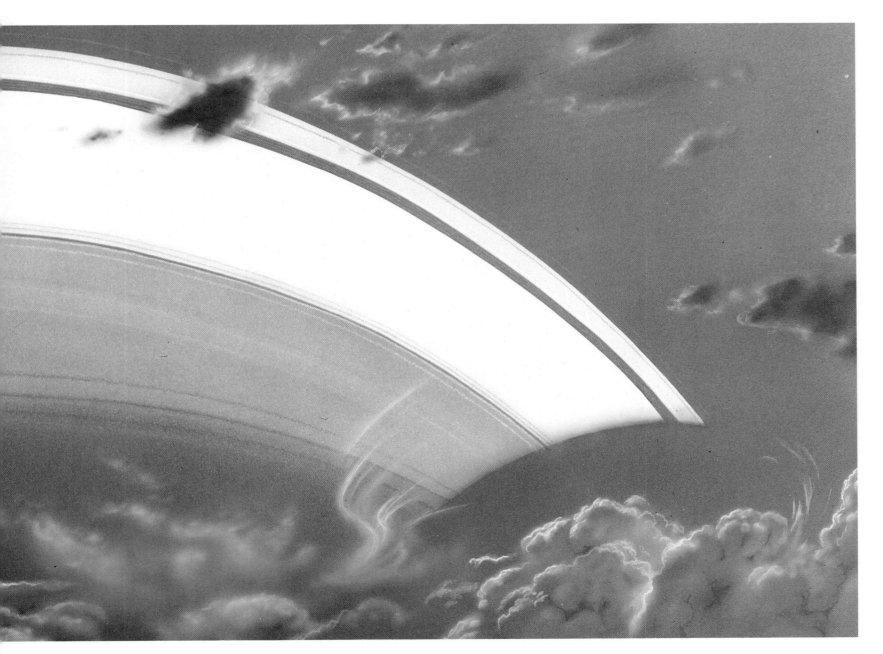

SATURN

in a narrow ring just outside the A ring. How swarms of ring particles can arrange themselves in filaments is not known.

Many scientists believe that the rings originated from material left over in the vicinity of the planet after Saturn formed. The rings of Saturn, like the rings of Jupiter and Uranus, are located mostly within a critical distance from the planet called *Roche's limit*. This is the distance within which the stretching forces associated with a planet would break apart a large, weak object. Just as the moon raises tidal forces in the oceans of Earth, any planet can stretch and raise bulges on the surface of a satellite.

Most satellites are outside Roche's limit and therefore are too far away for tidal forces to do any structural damage. However, inside Roche's limit, this stretching can pull a weak moon to pieces. Therefore, if small particles are formed inside this zone, they are unable to aggregate into a single satellite.

Some scientists believe that the Saturn ring material may have been left from primeval days because of this effect. Others suspect that a large comet or asteroid may have passed so close

Ron Miller

Left: Seen from Hyperion, Saturn is nearly three times farther from us than Earth is from the moon. Still, the ringed planet appears 10 times larger than our moon does. Only 257,600 kilometers (159,712 miles) away is the giant moon Titan, looking like an enormous tangerine. Saturn, here, is tilted to almost its greatest extent in relation to the sun. The shadow of the rings covers nearly the entire southern hemisphere. Light reflected from the brilliantly white rings dimly illuminates the planet's night side.

Hyperion is one of Saturn's smallest satellites, only 350 by 200 kilometers (218 by 125 miles) in diameter. It is the third from the outermost moon, between Titan and Iapetus. Its surface is moderately bright and probably contains a mixture of ice and soil. Hyperion is biscuit-shaped and has an unusual, uneven, wobbling rotation—hinting at the variety to be found among Saturn's moons.

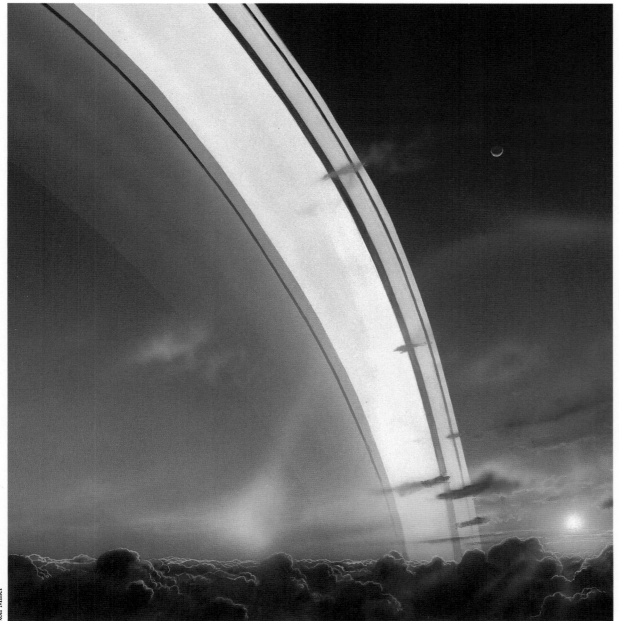

Ron Miller

Left: *Arching over the cloudtops like a silver rainbow, Saturn's rings as seen from the high atmosphere must be the most magical sight in the solar system. Their appearance would vary with the observer's location, the time of day, and the season. In this view, we watch the sunset during the Saturnian equinox. We are at 15 degrees south latitude, looking almost due west. Where the rings dip behind the horizon, they are tinted pink for the same reason the setting sun and moon often appear reddish to us on Earth. As Saturn's rotation carries us onto its night side, we will soon see the vast shadow of Saturn itself, cast across the rings.*

The distant sun—only a tenth as big as it appears in Earth's sky— is surrounded by a faint halo of light refracted from ice crystals high in Saturn's atmosphere. The crystals are also responsible for the bright "sun dog" near the center of the view.

The nearest visible edge of the ring system is about 14,000 kilometers (8,800 miles) away, though very thin parts of the rings may extend down to the top of the atmosphere itself. The outermost visible ring is 76,000 kilometers (48,000 miles) away— a fifth of the distance between Earth and its moon. Our moon could slip through the gap in the rings, known as Cassini's Division.

SATURN

to Saturn that it broke up inside Roche's limit, spewing a cloud of ring particles into the area. Alternatively, a small moon located within or near Roche's limit may have been shattered into many pieces by the impact of a large meteorite.

Whatever the origin and history of Saturn and its rings, the system reminds us that nature can not only create bizarre and beautiful environments on planetary surfaces, but may also create astonishing environments in orbit around those worlds.

NASA/JPL

Above: *Ribbonlike clouds are stretched across Saturn by 800-kilometer (500-mile) winds.*

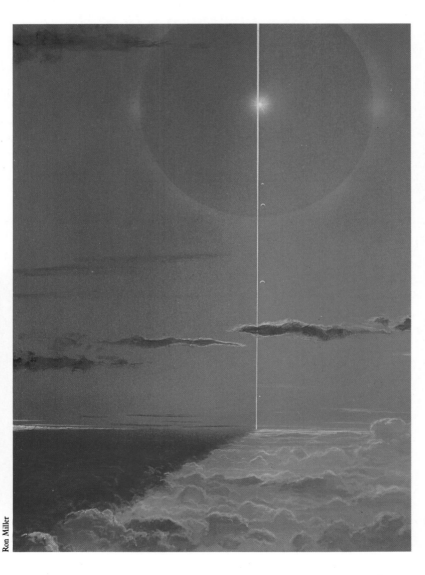

Ron Miller

Left: *The sky is split in two by a line of light. We are at Saturn's equator, directly below the rings, and are seeing them edge on. Despite their enormous width, the rings are very thin—probably less than a kilometer wide. From here, 14,000 kilometers (8,680 miles) away, they appear to be the width of a pencil line.*

The narrowness of the ring's shadow, seen to the left, indicates that it is almost spring leading to a 15-year winter in one hemisphere, and a 15-year summer in the other.

URANUS A SIDEWAYS WORLD

PLANET
Average distance from the sun:
2,870,000,000 km
Length of year: 84 years
Length of day: 17.9 hours
Diameter: 51,120 km
Surface gravity (Earth = 1): 0.79
Composition: ice, hydrogen, helium;
hydrogen-methane atmosphere

Uranus (pronounced *YOUR-a-nus*) is the first planet to have been discovered since prehistoric times. The discovery was made by the English astronomer-composer William Herschel in 1781, while he was charting stars with his six-inch-diameter telescope.

Uranus is so far from Earth that it appears only as a tiny disk in the largest telescopes.

Voyager 2 flew past Uranus in 1986 and gave us our first close-up look. No cloud markings are prominent; the disk presents only a nearly featureless greenish-blue face. The color arises for two reasons. First, the clouds are seen through a deep haze layer that scatters bluish light like the light of our own sky. Second, methane in this deep haze layer absorbs red and orange light from the sun, imparting a greenish-blue color.

Voyager 2 revealed that Uranus, like Jupiter and Saturn, has an atmosphere composed mostly of hydrogen and helium. About 83 percent of the molecules are hydrogen and about 15 percent helium. Methane and trace gases constitute the rest.

Uranus and its neighbor, Neptune, give us good examples of transitions between the "gas giant" planets, Jupiter and Saturn, and the rocky Earth. The diameter of Uranus is only 4 times Earth's, whereas Jupiter's diameter is 11 times that of Earth. Theoretical studies

suggest that the interior material is a mixture of roughly one-half water, one-quarter methane, and one-quarter rocky material. The rocky material forms a central core that resembles planet Earth. This is overlaid by a layer of high-pressure solid water, methane, and ammonia, grading upward into a mushy ocean of these materials, and a foggy, hydrogen-rich atmosphere. As with Jupiter and Saturn, there may be no well-defined surface. With its weaker gravity, Uranus was not able to trap as thick a hydrogen atmosphere as Jupiter and Saturn.

Voyager 2 discovered that Uranus's magnetic field, unlike that of most planets, is tilted at an odd angle of 60 degrees to the axis of rotation. It would be as if a compass on Earth, instead of pointing north, pointed to a spot in Mexico.

On March 10, 1977, a group of astronomers convened in Africa to watch Uranus pass in front of a star. The plan was to monitor the starlight as the star passed behind Uranus's

atmosphere. This would reveal information about the atmospheric composition and structure.

The astronomers were in for a surprise. The star went through a pattern of brief dimming *before* Uranus passed in front of it and then repeated the same pattern in reverse on the other side. Something that existed on both sides of the disk, in a uniform pattern, was blocking the starlight. This "something" was surmised to be a series of narrow rings around the planet.

Voyager 2 photographed the rings from close range and confirmed that they are beautiful, delicate, and unusual.

These rings are very different from Jupiter's or Saturn's. Jupiter's ring looks like a single, moderate-width band. Saturn's rings are a wide system divided by more than a hundred narrow gaps. Uranus, in contrast, has several narrow rings separated by

Uranus's satellite system to scale. Left to right: Oberon, Titania, Umbriel, Ariel, Miranda.

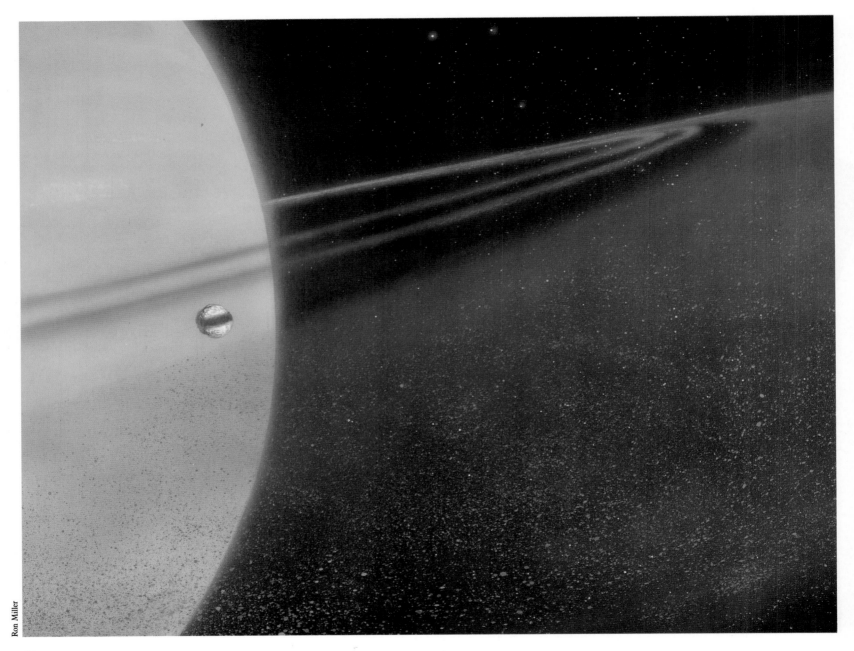

34

wide gaps. Their structure is believed to relate to forces exerted on the rings by nearby satellites, located within the ring system. The exact physical mechanism that causes the spacing of rings is still uncertain. Some theorists suggest that each Uranian ring is associated with a small, as yet undiscovered moonlet located in or near the ring.

A distinctive feature of Uranus and its ring system is that the whole system is "tipped over." Most planets' equators lie nearly in the plane of the solar system,

Left: Unlike the brilliant rings that encircle Saturn, Uranus's are narrow, dark hoops. They are barely visible until you are virtually within them— as we are here. We are positioned near a small moon that orbits between two of the nine rings. One of these moons may be within each gap, responsible for keeping these spaces swept clear of dark rock and dust. The bright disks are Ariel and Miranda, the innermost two of Uranus's five moons (not counting the moonlets within the rings). The shadows of two outer rings stripe our little moon, and the shadows of all nine rings on the planet itself run just below the fuzzy line of rubble.

While Uranus's rings lack the almost mystic grandeur of Saturn's, we can appreciate their simplicity: they are drawn like a vast geometric exercise around the placid, turquoise planet.

with their polar axes of rotation pointing "up" or "down," nearly perpendicular to the plane of the solar system. Jupiter's equator and rings, for instance, are only a degree or so off the plane of the solar system. Earth is 23.5 degrees off, meaning Earth's northern hemisphere gets more direct sunlight for part of the year (summer) and less sunlight six months later (winter). The seasons thus arise because Earth's northern hemisphere is tipped toward the sun for half the year and away for the other half.

In contrast, Uranus's pole lies almost in the plane of the solar system. This means that Uranus has extraordinary seasons. For one-quarter of the Uranian year, the north pole gets direct sun.

During this season, the equator is in perpetual twilight. After a quarter of its trip around the sun is completed, we find the sun rising and setting over the equator during each of Uranus's 18-hour days; the north pole at this time is just grazed by light. After another quarter of a year, the northern hemisphere is deep in night. The north pole's night lasts half a "year." After another quarter-year, the sun is over the equator again and summer begins to return to the northern hemisphere.

On Earth, the north (or south) pole is plunged into night for half the year, but on Uranus this long winter night happens to much of each hemisphere. At the height of summer, the sun shines continually almost directly above the north pole. Because Uranus takes 84 years to go around the sun, the night at the pole lasts a frigid, black 42 years, followed by a polar "day" equally as long.

Other planets are illuminated by sunlight that comes only from "the side," i.e., from a direction nearly in the equatorial plane. Uranus can be lit from almost any direction, above the equator or above the pole. Uranus's rings lie around its equator, so they, too, can be lit edge on, and sometimes from directly above or

below. The changing phases of the globe, the ever-shifting light on both Uranus and the rings, and the slipping of the rings' shadow back and forth across the globe present an endlessly changing panorama to observers in nearby space or on one of Uranus's moons.

Overleaf: Above Uranus, its cloudtops fogbound in a methane haze, we can get a clear view of its spidery system of rings. We're looking "down" on them from latitude 45 degrees north—if Earth had rings identical to these (but scaled down to match its smaller size), this is what we'd be seeing as we hovered over Ottawa or Portland, Oregon. In order to see their full width, we need this wide-angle picture—spanning about 135 degrees, more than you could see with the naked eye without turning your head.

The rings are very dark, even though the sun is shining on them. Unlike the rings of Saturn, which are made of billions of large and small particles all coated with (or made of) ice, Uranus's rings are the color of powdered coal. Tiny moonlets, which may orbit within the gaps between the rings, may keep these areas swept clean of debris. The sun is 19 times smaller than in Earth's sky, providing less than one three-hundred-and-fiftieth the amount of light and heat.

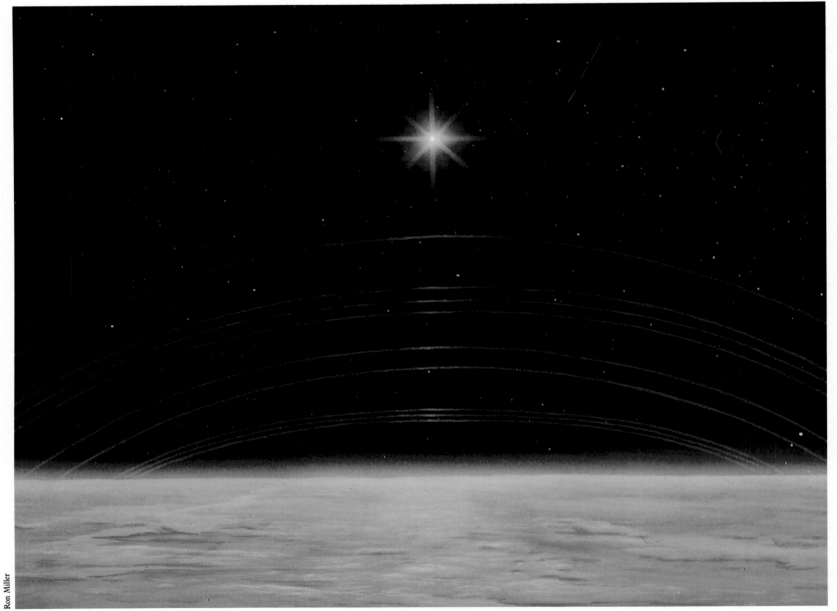

Ron Miller

Above Uranus and rings.

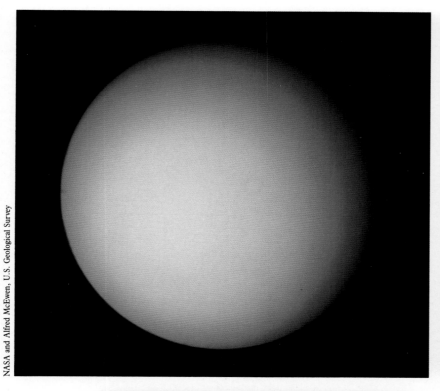

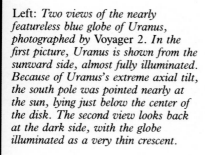

NASA and Alfred McEwen, U.S. Geological Survey

Left: *Two views of the nearly featureless blue globe of Uranus, photographed by* Voyager 2. *In the first picture, Uranus is shown from the sunward side, almost fully illuminated. Because of Uranus's extreme axial tilt, the south pole was pointed nearly at the sun, lying just below the center of the disk. The second view looks back at the dark side, with the globe illuminated as a very thin crescent.*

NASA

Left: *A portion of the peculiar, thin rings of Uranus are shown in this 15-second time exposure from* Voyager 2. *The brightest ring is the outer one, known as the Epsilon ring. The widths of the rings range from about 100 kilometers (60 miles) to only a few kilometers.*

Ron Miller

Above: *From an orbit close to icebound moon Umbriel, Uranus reveals one of its unusual-looking phases caused by its unique axial tilt. Inner moons Ariel (the larger one) and Miranda share the same phase. Uranus is on its way from its northern hemisphere midsummer (when its north pole is pointed directly at the sun) to spring, when the terminator (the line separating night from day) is at a right angle to the equator, as on a "normal" planet. Uranus's rings are in the plane of its equator, like Saturn's and Jupiter's. Like those planets, the moons of Uranus are probably composed mainly of ice.*

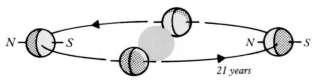

21 years

Above: *Uranus's axis is tipped nearly 90 degrees; twice during its year, one of its poles points directly at the sun.*

NEPTUNE THE LAST GIANT

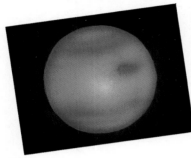

PLANET
Average distance from the sun:
 4,497,000,000 km
Length of year: 165 years
Length of day: 19.2 hours
Diameter: 49,530 km
Surface gravity (Earth = 1): 1.12
Composition: ice, hydrogen, helium;
 hydrogen-methane atmosphere

Neptune was discovered telescopically in 1846 after calculations showed that Uranus's motions were being disturbed by a still more distant planet. Neptune is too far away to be seen by the naked eye, but when dynamicists calculated the orbit that seemed to be required by the hypothetical planet's effects on Uranus, the planet was soon located telescopically. Telescopes reveal little information about this outermost large planet, but in 1989 *Voyager 2* flew close by and revealed its secrets.

One of the most wonderful surprises of space exploration is the variety of "personalities" that have become evident among different planets and satellites, and Neptune is no exception. Although Neptune is about the same size as Uranus, it has its own distinctive features.

Scientists expected Neptune to have even less cloud activity than Uranus because it is so cold. But *Voyager* cameras discovered prominent cloud belts and a huge, dark blue oval spot. It's a storm system as big as the whole Earth. Reminiscent of Jupiter's Red Spot, it came to be called the Great Dark Spot. It's flanked by white cirrus clouds and shares the planet with several smaller white and dark blue oval storm systems.

What powers the storms? *Voyager* showed that Neptune has the highest ratio of internal heat outflow to external incoming sunlight of any planet—a ratio of about 2:7. (In contrast, Uranus has the least among the four giant planets.) So Neptune's atmospheric unrest may be powered by warm currents ascending from below. The planet's interior structure and atmospheric composition are probably similar to those of Uranus.

Another surprise from *Voyager* was a discovery of hitherto unknown rings, with a unique feature. They comprise three narrow rings, and the unique feature is that the outer ring is not uniform but contains three broad, arc-like concentrations of particles along its circumference. These are called *ring arcs*. The forces that maintain the ring arcs are mysterious. Remember that all rings consist of millions of small particles, each moving independently around the planet. Something makes Neptune's outer ring particles "bunch up" into ring arcs. Probably this is caused by gravitational pulls from tiny unseen moonlets among the rings.

Voyager discovered that each giant planet has small moonlets just outside its ring system. In the case of Neptune, *Voyager* found six previously unknown satellites, from about 50 to 400 kilometers (31 to 250 miles) across, just outside or within the rings.

Overleaf: *Deep in the frigid, hazy atmosphere of Neptune, we watch its giant moon Triton about to eclipse a tiny, chilly sun. Thick clouds—similar to those that blanket Jupiter and Saturn—roil sluggishly. A thick ocean of haze surrounds us. It is fairly clear and scatters blue light the way Earth's atmosphere does. Triton appears almost half again larger than Earth's moon, while the shrunken sun is reduced 30 times in diameter compared to its visage from Earth: 900 times less in area, luminosity and warmth.*

Neptune's satellite system to scale. Left to right: Nereid, Triton. Innermost small moonlets are not shown.

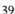

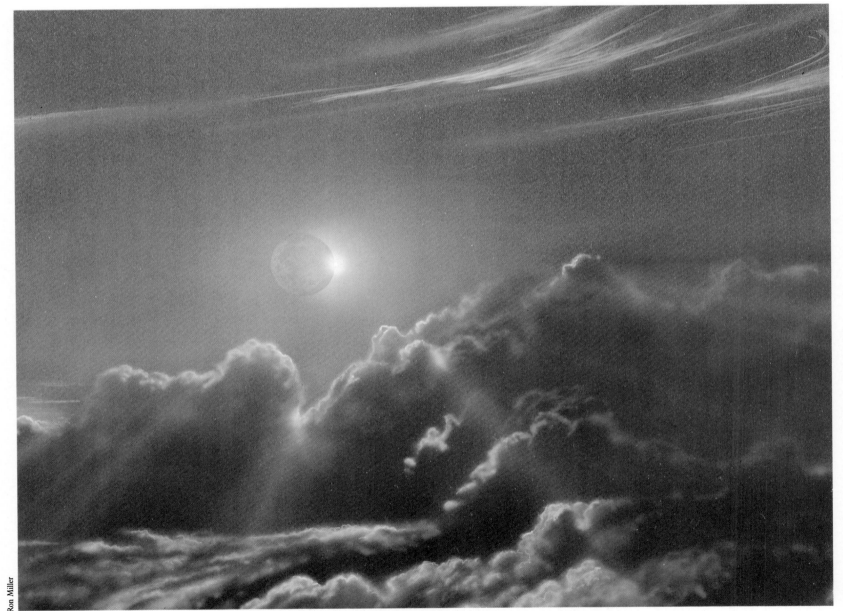

Triton eclipsing the sun.

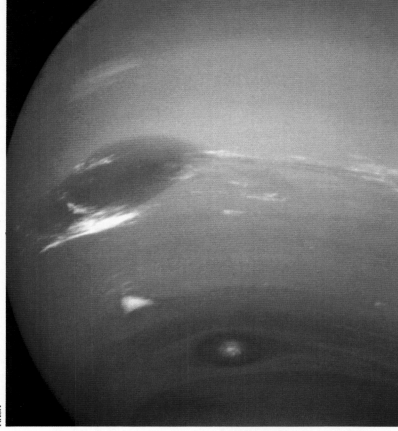

NASA

Below: *A portion of Neptune's bizarre ring system is seen in this* Voyager 2 *photo, in which part of Neptune's crescent is strongly overexposed at upper left. The rings are very narrow and, like Uranus's rings, composed of millions of tiny, dark dust particles. But unlike Uranus's, they have concentrations of particles, known as ring arcs (bottom), whose cause is uncertain.*

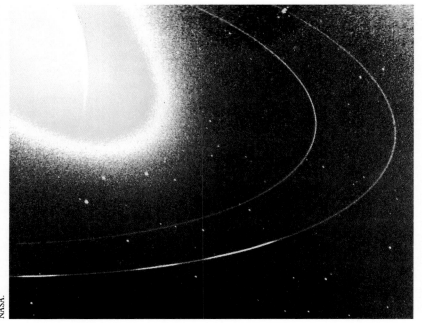

NASA.

Above: *The cloud-swept blue globe of Neptune, photographed by* Voyager 2 *in 1989. Unlike featureless Uranus, Neptune surprised scientists by the wealth of its cloud and storm features. The Great Dark Spot is a storm mimicking Jupiter's Red Spot. A smaller oval storm is seen at bottom, along with scattered white clouds. The storms circulate around Neptune at different rates and only rarely appear together, as in this view.*

EARTH THE PLANET OF LIFE

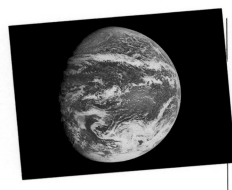

PLANET
Average distance from the sun:
 149,600,000 km
Length of year: 365 days
Length of day: 23 hours 56 minutes
Diameter: 12,756 km
Surface gravity (Earth = 1): 1
Composition: nickel-iron, silicates;
 nitrogen-oxygen atmosphere

At the turn of the century, rocket pioneer Konstantin Tsiolkovsky said, "Earth is the cradle of mankind, but one cannot live in the cradle forever." Earth is more than a cradle to us; Earth has helped shape us. And we are only its most recent product. Geologic studies have shown that Earth has evolved dramatically since it formed 4.5 billion years ago. It has gone through changes that have been extremely rapid and others that have been very slow.

Earth's atmosphere had much less oxygen for the first billion years of its existence, as shown by oxygen-poor sediments deposited during that period. The amount of oxygen increased after plant life evolved. This apparently happened early on; laboratory experiments confirm that complex organic molecules form easily as a result of lightning strokes and other bursts of energy in the primordial atmosphere.

For the first half of Earth's history, little life could be found on land, and there were few organisms even in the sea. Although signs of ancient life as old as 3 billion years have been found in rocks, trilobites and other organisms large enough to leave obvious fossils did not evolve until 600 million years ago, i.e., after 87 percent of Earth's history had already elapsed. The modern continents didn't start to take shape until 300 million years ago, and dramatic environmental changes have occurred even in the last 100 million years.

The point of all this is that Earth has been constantly changing. It may always have been a blue planet with swirling white clouds, but it has not always been a passive stage on which we living creatures play out our roles. The stage itself has changed, and so have we. Fortunately, we evolved fast enough to keep up with our changing Earth. But today, we have the technological ability to alter Earth's environment faster than we can evolve, and we threaten ourselves and other species in the process.

As environmentalist René Dubos has pointed out, our connection to Earth is umbilical. Earth has nourished us, and we are suited to it and comfortable

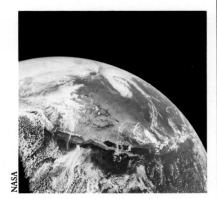

North America from space.

with it. Writers such as Carl Sagan stress the beauty of Earth; but this beauty is not an intrinsic or universal absolute. Earth is beautiful to us because we have evolved on it and have adapted to it; it is the only place in the

Right: *The good spaceship Earth is 25,000 kilometers (15,500 miles) ahead of us. Cloud-marbled, looking like a blue-and-white bowling ball, it swarms with life brought about by many happy circumstances. For example, it is just the right distance from the sun. If it were a bit farther out, the swirling patterns of water vapor would be frozen on the surface; even farther, the continents would be buried beneath crawling glaciers; farther still, the precious atmosphere itself would lie in drifts and frozen lakes. If Earth were closer to the sun, it would be an arid inferno like Venus. In the scale of this picture, the atmosphere is as thin as the ink with which it is printed. And as far as anyone knows, all the life there is in the universe exists within this fragile film.*

The aurora borealis flickers in a ragged ring around the north pole, while the distant moon wanly lights the night side of our home planet. So large is our moon in proportion to Earth (only Pluto and its moon, Charon, are as close in size) that it would be reasonable to call Earth and the moon a double planet.

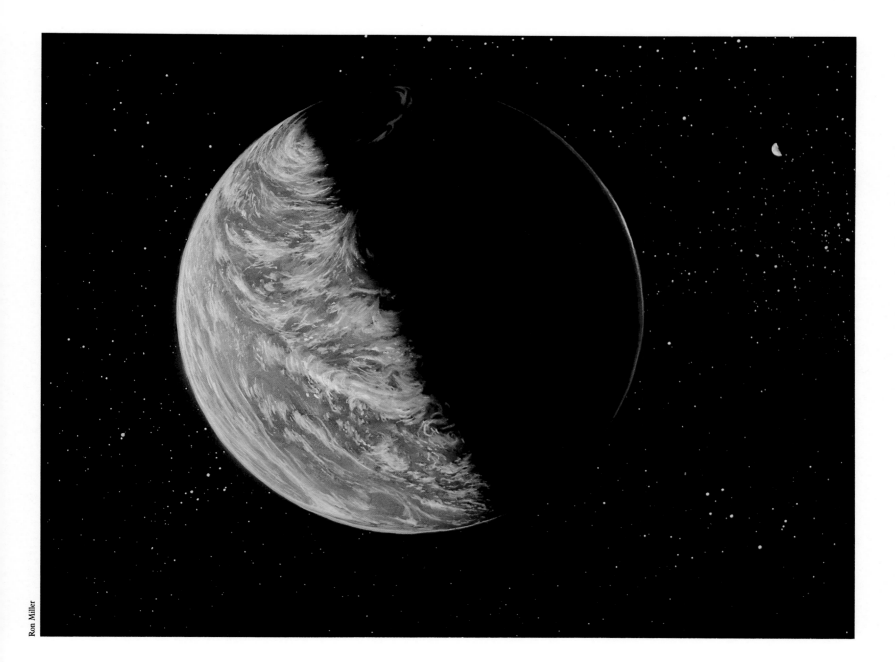

Ron Miller

43

Below: *The rugged, snow-capped mountains of Greenland, near the shore of the ice-filled Greenland sea, as seen in a photo looking downward from space.*

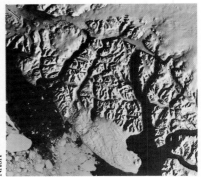

Left: *As Earth grew older, its crust buckled and wrinkled. Continental plates collided like sheets of ice in a frozen river. Where plates met, where the crust split and faulted, mountains were born. Volcanoes laboriously built up miles-high cones or broad piles of ash and cinder, layer by layer.*

The collision of India and Asia created the Himalayan plateau; one of the wrinkles on top of it became Mt. Everest. An enormous block of Earth's crust was suddenly vertically thrust 3,000 meters (9,900 feet). The craggy, eroded remnants of this vast cliff are the Tetons.

Earth's largest mountain was created by a volcano. From its under-water base to its summit, Hawaii's Mauna Kea is 10 kilometers (6.2 miles) high, 1,500 meters taller than Everest.

Precipitous ranges like the Rocky Mountains are relatively young. But mountains, too, grow old. Millions of years of wind, rain, and plant life can eventually reduce a range like the Andes to the elderly undulations of the Appalachians.

solar system where we can stand naked, breathing the air and feeling the sun, and see water trickle by our feet.

Space exploration is helping us to realize that Earth is a fecund paradise. That realization should provide us with sufficient motivation to try to keep it that way. How beautiful and how varied Earth is! Its active geology has created landscapes of enormous variety—rolling blue seas of liquid water, windy ravines, fields of sand dunes, dark overgrown jungles, barren polar deserts, volcanic explosions, golden prairies, waterfalls, and jagged peaks looming over glacial valleys. Our skys encompass clear blue vistas, white cloud puffs, dusty yellow glows, sunset reds, foggy grays, crystal moonlight, and spectral auroras.

Today there is little doubt that nomadic humans will eventually be able to journey to other planets, build space cities, collect energy, manufacture new tools, and multiply. There is increasing evidence that this may be a way to save our race from some natural or man-made disaster that could make Earth uninhabitable. By moving some of our industries to space, we may be able to reverse the rising tide of acid rains, nuclear waste production, desperate strip mining for fuels and oils, hydrocarbon damage to the ozone layer that protects us from ultraviolet rays, and other results

of the activities of a population whose appetites have grown beyond Earth's ability to sustain them.

Space exploration will also help us to determine whether Earth is so unusual that life is rare in the universe, or whether Earth-like conditions, and hence living organisms, are common.

Nineteenth-century beliefs that nearby planets were populated are both overly anthropocentric and incorrect. Recent space flights suggest that we don't share the solar system with anyone else. Certainly, there are no civilizations on Mars, no dusty cities or even organic sediments. Nonetheless, some meteorites contain the building blocks of life—amino acid molecules—formed probably in moist, subsurface layers of an ancient asteroid or comet.

Right: *After leaving the sun, particles blown from a sunspot slam into Earth's upper atmosphere, creating an aurora in exactly the same way that electricity passing through the gas in a neon tube causes it to glow. Different gases give off different colors. Earth's magnetic field funnels the charged particles into the north and south magnetic poles like water funneled into a drain. Here, not far from the magnetic north pole in northern Canada (nearly 1,600 kilometers, or 1,000 miles, south of the geograhpic north pole defined by Earth's rotation axis), the shimmering atmosphere is alive with ghostly curtains and veils. They constantly and abruptly flicker and change, as though they were connected to a switch.*

Ron Miller

Ron Miller

Above: *Fully a third of Earth's surface is desert—more, if the Arctic and Antarctic regions are included. There are almost as many definitions of desert as there are deserts. All are arid, with little or no rainfall. Even the polar regions are arid, receiving scarcely 10 inches of precipitation a year. Still, lifelessness is not necessarily a characteristic of deserts. The most hostile of Earth's arid regions, seemingly without a trace of water, encrusted with salts and broiling in temperatures reaching 48 or even 65°C (120 or 150°F), can still support life, and, in some cases, that life even flourishes. The danger of the deserts is that they are expanding as we destroy more and more of our land and its delicate ecological balance. Three-quarters of this planet is underwater, a third of the remainder is desert, and a large portion of what's left is uninhabitable or not useful for one reason or another—mountains, swamplands, and such. We have very little planet to waste.*

Above: *The great sand dunes of Africa's Namib Desert dominate this photograph, made from an altitude of 914 kilometers (570 miles).*

On Earth, the most unique feature was the moist, warm climate that persisted for billions of years, allowing such chemicals to assemble into viruses, cells, microbes, and eventually (in only the last 10 percent of planetary history) large living creatures.

Biologists once thought this evolution was slow and steady. But recent research reveals some "abrupt" changes that happened during intervals of only a million years or less.

To take one example, something suddenly changed Earth's environment 65 million years ago. An extraordinary 75 percent of plant and animal species, including dinosaurs, became extinct in only a few million years or less, and mammals emerged from their previous obscurity.

What changed Earth so suddenly? Research in the 1980s provided an unexpected "cosmic" answer. In 65-million-year-old strata, geologists found evidence that a meteorite 10 kilometers (6 miles) wide crashed into Earth at that time. The evidence included concentrations of elements associated with meteorite material, plus grains of quartz showing unique shock-fractures caused by the giant explosion, and a layer of worldwide soot implying forest fires around the world!

The effects of the impact were awesome. The blast ejected debris that shot into space and fell back into the atmosphere around the world, lighting the sky with the glow of a billion meteors. The heat from this glow probably ignited the forest fires and killed many animals in the hours after the impact, except in areas protected by snowstorms and heavy rainstorms. Dust and soot from the explosion and fire settled in the stratosphere, obscuring sunlight for several months. This killed off many surviving plants and disrupted the food chain. Scientists in 1990 announced the probable discovery of an impact crater 180-kilometers (110 miles) wide, hidden under sediments on the coast of Yucatán. It has been dated at about 65 million years.

Another confirmed meteorite crater of the same age (within a million years), only abut 32 kilometers across (19 miles), is buried under sediments at Manson, Iowa, and still another 50-kilometer (30-mile) crater in Russia is suspected to be of this age. Thus more than one meteoritic body may have hit Earth at that time, possibly due to breakup of a comet near our planet. Earth's environment, we now see, is really part of a larger cosmic environment!

Additional mass extinctions of species happened in other epochs, including the strongest of all, 250 million years ago. Some scientists think these episodes may have been due to random impacts of additional giant meteorites every 100 million years or so. Other scientists point out that impacts have not been proven for many of these extinctions. They think the extinction process involves some other geological force, such as occasional massive lava eruptions that release large amounts of carbon dioxide and thereby affect the global climate.

Clearly, Earth's environment and biology have had a complex history. Species have evolved not in a linear, preordained way, but along a twisting path, probably involving elements of chance such as climate changes due to random impacts. But always, the species that succeeded in any given era were the ones best suited to the environmental conditions of that era.

This is why we are so uniquely adapted to our planet today. Note carefully that Earth's environment was different in the past. For example, ancient Earth had a carbon dioxide–dominated atmosphere, like Mars and Venus; oxygen became important only after plants evolved,

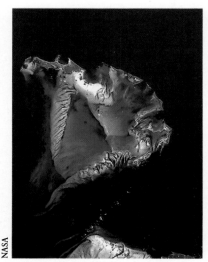

Above: *The varying depths of the ocean are apparent in this* Skylab 3 *photograph of the Great Bahama Bank.*

Overleaf: *This is the most typical Earth "landscape": 71 percent of Earth is covered by oceans. It belies the name we have given our planet and illustrates how careful we must be in extrapolating the nature of a planet from a single, random sample at one point on its surface. The seas of Earth dominate more than a mere area: they dominate our weather and climate, and ultimately the fate of the continents themselves. They nurtured life itself, and maintain it. Perhaps we should have named our planet* Ocean.

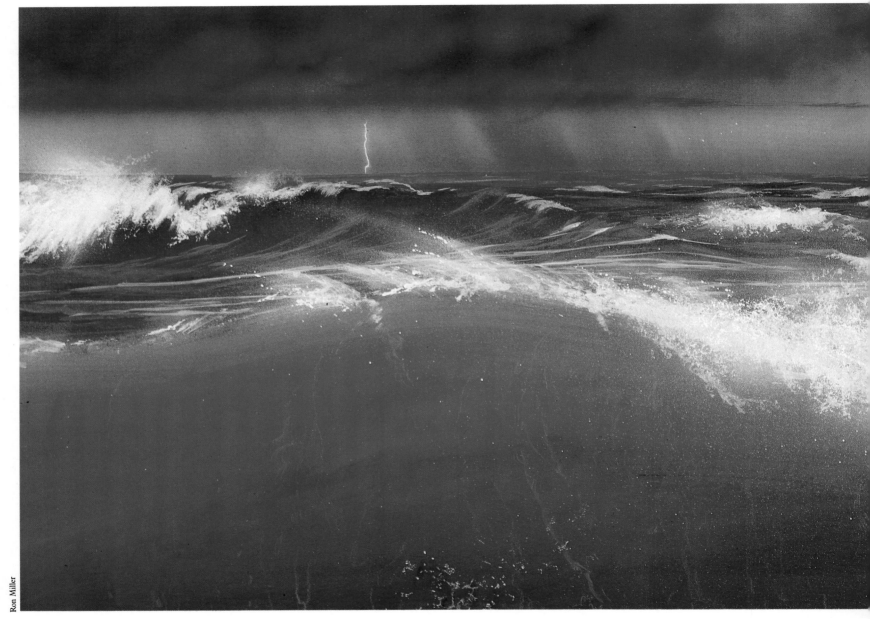

Earth's seas.

48

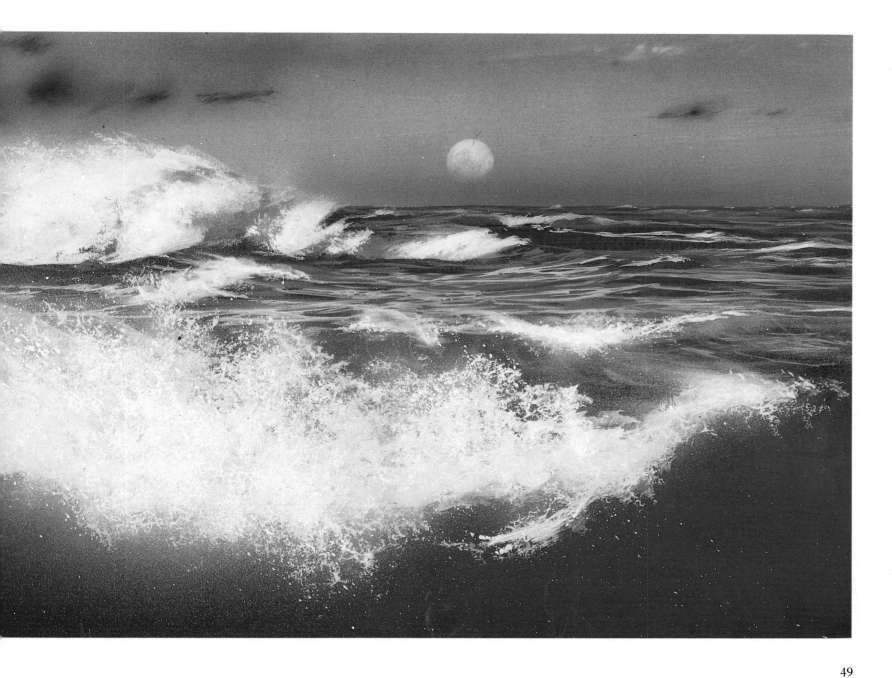

Above: An erupting volcano in the Galápagos Islands leaves a long plume, seen from over 430 kilometers (270 miles) above the surface.

Left: A contest between ocean and land is a continuing, unique feature of Earth's geology. Waves erode spectacular coastlines, upheavals and lava flows expand the land, and subsidences allow the ocean to expand its domain in the form of shallow seas. The contact zone between land and sea produces some of the most fertile environmental niches for Earth's unique biology. Earth's sky is normally pure blue because of the effects of atmospheric molecules on sunlight, although the sky takes on a rosy glow at dusk, especially along seacoasts, because of the effect of larger airborne particles of dust and salt.

consuming the carbon dioxide and releasing oxygen.* That's why the biggest danger to Earth is not change per se, but change that happens too fast. Change happens throughout a planet's history. We cannot force things to stay as they are. The danger is change that happens faster than species can adapt, such as the increase of industrial carbon dioxide that causes global warming within a century.

Our first duty among planets is to nurture the unique Earth, whether flowered fields or ripples of desert dunes, from restless seas to the silent play of fluorescent auroras over icy polar wastelands.

As our eyes shift heavenward from these extremes of our own planet, we recognize kindred landscapes on other planets, and we are drawn to explore further. Alien worlds may teach us more about the history of our own planet. We may be umbilical to Earth, but to paraphrase the Russian space pioneer Tsiolkovsky, a species can't survive in its cradle forever.

*For further information on the dramatic environmental changes, slow evolution, and sudden catastrophes that have marked our planet's development, see our companion book, *The History of Earth.*

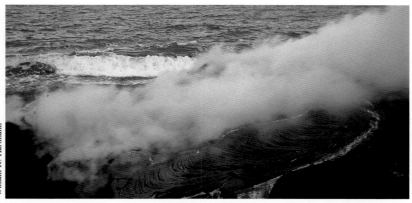

Above: A confluence of earth, air, fire, and water gives Earth its unique qualities. Here, a lava flow entering the sea in Hawaii symbolizes Earth's evolution. The dense steam clouds from such flows condensed and provided much of the water for Earth's unique oceans. Lava erupting from Earth's interior helped build up land masses in the middle of the seas. Gases from the volcanic vents helped build Earth's original atmosphere. This scene must have been repeated countless times during Earth's history.

The Earth and its moon compared in size.

The Earth-moon distance to scale.

51

Left: Fooled into thinking night has fallen, an owl is silhouetted against the pearly streamers of the sun's corona during a total eclipse. Seen from Earth, our moon is almost exactly the same size as the sun (it sometimes looks a little smaller, depending upon where it is in its orbit). By this happy coincidence, only the solar disk is covered when the moon passes before it: none of the fine details and structure of the sun's atmosphere are hidden.

At the predicted hour, we see the moon carve a dark segment out of the edge of the sun, slowly advancing from the west, eating away at the sun until only a thin, brilliant crescent remains. At the moment the sun disappears, a wan and sinister twilight replaces the bright daylight sky. We can even see stars, and Venus shines above the eclipsed sun in the noon sky. The landscape around us remains vaguely illuminated—the solar corona provides as much light as a full moon. A total eclipse is a rare, sublime, and brief spectacle; at its longest, it lasts less than eight minutes.

Above: The sun glints off the ocean near East Africa in this Apollo 11 *view of a crescent Earth.*

Ron Miller

NASA

VENUS THE VEILED INFERNO

PLANET
Average distance from the sun:
 108,200,000 km
Length of year: 224.7 days
Length of day: 5,832 hours (243 days)
Diameter: 12,100 km
Surface gravity (Earth = 1): 0.91
Composition: nickel-iron, silicates;
 carbon dioxide atmosphere

Closest to Earth in distance and size, Venus at the same time is one of the most unusual and fearsome environments in the entire solar system, with a dense carbon dioxide atmosphere and a surface temperature of 460°C (865°F). Because Venus formed not too far from Earth and has a similar mass, it probably has a similar basic mineralogy. Why, then, the differences?

For a start, Venus's proximity to the sun means that it probably contained less water to begin with; certainly it never had the great oceans of Earth. Long ago, when the interiors of Venus and Earth heated up due to radioactivity, volcanoes and fumaroles erupted on both worlds. Carbon dioxide was one of the most abundant volcanic gases. On Earth this carbon dioxide dissolved rapidly in the oceans, making weak carbonic acid that reacted with the rocky ocean floor, ultimately creating carbonic rocks. Most of Earth's vast amount of carbon dioxide thus "disappeared" into the oceans and rocks, and did not accumulate in the atmosphere.

But on Venus there was no ocean. Venus contains the same amount of carbon dioxide as Earth, but on Venus all of this heavy gas is in the atmosphere. Venus, therefore, has a very dense atmosphere, exerting more than 90 times as much pressure at the surface as Earth's does. Instead of a familiar 14 pounds per square inch, Venus's air pressure is a crushing 1,260 pounds per square inch! Standing on the surface of Venus, you are subject to a pressure comparable to being over 1,000 meters—over half a mile—beneath the surface of the sea.

Venus's excessive amount of carbon dioxide had another consequence, called the *greenhouse effect*. The glass windows of a greenhouse let in sunlight but prevent infrared "heat waves" from getting back out. The infrared radiation is thus trapped, warming the air inside. Similarly, carbon dioxide gas blocks infrared heat radiation from a planet's surface, preventing it from getting out into space. So sunlight warms Venus to an extremely high equilibrium temperature.

Venus is completely covered by almost featureless, yellowish-white clouds. Ultraviolet photos reveal swirling cloud patterns, but these are mostly invisible to the eye. Prior to the 1970s, therefore, there was intense speculation on the nature of Venus's surface. Suggestions ranged from dusty deserts to swamps inhabited by dinosaurs. Early observers mistakenly assumed that the clouds were made of water droplets and pictured continual, torrential rains.

The atmospheric pressure and temperatures of around 460°C (860°F) were confirmed by direct measurement when the Soviet Union parachuted the first probes onto Venus in the mid-1970s. This was a difficult feat; the earliest Soviet probes were destroyed by the pressure and temperature before reaching the surface. And there was another problem. The clouds of Venus consist of sulfuric acid droplets (instead of water droplets, like our clouds) and tended to corrode the instruments on the Venus probes.

Soviet probes *Venera 9* and *10* transmitted the first surface photographs in 1975, answering some of the questions about surface conditions. They showed landscapes of rocky rubble at one site and dusty, flat rock outcrops at another. The lower atmosphere was remarkably clear. Other instruments indicated granitic and basaltic rocks and soil, similar to volcanic or igneous soils found on Earth.

The United States' *Pioneer* missions to Venus in 1978 parachuted new probes through the clouds and collected more atmospheric data (the U.S. probes were not designed to gather surface data). The clouds are concentrated in a layer at

54

NASA

Left: Even nearby, Venus reveals little more of itself than can be seen through a telescope back on Earth. Its thick blanket of opaque clouds (sulfuric acid gives them their creamy yellow color) is still impenetrable and nearly featureless. From this side of the clouds, it is easy to understand why Venus was named for the goddess of love. But the brilliantly pearly globe (so bright that it is capable of casting shadows back on Earth) belies the hellish inferno at its surface.

Faint cloud patterns can be seen in the lit crescent. Venus rotates so slowly (only once every 243 Earth-days) that its sunward side becomes overheated, sending its atmosphere racing at over 350 kilometers per hour (217 mph), three times faster than hurricane force, toward the cooler night side. The winds travel in only one direction, the same direction Venus spins—perpetually westward. The uppermost winds circle the planet in only four Earth-days.

The night side of Venus glows faintly, like "the old moon in the new moon's arms." This dim phosphorescence has been seen from Earth for many years and is still mysterious. It may be due to a combination of causes: chemical reactions in the atmosphere, some electrical phenomenon related to the perpetual lightning deep within the clouds; or it may be similar to an Earthly aurora.

Above: *Puffy cloud structures in Venus's mid-latitudes, photographed from space in ultraviolet light.*

altitudes 48 to 58 kilometers (30 to 36 miles), much higher than normal terrestrial clouds. The particles in the clouds have a cyclical life history. Sulfur compounds condense into tiny crystals in a layer near the tops of the clouds. They react to form sulfuric acid droplets, which begin to fall as they grow. However, updrafts tend to catch them and carry them back up through the clouds, just as raindrops in our own thunderclouds may cycle up and down.

Eventually, they get large enough to fall out of the lower surface of the clouds as a "rain" of sulfuric acid, actually detected by *Pioneer* probes just below the clouds at an altitude

of around 31 to 38 kilometers (19 to 24 miles). Particles detected by *Pioneer* were microscopic, but larger particles can also form.

The "rain" on Venus never reaches the surface. The temperature increases rapidly from a "pleasant" 13.3°C (56°F) at the cloudtops to 220°C (428°F) at 25 kilometers below the clouds, at an altitude of 31 kilometers (100,000 feet). Therefore, the droplets evaporate as they fall out of the clouds. None survive below about 31 kilometers, and *Pioneer* and Russian probes observed open air and a surprisingly clear landscape below this level. The light level below the clouds is something like that of an overcast day on Earth.

Exploration of cloud-shrouded Venus took a great leap forward

in the 1980s and early '90s when *Pioneer, Venera,* and *Magellan* orbiters (U.S., U.S.S.R., and U.S., respectively) circled the planet and began bouncing radar waves down through the clouds and off the surface. This permitted the first detailed maps of the surface. Crude maps made by the first two orbiters revealed that about 80 percent of Venus is covered by rolling plains with only about a kilometer (3,000 feet) of gentle relief. The implication of the level topography is that, unlike Earth, Venus has had only limited "continental drift," the so-called plate tectonic activity that crumples one "plate" of the crust into another, creating giant folded mountain ranges like the Himalayas.

Another 20 percent of Venus is covered by a few fractured and contorted Australia-sized plateaus that resemble continents. Parts of these are giant volcanoes, towering as high as 10 to 11 kilometers (about 35,000 feet) above the plains. Thus, some volcanic peaks of Venus are higher than Earth's Mt. Everest.

In 1990-91 the *Magellan* mission mapped astonishing details of all these features. The volcanic peaks have immense lava flows on their flanks. Much of the ground around them is broken by enormous fractures

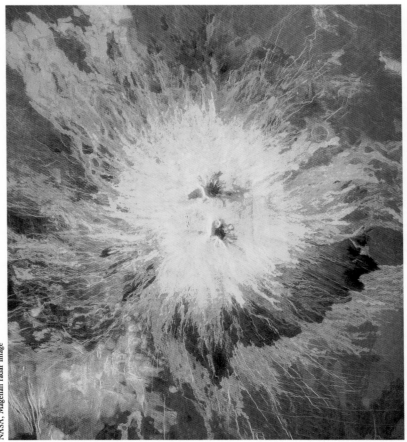

NASA, Magellan radar image

Above: *We are looking straight down on Sapas Mons, one of the large volcanoes of Venus. What appears to be an aerial photo is actually an image constructed from radar waves bounced off the planet by the U.S. Magellan orbiter. The almost abstract radial pattern is caused by lava flows of different textures that erupted on the* central summit and cascaded down the slopes. The volcano is 400 kilometers (249 miles) across and 1.5 kilometers (4,900 feet) high. Near the summit are two mesas whose smooth, flat tops appear darker than the surroundings. The color was added during image processing to simulate the yellowish light filtering through Venus's clouds.

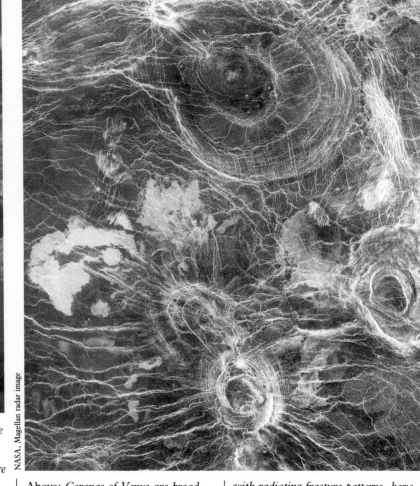

NASA, Magellan radar image

Above: *Coronas of Venus are broad, circular fracture patterns, probably caused by magma welling up from the planet's interior, causing the surface crust to crack. These examples range from 50 to 230 kilometers (31 to 143 miles) across. The smaller coronas,* with radiating fracture patterns, have also been called "arachnoids" after their resemblance to spiders and cobwebs. The Magellan spacecraft has returned thousands of images of strange features on Venus that are still being analyzed.

and chaotic slumped ridges probably caused by the stresses resulting from the pile-up of kilometers of lava.

The dramatic volcanoes support the Soviet surface chemical measurements, indicating volcanic lava rocks. In short, Venus is a volcanic planet. Some of the volcanoes are probably active today, but this has not been proven.

How old is the surface, in general? Nature gives us a handy tool for estimating the age of planetary surfaces. Suppose a lava flow creates a new surface. The surface will be exposed to a steady, random bombardment by large meteorites (i.e., asteroids and comets) during geologic time. The older the surface, the more impact craters. By counting craters (for example, all craters larger than 1 kilometer, or roughly .5 mile, wide) and comparing them to surfaces of known age on the Earth and moon, scientists can estimate ages of surfaces. Earth, of course, has few craters because rapid geologic erosion wipes them away. Typical surfaces on Earth are only 100 million years old, in terms of their larger geologic features. A few areas, such as the central plains of Canada, go as far back as a billion years and show numerous scars of eroded impact craters. The lunar plains and highlands, at 3 to 4.5 billion years, show many craters.

Venus's surface shows more craters than Earth, including beautifully preserved double-ring craters up to 200 kilometers (124 miles) across. Scientists estimate that the surface is 200 to 700 million years old on average, with a few younger regions where volcanoes are adding new lava surfaces. Thus, Venus formed its present hadean surface in the last 10 to 15 percent of solar system history, just as its sister planet, Earth, was spawning trilobites, early fishes, and the first land plants.

An interesting feature is that Venus, unlike other planets, has virtually no craters less than two kilometers across. The atmosphere is so dense that the smallest asteroids shatter into powder before getting through to the surface; they make no craters.

One of the puzzles of Venus is that the larger craters are so well preserved. Of course, Venus has no rains to wash them away, but why don't we see ancient craters partly destroyed by lava flows? Some researchers explain this by saying that all the lava surface formed at once, during one episode of deep lava flows. This might have been due to a massive upwelling of magma from Venus's mantle, the semi-molten layer below the rocky crust. If so, the ancient surface was destroyed and fresh impact craters have accumulated ever since.

Whether or not Venus's surface formed in one surge of

Photo courtesy of A. T. Basilevsky, Vernadsky Institute, Moscow, and courtesy of Brown University

Above: *The surface of Venus was photographed for the first time by several probes sent to Venus by the Soviet Union between 1975 and 1982. This photo is part of a diagonal panorama from* Venera 14. *The photos show mostly platey rocks, believed to be slabs of basaltic lava, with a few scattered boulders and patches of gravelly soil. Note the clarity of the air and the bright sky. The dark silhouettes at left are part of the spacecraft.*

NASA, Magellan radar image

Above: *One of the most spectacular meteorite impact craters on Venus is this beautiful double-ring crater, named Barton after Red Cross founder Clara Barton. Through poorly understood mechanisms of impact explosion, the central peak that appears in smaller craters changes form in larger craters, where it appears as a ring of peaks. The smooth, dark crater floor consists of lava flows that partly filled the crater after it formed.*

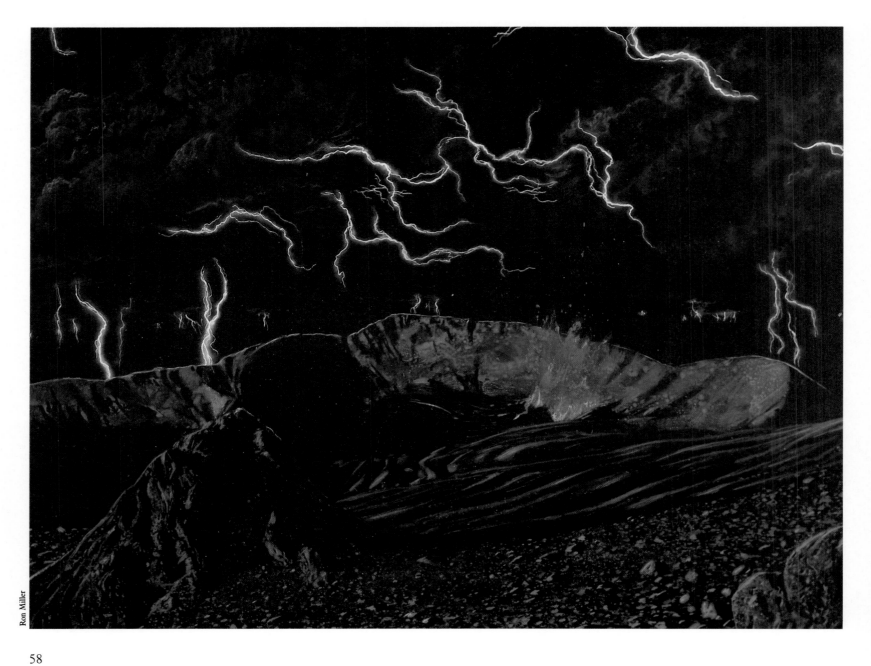

58

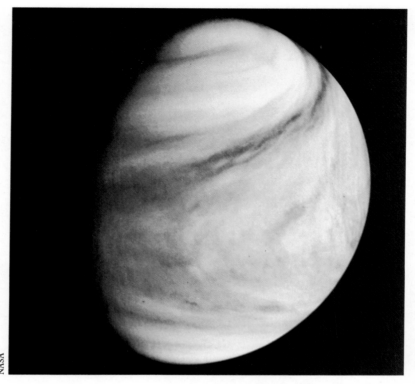

Left: *Night on Venus. Daylight on the surface of Venus was brighter than scientists had expected, but nighttime would be total darkness in most places. No moonlight exists; no starlight penetrates the clouds. The darkness is broken only by occasional lightning storms and volcanic eruptions. Night is both dark and long. Due to the combination of orbital and rotational motion, daylight and darkness each last 58 Earth-days.*

NASA

Above: *Ultraviolet photography enhances the contrast of Venus's radiating cloud belts. Seen here are the weather patterns caused by clouds rushing westward at 100 kilometers (62 miles) per hour from Venus's sunlit hemisphere.*

lavas, signs of mantle upwellings and lava outpourings abound. Using the *Venera* radar images, Soviet scientists in the 1980s discovered features called coronas—vague bull's-eye-like scars from 200 to 2,000 kilometers (130 to 1,300 miles) across. They seem to be caused by uplift from below, followed by lava emission and then sagging of the central portions.

From such data, scientists conclude that the mantle of Venus has hot, ascending currents called *mantle plumes.* These may be less active than mantle plumes on Earth, which push around crustal plates, causing continental drift. Instead, the mantle plumes of Venus bring up magma under a given spot, create a corona by deforming that spot, and then break through the surface,

initiating volcanism. If enough volcanism occurs, the lavas may cover the corona, pile up, and create a giant volcanic peak. Because the surface of Venus is so hot, the crustal rocks are only a few hundred degrees short of melting. Heat from mantle plumes deforms and melts them, and this may explain the ease with which Venus accumulates massive lava outpourings.

Venus provides a vivid indication of the difficulties involved in the creation and maintenance of a habitable planet. Here is an Earth-sized globe only 30 percent closer to the sun than Earth is; yet its climate could scarcely be more different. Some theorists have calculated that if Earth were only 10 percent closer to the sun, the combination of increased solar heat and the greenhouse effect

would have boiled off much of our oceans, leaving more water vapor and carbon dioxide in the air. This in turn would have led to an even stronger greenhouse effect and more warming. Thus, a slight decrease in solar distance (or increase in the sun's radiation output) could have disastrously altered Earth's climate. A small change in environmental "input" can be magnified through environmental feedback into a large change in final climatic "output." Venus's searing heat, thick carbon dioxide atmosphere, fearsome acid clouds, and thunderous lightning blasts make us stop and think about the consequences of our own alterations of Earth's atmosphere, which have already increased its carbon dioxide content and produced acid rains in industrialized regions.

59

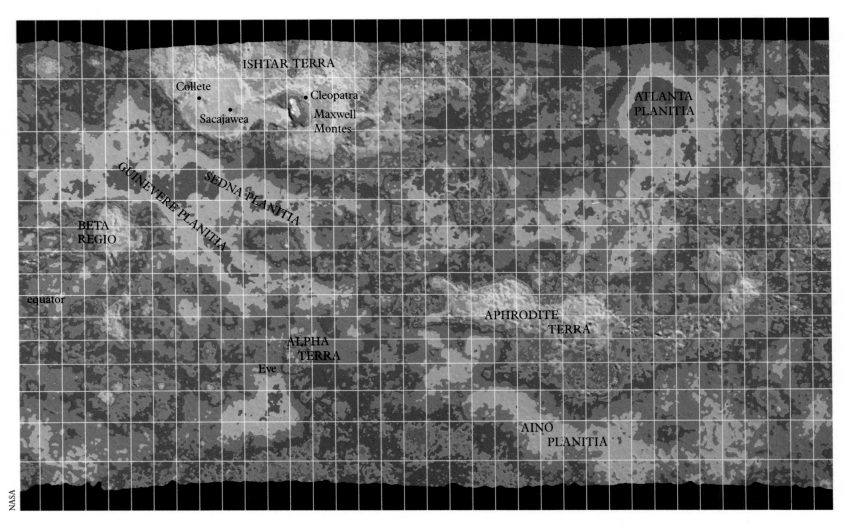

ISHTAR TERRA

Collete

Sacajawea

Cleopatra

Maxwell
Montes

ATLANTA
PLANITIA

GUINEVERE PLANITIA

SEDNA PLANITIA

BETA
REGIO

equator

APHRODITE
TERRA

ALPHA
TERRA

Eve

AINO
PLANITIA

NASA

A global map of the features below Venus's clouds has been completed by Soviet and American space probes. The yellow areas are continent-like uplands, and the blue areas are "planitia," or rolling lava plains something like Earth's seafloors. The highest mountain masses (red and brown, top) are named

Maxwell Montes and rise higher than Earth's Mt. Everest. As befitting the feminine goddess of love, most features on Venus are named after real and mythical women. The main "continents" are Ishtar Terra (named for the Babylonian goddess of love) and Aphrodite Terra (named for the Roman

goddess of love). The smaller uplands, Alpha and Beta Terra, were discovered by radar from Earth. Also marked are craters named Cleopatra, Sacajawea, Colette, and Eve—the last used fittingly to define the zero longitude meridian, from which other longitudes begin. Many other features have also

been named, giving too much detail to mark on this map. Despite the romantic names, the scorching air, volcanic geology, and permanent cloud pall of the planet of love come ironically close to medieval ideas of mythical Hell.

In the mountains of Venus.

Ron Miller

MARS THE RUSTED PLANET

PLANET
Average distance from the sun:
227,392,000 km
Length of year: 687 days
Length of day: 24 hours 37 minutes
Diameter: 6,786 km
Surface gravity (Earth = 1): 0.38
Composition: silicates, iron; surface
minerals oxidized to rust-red; carbon
dioxide atmosphere

Mars is unchallenged as *the* planet of intrigue. About half the size of Earth, it has desert landscapes colored red by the rusting of iron-bearing minerals—similar to those of our southwestern deserts. As early as 1800, telescopes showed polar ice caps and shifting clouds. Further study showed dusky patches that darken during the Martian spring.

Around 1895, the colorful American atronomer Percival Lowell put all of this together into a magnificent new theory. Mars, he said, was populated. Not only had life-forms evolved into a civilized state; the planet itself had evolved. Water vapor and other gases had slowly leaked off into space because of Mars's slight gravity, so that the air was thin and dry. The Martian civilization was dying for lack of water. The streaky markings, which Lowell drew as straight lines, were canals or vegetated land alongside canals. Martians constructed the canals to carry water from the polar ice caps to those dry equatorial regions that were warm enough to live in. The seasonally changing markings were vast fields of vegetation.

Wonderful though Lowell's theory might be, it was all wrong. As early as the 1920s, astronomers accumulated evidence that the Martian air was even thinner and drier than Lowell thought, and that his straight canals were only streaky alignments of patchy markings.

The pendulum of Martian theory continued its swing away from Lowell's picture in 1965 when *Mariner 4* returned the first close-up pictures, showing not ruined cities but moonlike craters. No canals existed. Many analysts jumped to the conclusion that Mars is a moonlike world, geologically and biologically dead.

Not so. The 1971 flight of *Mariner 9* revealed an astounding discovery. Mars, a planet with no known liquid water, has winding valleys that appear to be dry riverbeds. They are called channels (although they have nothing to do with the non-existent canals). They travel downhill, are joined by tributaries, show streamlined deposits on their floors, and empty into broad plains, sometimes with delta deposits at their mouths. In short, they have all the properties of riverbeds.

Now the pendulum swung back a little way. Mars once *had* been a wet planet. True to its reputation, the red planet gave us a host of exciting new mysteries. How could the desert planet Mars have had abundant rivers in the past? How *old* are the channels?

One clue lies in the inventory of water on Mars. Water is hidden in three places: frozen in the polar ice caps, chemically bonded in the minerals of the soil, and frozen underground in permafrost layers like those in our arctic tundra. One possible mode of channel formation apparently involves local underground heating by geothermal activity associated with the huge Martian volcanoes (also discovered by *Mariner 9*). Geothermal heating created localized "Martian Yellowstone Parks," where vast catastrophic floods of water gushed forth, eroding channels many kilometers wide and hundreds of kilometers long. Evidence for this process includes channels that start in jumbled box canyons called *chaotic terrain*. These depressed areas of crumbled ground at the heads of some channels apparently collapsed as the underground ice disappeared and water gushed forth.

A second process of channel formation, called *groundwater sapping*, is known in arid regions of Earth. If a landscape exposes an underground permafrost layer,

Cross-section of typical part of Valles Marineris.

Ron Miller

Left: *Early morning sun floods the grandest canyon in the solar system— Valles Marineris. Fog and mist still linger, made of ordinary water vapor that will disappear before the sun rises much higher. At an average lookout point, the far walls of the canyon are too far away to see clearly.*

Valles Marineris dwarfs our Grand Canyon. The Grand Canyon stretches some 450 kilometers (280 miles) across plateaus of northern Arizona. Transferred to the United States, Valles Marineris would stretch across the entire country. With a depth as much as 5 to 7 kilometers (3 to 4 miles), it is about four times deeper than the Grand Canyon.

But the comparison is unfair. This canyon is a cousin not of the Grand Canyon, but of the Red Sea, the Gulf of California, or the Great Rift Valley of Africa. On both planets, these regions mark sites where the crust of the planet is pulling apart. Similarly, Valles Marineris may resemble the beginning stages of the Atlantic Ocean 100 million years ago, when the American continents began to pull away from Europe and Africa.

Valles Marineris is so long that when one end is well into night, the other end can still be in sunset. The difference in temperature between the ends may set up winds, shrieking down its enormous length. Winds, volcanic deposits, and landslides have all played a role in sculpting the canyon's convoluted walls.

Small block shows section of the Grand Canyon to the same scale.

MARS

Below: *Fog fills the canyons in a view of a portion of Valles Marineris.*

William K. Hartmann

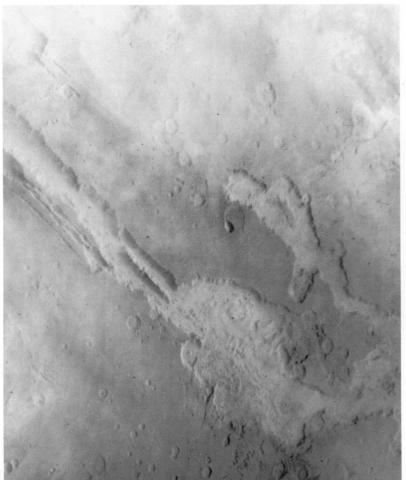

NASA

NASA, Alfred McEwen, U.S. Geological Survey

Above: *This view of the globe of Mars was made by electronically compositing several images from the Viking spacecraft. The long dark streak (bottom center) is the Valles Marineris, once mistaken for a canal. Three of the largest volcanic summits protrude through hazy, late afternoon clouds (lower left). Contrast and color differences are somewhat enhanced by the computer processing.*

Above: *As early morning mists burn off, the fault-cracked floor of a typical branch of the Valles Marineris, named for the* Mariner 9 *spacecraft that discovered it, is revealed. Mesas 100 meters and more in height look like the stumps of petrified trees beneath canyon walls more than ten times higher. Valles Marineris is not a water-carved gorge like the Grand Canyon. Rather, it is the result of enormous blocks of Mars's crust moving apart—the opposite walls of the canyon were once touching. This is just how Earth's Atlantic Ocean formed, and like it, Valles Marineris has a "mid-Atlantic Ridge" running down its center.*

Ron Miller

the water can melt (or sublime directly from ice to vapor), causing the cliff face to cave in and eat its way backwards into the landscape by successive collapses. This type of channel could grow from its mouth through plateau country toward the apparent "headwater," even though the latter was not the source of the water.

Do these two processes account for all Mars channels? Perhaps not. The Martian air has a pressure that ranges from only around 3 millibars in the high areas to as much as 10 to 15 millibars in the lowlands, compared to a thousand millibars on Earth. In the regions with pressure less than 6 millibars, liquid water spontaneously boils away, and even in other areas it evaporates very fast. So it is hard for water to flow anywhere on Mars under present conditions. A channel might possibly extend its erosive lifetime by forming a frozen ice layer on its surface, shielding the water underneath from rapid evaporation. Nonetheless, many scientists think that the abundant Martian channels may have formed under different environmental

Left: *Mars seen from its smaller, outer satellite, Deimos, a dark lump of rock barely 15 kilometers (10 miles) wide. The dusky markings on Mars's ruddy surface are those that for decades made astronomers hope—in vain—that at least plant life existed on the planet.*

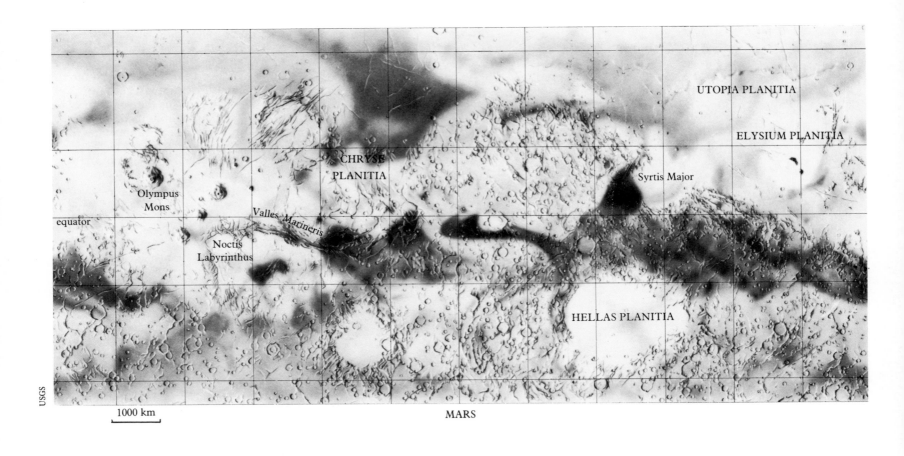

UTOPIA PLANITIA

ELYSIUM PLANITIA

CHRYSE
PLANITIA

Syrtis Major

Olympus
Mons

Valles Marineris

equator

Noctis
Labyrinthus

HELLAS PLANITIA

1000 km

MARS

Schematic of Olympus Mons. Small white triangle is Mt. Everest, drawn to the same scale.

Right: A shrunken sun sets over the vast polar dune fields of Mars. Orbital photos show that the polar ice caps of Mars are surrounded by the largest dune field known in the solar system. Apparently, Martian winds transport dust into the polar regions, leaving it in dune formations of stratified deposits. Closer to the pole, the stratified deposits form the terraced hillsides that can be seen on the horizon. Erosion of these hills probably forms buttes similar to those in the American Southwest, as seen on the horizon at right. They would make an interesting target for geologic exploration, since they may contain exposures of strata laid down billions of years ago, giving clues to Mars's environment at that time. A light frosting of mixed ice crystals and dust has precipitated on the ground and sunlight glints off the frozen surface. The sun itself is a disk only two-thirds as big as it appears from Earth. Angle of view is about 55 degrees.

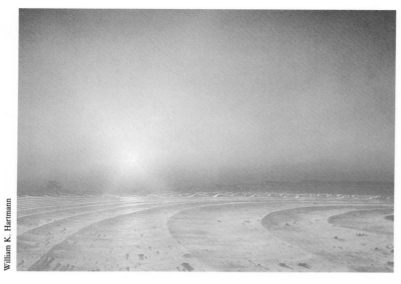

William K. Hartmann

conditions, when air pressure was higher and there was more water available. Some scientists believe there were once rains on Mars to account for the channels' filigree-like tributary systems. Others have suggested glaciers or even a short-lived ocean that occupied the northern lowlands.

The number of impact craters on channel surfaces suggests they formed anywhere from 100 million to 3 billion years ago. Thus, Mars may have evolved much in the way Lowell suggested, slowly losing air and

drying out. Perhaps the climate 2 billion years ago was more moist and clement.

This hypothesis again raised hopes that Mars might yet be found to have supported life in the ancient pools of water that once existed on the red planet.

Mariner 9 revealed additional evidence that Mars is a dynamic planet, with considerable geologic activity. Photos showed that one side of Mars is dominated by a huge volcanic complex called the Tharsis Montes, containing lava plains created by several enormous volcanoes and estimated to be 1 to 3 billion years old. The mightiest is Olympus Mons, towering about 24 kilometers (15 miles), three times as high as Everest's rise above sea level. Its base would cover Missouri.

Olympus Mons is probably the largest volcano in the solar system. It has very young-looking lava-flow slopes and a summit caldera. The paucity of impact craters on these surfaces suggests that Olympus Mons formed within the last billion years and that it might still be active today.

On the morning of July 20, 1976, seven years to the day after *Apollo 11* astronauts first stepped onto the moon, the *Viking 1* lander parachuted through Martian skies above the dusty, boulder-strewn plain of Chryse, turned on its braking rockets, and bumped onto the Martian desert. *Viking 2* touched down on a similar desert plain called Utopia on September 3. The *Viking* landers' mission was to search for life.

Overleaf: An unmoving sea of rust-red waves, the enormous dune fields of Mars stretch to the horizon and beyond. We're standing in a very typical Martian landscape. Dark eroded rocks protrude from wind-rippled russet dust—dust that blankets most of the planet and turns the sky itself pink. Winds reaching speeds of up to 200 kilometers per hour (124 mph) keep the dust churning; enormous dust devils, tornadoes that whip the soil high into the atmosphere, feed monstrous dust storms that can cover the entire planet. In the far distance, at the right, a dust devil has begun its work as advance agent, and at our far left are the first signs of the coming dust storm. When the storm does arrive, it may last for weeks—the rocks, even the ground beneath our feet, trembling under the howling blast. Dust will billow as high as 10 kilometers (6 miles), and the wan sun will seldom be visible.

Buttes and flat-topped mesas, eroded by millions of years of sandblasting, give the landscape a distinctly familiar flavor: if it weren't for the salmon sky, we could easily imagine ourselves in Arizona.

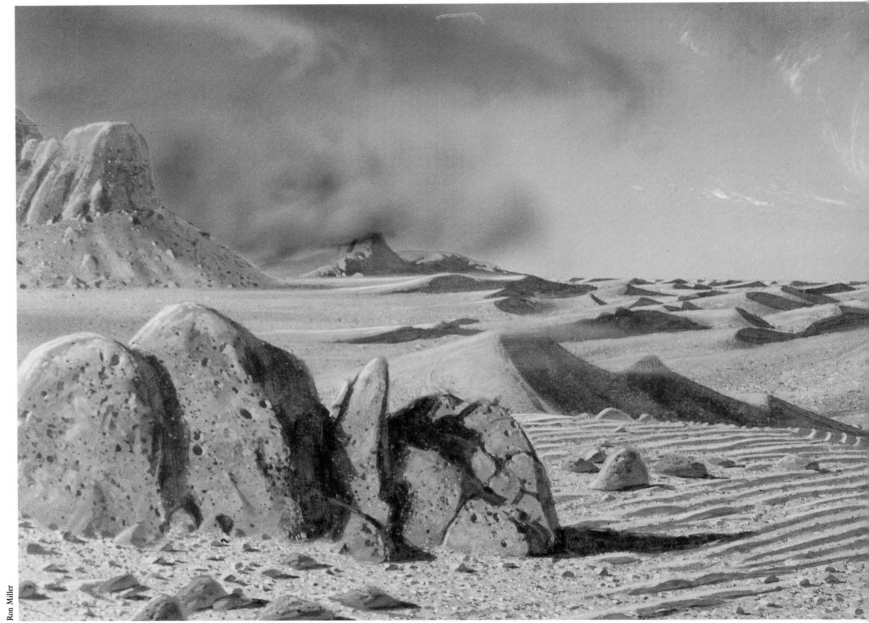

The surface of Mars.

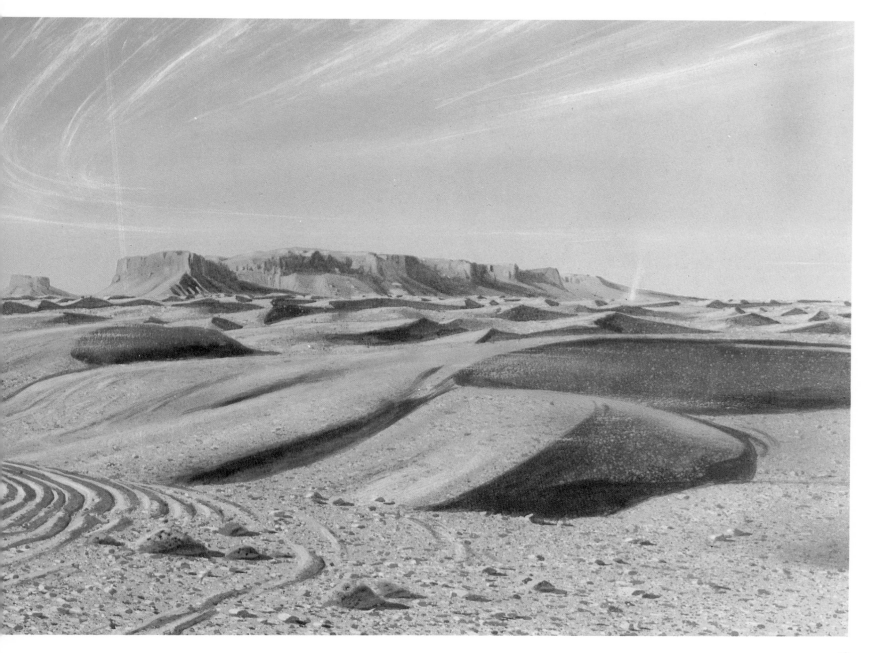

MARS

The Martian satellite system to scale. Left to right: Deimos, Phobos.

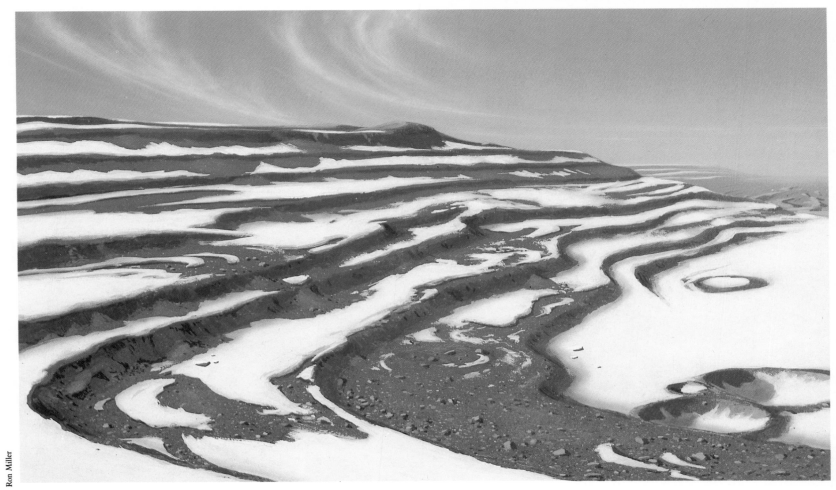

Ron Miller

Left: *Rising in 30-meter (90-foot) steps like a giant's staircase, the layered terrain that surrounds the Martian south pole makes the landscape look like an enormous strawberry-and-vanilla parfait. Fine dust deposited by storms and ash from volcanic eruptions built up the layers over millions of years. Sheets of water and carbon dioxide ice are buried within the deep, insulating blankets of soil. Wind erosion and evaporation of exposed ice deposits have created hundreds of miles of sinuous laminations that, from above, look like the contour lines on topographic maps. As scouring by wind-borne dust and sand continues, and as newly exposed ice evaporates and allows some small or large sections to collapse, the gracefully curving cliffs constantly change shape and direction, writhing around the pole in ponderous, geologic slow motion.*

NASA

Above: *Morning frost condenses at high latitudes on Mars as winter approaches. Although the horizon is level,* Viking 2 *landed on uneven ground, giving an 8-degree tilt to this picture.*

Disappointingly, Mars turned out to be dead as a doornail—or more so. Even a doornail might be expected to have some organic matter on it, but the Martian soil has no complex organic molecules to an accuracy of a few parts per billion. The soil samples did reveal curious chemical reactions when exposed to nutrients, but these are probably not caused by organisms since no organic matter was found. Instead, chemists think the soil chemistry has been altered to unusual states by exposure to solar ultraviolet light.

These findings alter our ideas about life elsewhere in the universe. Laboratory experiments show that life's building blocks—amino acids and other organic molecules—*easily* form in carbon and water-rich environments similar to those of primitive planets. Even certain types of meteorites, carbon-rich stones called *carbonaceous chondrites*, contain amino acids that formed on their parent planetary bodies and not on Earth. So scientists had come to believe that life would probably arise spontaneously on any planet where liquid water persists, and that it might even evolve and adapt to later, harsher conditions. Mars, with its seasonally melting polar ice, its occasional balmy 15°C (60°F) summer days, and its ancient riverbeds, seems a plausible place for life to have evolved. In June 1976, before the *Viking* lander touched down, the majority of planetary scientists probably would have bet that microorganisms would be found on Mars.

So why did the *Vikings* not find life? The answer probably lies in one of two scenarios. Ponds of liquid water may never have existed long enough in any one place to allow living organisms to evolve. Adding to the difficulty would be the high intensity of ultraviolet sunlight that breaks down organic molecules. (On Earth, this ultraviolet light is screened by the ozone layer of our high atmosphere, so that we receive much less of this damaging radiation even though we're closer to the sun. Still, even a short overexposure can result in a painful and possibly even fatal sunburn.) In this scenario, Mars has been permanently without life.

In the second scenario, which is more provocative, primitive life did evolve 4 billion years ago, when Mars had more abundant liquid water and a thicker atmosphere. But the atmosphere thinned, and Mars grew cold and dry. The organisms all died billions of years ago. For a while,

MARS

organic remains enriched the soil, but erosion broke the soil into fine dust. All of this dust, over the course of eons, has been blown into the thin air and exposed to ultraviolet sunlight, destroying the ancient organic molecules. In this view, Lowell was partially right in hypothesizing that Martian life was killed by the planet's evolution—his timing was just 3 billion years off.

Even more intriguing is a third scenario. After the *Viking* mission, scientists realized that in Mars-like frozen valleys of Antarctica the soil is sterile, but microbes live in fractures *inside* rocks. Therefore, some believe that microbial life on Mars might still be possible—inside rocks, in deep sediments, or in other hidden, protected locations.

What might such life tell us about the evolution of life on our own planet? What might we learn about the causes of planetary climate change that forced a planet from rivers to permafrost? The only way to find out is to return to Mars with a renewed commitment to exploration.

Mars remains a fascinating environment, strangely reminiscent of our own world. Summer winds frequently whip

NASA

Above: *The streamlined forms in this landscape in the Chryse Basin are powerful evidence of erosion by flowing liquid—probably water flooding from melting permafrost.*

NASA

Above: *A wide-angle panorama of the* Viking 1 *landing area. A dusty sky looks bright pink.*

NASA

Above: *The sudden melting of underground layers of permafrost caused this area in Capri to collapse (the picture covers a region 300 by 300 kilometers, or 200 by 200 miles). The outflowing water carved the channel at the left.*

Right: *A towering column of talcum-fine dust rears out of one of Valles Marineris's tributary canyons. Throwing dust high into the thin atmosphere, whirlwinds like this feed dust to the enormous, planet-blanketing storms that can bury most of the Martian surface for days. The canyon shows the wear and tear of thousands of years of sandblasting: worn rocks and boulders, fluted canyon walls, and eroded buttes and mesas.*

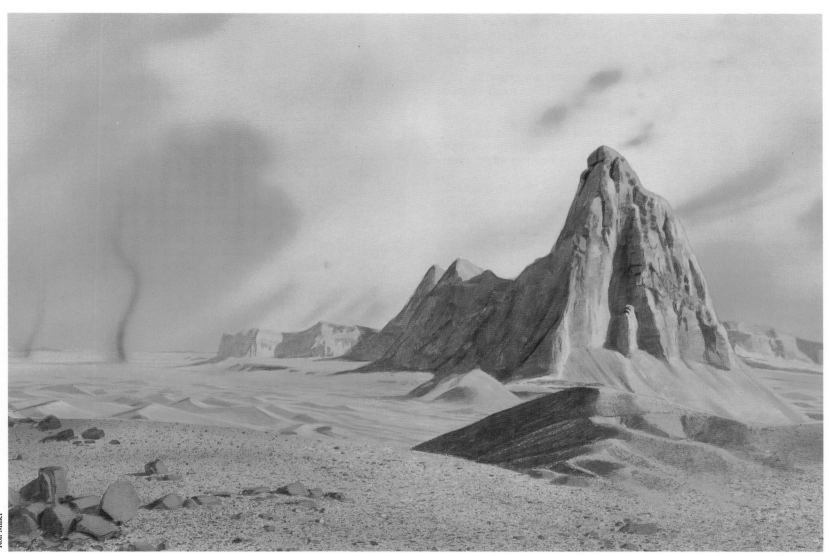

Ron Miller

MARS

up huge dust storms that may start out as dust devils but grow to envelop much of an entire hemisphere. Air temperatures are so cold that not only water vapor freezes into puffy and wispy clouds; the main constituent of the atmosphere, carbon dioxide gas, also freezes on cold polar mornings, forming dense fogs or cloud layers of carbon dioxide mist. (The familiar "dry ice" of the ice cream vendor is this same frozen carbon dioxide.) Ice may condense on dust in the air, falling to the ground as a combination of snow and frost. The sun may burn off the carbon dioxide "snow" but leave the frozen water frost. This happened during winter at the *Viking 2* site, leaving the boulder-strewn desert white with a thin layer of frost.

Cold winds blow down lonely canyon floors; seasonal storms pile up the system's largest dune fields around the north polar cap; Olympus Mons ponders a future volcanic outburst; landslides break loose and rumble down canyon walls, leaving enormous scars like the scratchings of an ancient giant; stratified polar hills hide buried secrets of past ages; the sun rises and sets every twenty-four

hours. All these events are happening now, although no one is there to witness them. Mars awaits our first visit.

Scientists are preparing for that visit. The United States in 1992 launched *Mars Observer* to orbit around the planet in 1993-94 and map the mineralogical properties, taking photographs of details as small as a few meters across.

In Russia, despite economic hardship, scientists are building two ambitious probes with the cooperation of scientists from America and Europe. The first is intended to map Mars from orbit in 1995-96 and to drop "penetrators," torpedo-like probes to measure soil properties. The second probe would reach Mars in 1997 and land an automated roving vehicle. (Russian engineers "drove" such a vehicle 37 kilometers on the moon in 1973.) This probe would also drop a balloon into Mars' atmosphere, for 10 days of close-up studies and nightly touchdowns. By the year 2000, we should know much more about the mysterious red planet.

Ron Miller

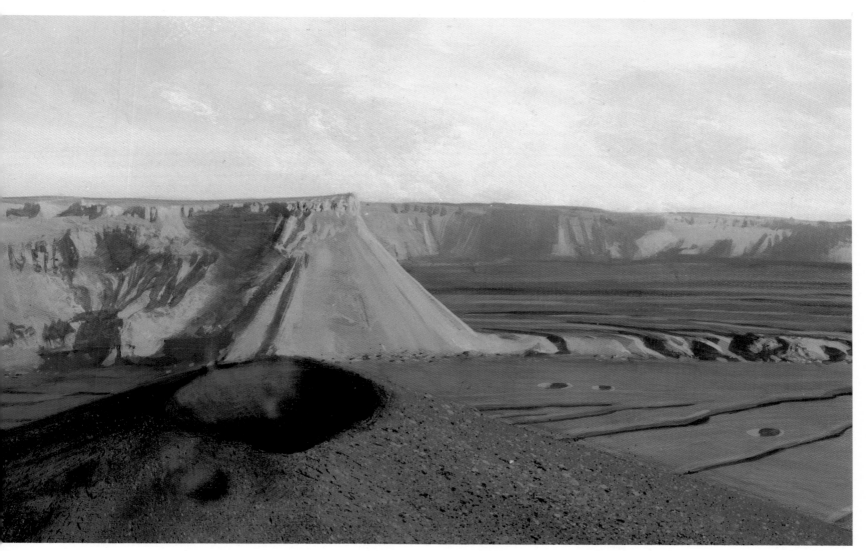

Above: A young cinder cone nestling within the enormous caldera of a Martian volcano was built by renewed eruptions, long after the volcano's main activity ended. Do the faint wisps of vapor in the cinder cone's crater suggest that there is still the possibility of active volcanism on Mars even today?

No one knows how long it has been since the last eruption poured lava down the slopes of the volcanoes, but photos show that the flanks of the large Martian volcanoes have accumulated few impact craters and, therefore, must be geologically young. Some researchers think new eruptions are still possible.

VIKING PANORAMAS

Left: *An 85-degree panorama taken by the* Viking 2 *lander. North is to the left. It is afternoon in Utopia. On the horizon at the right are low ridges. The rocks are volcanic in origin, full of holes caused by gas bubbles, and average about half a meter in size.*

Below: *An early morning scene in Chryse. It's 7:30 A.M. local time. In this 100-degree panorama (northeast is to the left) are dark, eroded rocks (the big one is one by three meters), sand dunes, and the rim of a distant crater on the middle horizon.*

MARS

Ron Miller

Right: *Cruising several kilometers above the 64-kilometer-wide (40-mile-wide) caldera of the giant volcano Olympus Mons, we begin to appreciate the vast size of its crater. The state of Rhode Island would fit within its steep walls. The mountain's base is as large as Missouri, and the mountain itself rises 24 kilometers (15 miles) high— more than 15 kilometers (10 miles) higher than Mt. Everest.*

We're above most of the Martian atmosphere. We have left the dust below us, and the sky is turning to indigo. Water vapor crystallizes in the thin, frigid air, and wave clouds form as winds pour over the broad summit.

Is Olympus Mons still active? No one knows for sure, but strange clouds observed over the years and photographed from orbit may be signs of volcanic life.

Above: *In some of the lowest regions of Mars, e.g., within the giant basin Hellas, air pressure may be high enough and temperatures warm enough to permit liquid water to exist beneath the surface. If you quickly dig in such an area, you might find—briefly— a few drops of water glistening on your gloved hand . . . gone in a few seconds, absorbed by the dry, thin atmosphere. Still, you've witnessed something hitherto unique to Earth: liquid water in the open air. And it is not a long step from liquid water to life as we know it.*

NASA

Above: *The Nile Valley, a lush, fertile, border on either side of a watercourse—what the Martian "canals" were once thought to be.*

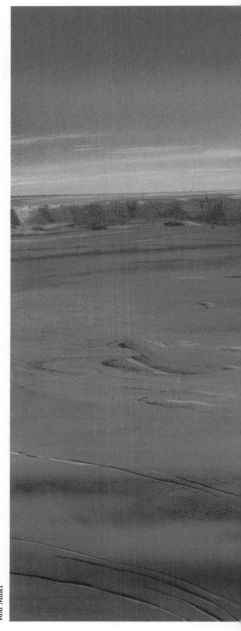

Ron Miller

78

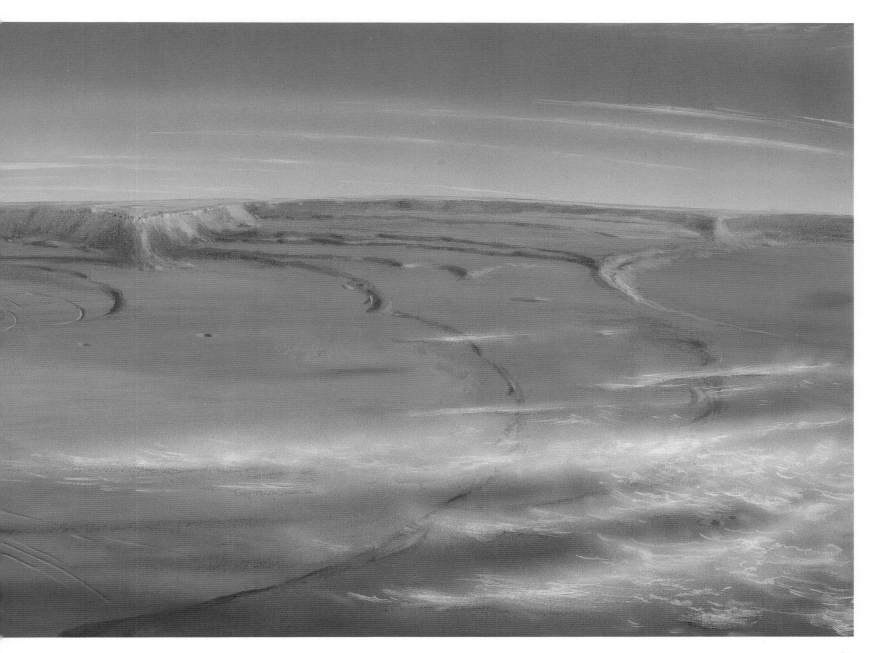

MARS

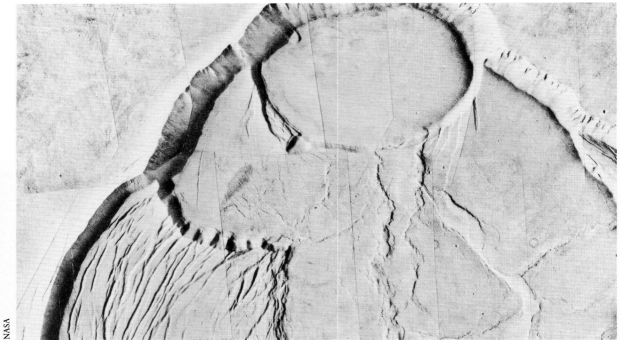

NASA

NASA

Above: *The bright, white polar ice caps of Mars are believed to consist of a permanent residual cap of frozen water that lasts through the summer, and a much broader cap of frozen carbon dioxide that forms in the winter and evaporates in the spring. This Viking orbiter view shows the small residual cap, about 350 kilometers (220 miles) across, at the south pole. Some observers believe the water ice at the south pole is hidden under a layer of permanent carbon dioxide frost, which would make the white surface in this picture.*

NASA

Above: *An enormous landslide has bitten out a section of Valles Marineris's cliffs. From the top of the wall to the valley floor is about* 2 *kilometers (6,500 feet). Striated terrain below is debris that slumped off the cliff and flowed into the valley.*

Above: *The caldera of Olympus Mons. The upper crater is 25 kilometers (16 miles) across, bound by sloping cliffs 2.8 kilometers (9,000 feet) high.*

Right: *In the dusty atmosphere of Mars, there is a faded twilight glow as the distant sun sets. In a few more minutes, the bloodred landscape will be plunged into a dark, subzero night. High, noctilucent clouds glow brightly above the sun.*

80

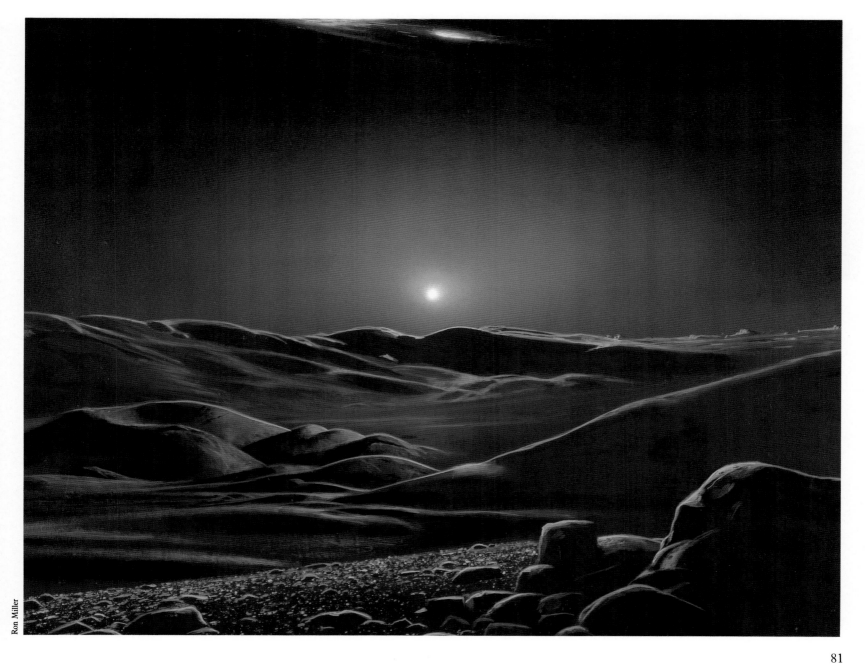

Ron Miller

GANYMEDE A NEW WRINKLE

Satellite of Jupiter
Distance from Jupiter: 1,070,400 km
Revolution: 7 days 3 hours
Diameter: 5,280 km
Composition: ice, carbonaceous silicates

Ganymede, the largest satellite of Jupiter, is also the largest moon in the entire solar system. In fact, it is the solar system's eighth-largest world, with a diameter exceeding those of the planets Mercury and Pluto. Like most major moons (including ours), Ganymede keeps one face pointing toward its "parent" planet, as if transfixed. Such moons are said to be "synchronous" (because their revolution around the planet is synchronized with their daily rotational spin). Thus, even though the sun rises and sets on Ganymede, Jupiter remains at a fixed point in the sky on the planet-facing side.

Even the largest telescopes on Earth show Ganymede as only a pinhead with vague markings. These cryptic shadings tantalized generations of astronomers until the age of spacecraft exploration; in 1979, *Voyagers 1* and *2* first revealed the geology of an ice-dominated world. As on most such worlds in the outer solar system, ice and water, respectively, play the roles of rock and lava on Earth. Much of the surface is ice, impregnated with carbon-rich soil. When internal heat melts the ice, a "magma" of watery material may erupt and freeze, making a fresh surface of bright ice.

One of the best clues about the interior of Ganymede comes from its mean density, i.e., total mass divided by total volume: it is higher than the density of pure ice but lower than that for most rock types. This indicates that the interior is also a mixture of ice and rock. Most of the rock has probably sunk through the ice to form a rocky core surrounded by an ice mantle.

Remember our rule of thumb: larger worlds are geologically more active; small worlds cool faster and have less internal heat to drive geologic activity. Many scientists had expected that modest-sized, icy Ganymede would show only an ancient, static surface crowded with impact craters from the early days of the solar system. But Ganymede was only the first of many outer-solar-system worlds to surprise the first generation of space explorers. True, like Earth's moon, it has broad regions of ancient craters, but these are broken by swaths of younger furrows—seemingly youthful flows and ice squeeze-ups.

The older, cratered terrain is dark, as if the ice component has been vaporized by countless meteorites, leaving soil behind. Stretching hundreds of kilometers across the ancient cratered areas are giant arcs of parallel furrows a few kilometers wide. These seem to be fragments of giant, ancient impact craters called *multi-ring basins*. The largest impacts produce not simple craters, but multiple, concentric rings of cliffs, hundreds of kilometers across. They are giant fracture patterns, suggestive of eerie bull's-eye targets inscribed on the sides of worlds by the gods of old. More complete multi-ring systems have been found on Mercury, our moon, and the neighboring moon Callisto. Strangely, those on Ganymede have been broken and perhaps even shifted in position by the puzzling resurfacing processes.

Ganymede's surface resembles a giant jigsaw puzzle, where some pieces have been replaced with newer, brighter material. Most of the original picture is preserved, but a few parts have been replaced by swaths of fresher ice. The newer regions are lighter, wandering in wide bands among the darker polygonal cratered areas. The lighter regions are traversed by intricate systems of narrow fissures, usually arranged in parallel streaks, here and there broken by craters.

Analysts suggest that the original dark crust broke apart due to internal heating and expansion, allowing Ganymede's equivalent of lava—erupting water—to flow out onto the surface and freeze into ice floes. Subsequent eruptions along the fissures squeezed out new parallel ridges of ice. The same phenomenon also occurs in our Arctic ice floes.

Ganymede may well be

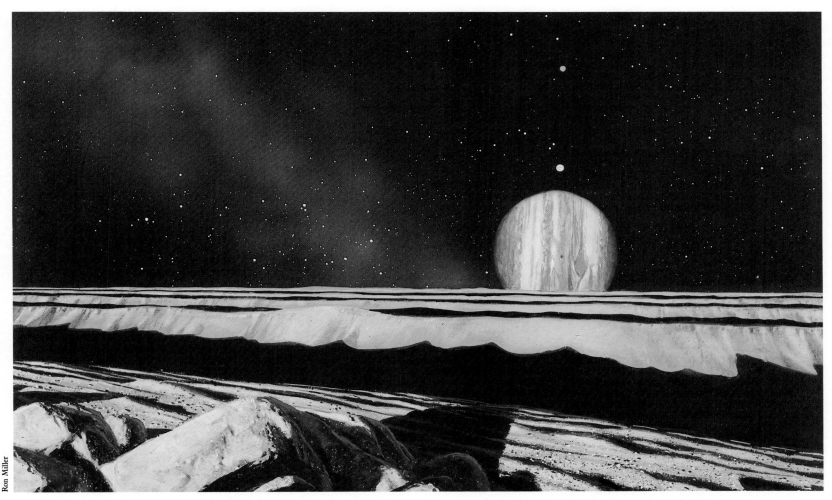

Ron Miller

Above: *A tedious climb up a long slope, ice powdered by millions of years of micrometeorites crunching underfoot, has brought us to the top of one of a series of parallel ridges that wrinkle the surface of Ganymede like a washboard.*

It's about 10 kilometers (6 miles) to the next ridge, and about 100 meters (300 feet) to the bottom of the valley below us.

Jupiter sits 890,000 kilometers (551,800 miles) away, the Great Red Spot peeking coyly over the horizon. Above the planet are two more of the four Galilean satellites: Europa and orange Io. The sun is at our backs and Jupiter is directly in front of us, so we can see the shadow Ganymede casts, the small black spot near the center of Jupiter. *Since the shadow is nearly the same size as Ganymede itself, you can get a good idea how much larger Jupiter is than its relatively tiny moon.*

GANYMEDE

Below: A short descent takes us into the shallow, curved valley between the crests separating Ganymede's grooves. Although we are standing in shadow, our surroundings are brightly lit by Jupiter and by sunlight reflected off the sloping wall of ice opposite us.

showing us an incipient process of plate tectonics, thus adding to our understanding of Earth. On Earth, the lithosphere—or solid rock layer—long ago broke into plates that ride on a partly molten lower layer. Dynamic currents in this lower layer, driven by Earth's internal heat, drag the surface plates, causing collisions and throwing up mountain ranges. On Ganymede, the process is not as dynamic. Ganymede's interior may be warm, but it is not as hot as Earth's. The ice "lithosphere" at the surface may have broken into "plates," but the plates have only jostled one another. Little pieces here and there seem to have moved tens of kilometers, offsetting craters and faults, but there have been no large-scale motions or collisions and no folded mountain ranges like the ones found on Earth.

Ganymede has other interesting features. Whitish polar caps, seemingly thin water frost deposits, extend down to latitudes around 40 degrees. The caps may mark condensation of water vapor escaping from

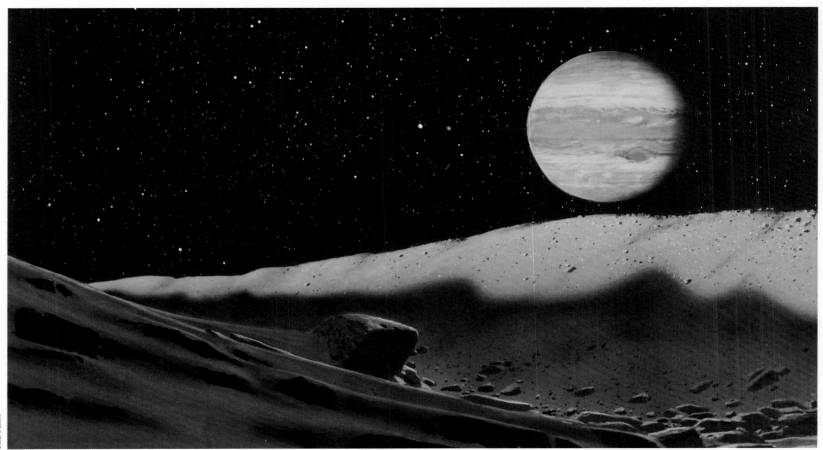

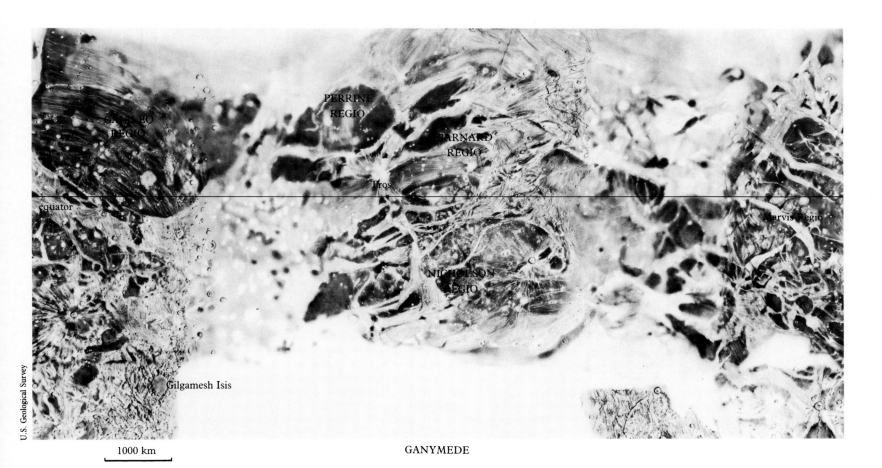

GALILEO REGIO

PERRINE REGIO

BARNARD REGIO

Tros

equator

Marvis Regio

NICHOLSON REGIO

Gilgamesh Isis

1000 km

GANYMEDE

fractures around the planet.

Most fresh craters have bright radiating rays of ejecta blown out onto the surrounding surface. These craters have probably blown away the darkish surface soil, exposing fresher ice. But occasional small craters, typically 10 to 20 kilometers (6 to 12 miles) across and a few kilometers deep, have dark rays.

They probably reflect a layered structure beneath Ganymede's surface. If surface layers ever melted or if "volcanic water" gushed out carrying soil with it, the soil would sink before the resulting oceans froze. Thus, craters penetrating to a few kilometers may tap layers of blackish soil. Ganymede's surface may contain intricate

sedimentary layers of ice and rock.

Ganymede provides us with a simple model in which ice, one of the prime geologic constituents, interacts with rocky material. The remnants of cratered "plates," partially erased by fractures and ice flows, testify to the forces that shape all worlds.

Overleaf: *Ice fractures of Ganymede. Tumbled ice blocks mark a squeeze-up along one fracture in this panorama with a 47-degree angular width.*

85

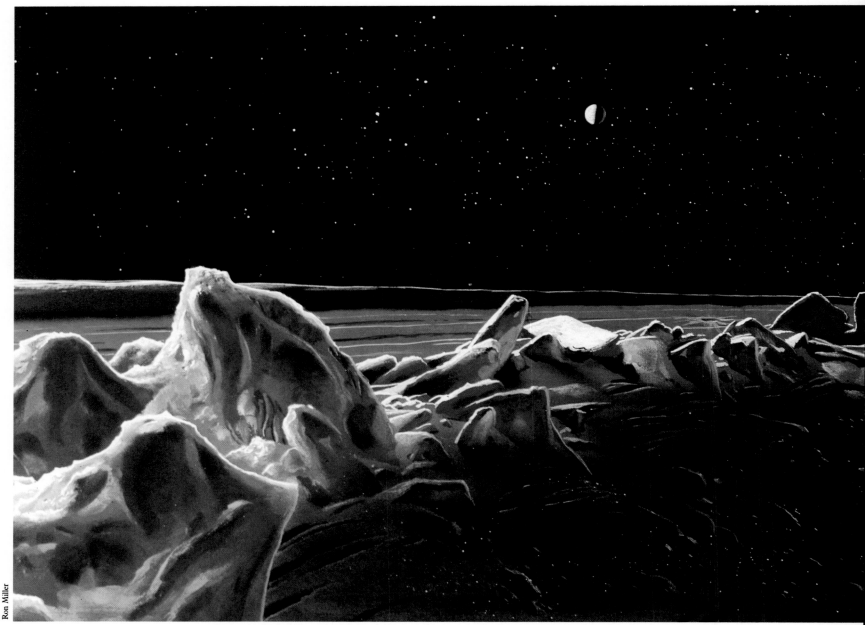

Ice fractures on Ganymede.

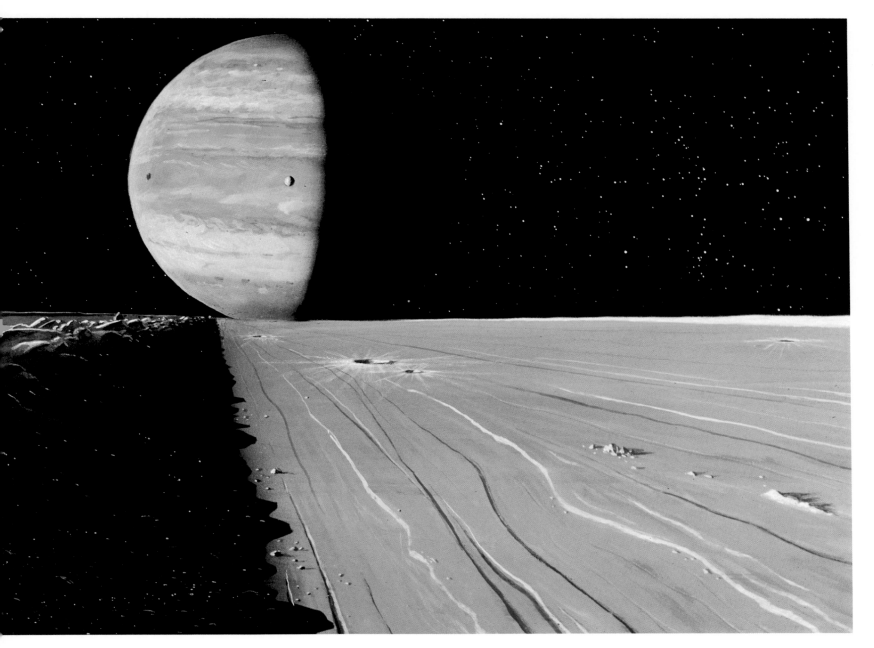

GANYMEDE

 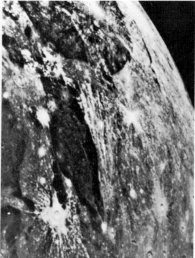

NASA

Left: *Two close-up views of piebald Ganymede taken by* Voyager 2. *Both show contrasts between the old dark, heavily cratered terrain, and the light younger, fissured terrain, which appears to be regions of younger, cleaner ice. Recent craters are also surrounded by halos of bright, fresh ice.*

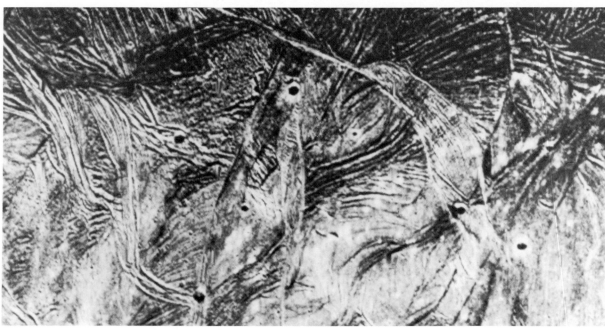

NASA

Left: *Complex patterns of ridges and grooves swirl in an area of Ganymede's surface about 580 kilometers (360 miles) across (the smallest feature visible is about 3 kilometers, or 2 miles wide). Younger grooves are superimposed on older ones.*

TITAN THE MASKED MOON

SATELLITE OF SATURN
Distance from Saturn: 1,222,000 km
Revolution: 16 days
Diameter: 5,140 km
Composition: (?); hydrogen atmosphere

In 1944, the Dutch-American astronomer G.P. Kuiper wrote a paper with the surprising title "Titan: A Satellite with an Atmosphere." This title was surprising because until that time, all satellites had been assumed to be desolate, airless worlds something like our own moon. But Kuiper's spectra showed strong absorptions of certain colors due to methane gas on Titan.

Artists such as Chesley Bonestell quickly recognized the potential beauty of Titan: a gaseous atmosphere of methane would scatter sunlight with a sky-blue color similar to that of Earth. Bonestell produced stunning paintings of a yellowish-tan Saturn hanging in the beautiful blue sky of Titan over rugged mountains and white snowfields. Unfortunately, observations in the early 1970s revealed that the light we see from Titan is reflecting off clouds or a thick layer of haze. This means, to the dismay of space artists, that Titan's surface probably is completely obscured by clouds, making Saturn invisible to an observer standing on Titan . . . and making the scene in Bonestell's painting impossible.

Meanwhile, astronomers debated the composition of Titan's atmosphere. In some models, methane was the major constituent and the atmosphere was very thin. Other models suggested that nitrogen, probably released from Titan's interior, might form a major portion of the atmosphere, perhaps with small amounts of hydrogen mixed in as well. Chemical models suggested that chemical compounds formed from the reaction of these materials would give the clouds their observed orange-red color. Some theorists pointed out that very large amounts of nitrogen might be present in Titan's atmosphere without being observable from Earth, so that instead of a wispy, thin atmosphere, Titan might have an atmosphere as dense as Earth's.

In 1980, *Voyager 1* flew through Saturn's system of satellites and was programmed to pass close to Titan. Scientists hoped that its cameras would not only photograph the clouds but also penetrate the haze and reveal the nature of surface features. Would they see a cratered landscape with little geologic activity, or a terrifically active landscape with geysers of water erupting through clouds of methane and steam? Perhaps the haze would be thick enough to obscure nearly all the surface, with only an occasional volcanic mountaintop protruding above the clouds.

The *Voyager* cameras revealed a world that was disappointing in terms of atmospheric clarity, but terribly exciting as an example of planetary evolution. Titan appeared as an orange ball with no surface features visible and

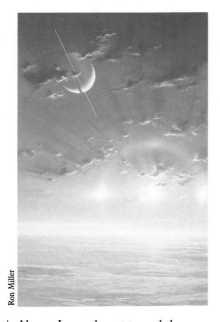

Ron Miller

Above: *In our descent toward the surface of Titan, we pause for a minute a few score kilometers above the sluggish orange clouds to enjoy the sight of a crescent Saturn, its arc bisected by the thin line of the rings, like a drawn bow and arrow suspended in a hazy blue sky. The turgid clouds beneath us are almost opaque, barely allowing us to see the dim glow of Saturn from Titan's surface.*

TITAN

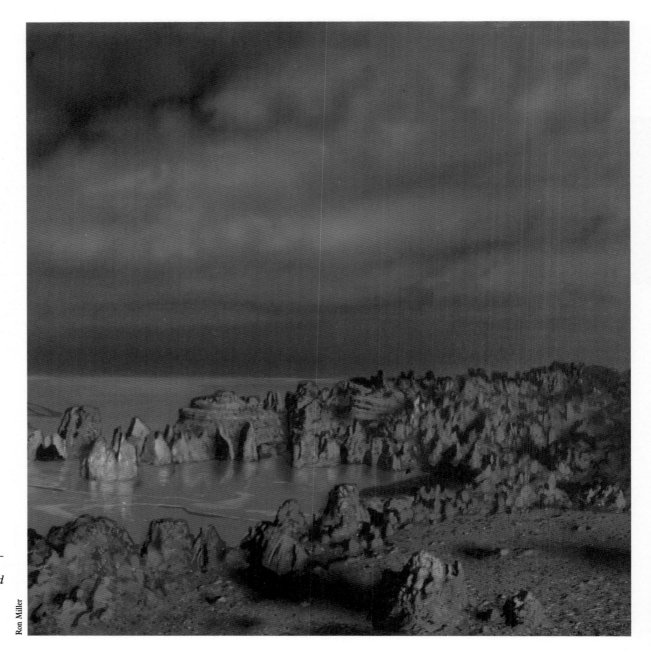

Right: *Titan's mysterious surface is a bleak but intriguing landscape of weird ice formations and shattered lakes of frozen methane and organic compounds, beneath a forbidding ceiling of dark, amorphous clouds.*

Ron Miller

with only a few mottlings in the atmospheric cloud layer. A dark-toned polar cap was visible, and the cloud surface seemed to be brighter in the southern hemisphere.

There is some suggestion that bands or contrast shadings run parallel to Titan's equator.* But the *Voyager* instruments strongly confirmed the thick atmosphere. The spectra indicated that nitrogen is much more prevalent than methane. *Voyager* instruments measured pressures at Titan's surface of roughly 1.6 times the air pressure at sea level on Earth. The amazing "bottom line" is that modest-sized Titan, orbiting Saturn in the cold depths of the outer solar system, has a nitrogen-dominated atmosphere more like Earth's than that of any other world.

Many scientists had hoped that if the air of Titan turned out to be that thick, it might produce a warming or blanketing effect similar to the greenhouse effect on Venus and Earth. If this were true, Titan might be considerably warmer than predicted, considering its distance from the sun. However, preliminary measurements from *Voyager* instruments suggest that

most of Titan's atmosphere is very cold, with typical surface temperatures around −180°C (−292°F).

Nonetheless, the *Voyager* discoveries indicated a phenomenal world. *Voyager* instruments revealed not only methane and nitrogen, but other gases such as ethane, acetylene, ethylene, and hydrogen cyanide. *Voyager* scientist Don Hunten commented that ultraviolet radiation from the sun "would work on the methane in the upper atmosphere of Titan to produce octane, which is, after all, the main component of gasoline . . . I can imagine it

Ron Miller

raining frozen gasoline on Titan." Indeed, chemical studies suggest that many of the heavier compounds formed by reactions in its atmosphere would precipitate onto Titan as rain, perhaps intermittently.

On Titan's frigid surface, methane may exist as ice (or snow), liquid, *and* gas, and some of the nitrogen may also be in liquid form. One *Voyager* scientist characterized the surface as "a bizarre murky swamp" of "liquid nitrogen and hydrocarbon muck." Other scientists proposed a global ocean of liquid hydrocarbons. Radar signals bounced off Titan

from 1989 to 1992 in search of evidence of a global ocean suggested primarily an icy surface, but they did detect regional variations that might be due to local lakes and swamps.

We hope to learn more in 2004, when the joint U.S.-European *Cassini* mission is scheduled to parachute a probe to Titan's surface. Will there be enough light to see anything? Certainly the surface has a gloomy cast. Saturn's system is nine and a half times as far from the sun as we are, so that full sunlight is only about one-ninetieth as bright as on Earth—something like the level of indoor illumination. Titan's haze cuts the light still further. Nonetheless, a 1991 French study concluded that the amount of light at ground level might resemble that in a thick fog on Earth.

Titan's murky landscape is bound to provoke our imagination. Here is a world rich in organic molecules, with a nitrogen atmosphere like Earth's. Although no one expects to find life there, Titan will give intriguing clues about the early synthesis of organic chemicals and the fateful beginnings of biochemistry on our own world.

Left: *Saturn shimmers through the haze above the dense, orangish smog that obscures the surface of Titan. Above the clouds and haze, there may be a level in Titan's atmosphere where a blue sky color can be seen.*

MERCURY CHILD OF THE SUN

PLANET
Average distance from the sun:
 57,900,000 km
Length of year: 88 days
Length of day: 1,416 hours (59 days)
Diameter: 4,880 km
Surface gravity (Earth = 1): 0.38
Composition: nickel-iron, silicates

Mercury, the 10th-largest world in the solar system, is the next-to-smallest planet and the closest of all to the sun. Only a bit smaller than Titan, it is radically different—instead of a smog-shrouded world of ice and slush, Mercury is an airless, sun-scorched planet.

Mercury's closeness to the sun means that it formed from only the minerals that could survive high temperatures. Here there were no ices, no minerals with low melting points. The dust from which Mercury aggregated consisted mostly of high-temperature minerals: metals and silicates. Supporting our conjectures is Mercury's high average density, unusually high for such a small world. Taking into account central compression by the weight of overlying material, analysts calculate that Mercury has a metal core proportionately larger relative to its size than the core of any other planet. Mercury probably melted due to heat released by radioactive minerals, and its iron and other metals drained downward to the core.

This melting must have taken place long ago. Mercury's scorched surface has since been battered by meteorites, comets, and asteroids; it is almost entirely covered by impact craters. Only a few small lava plains have survived the bombardment. Geologically, Mercury appears to have been dead for 3 or 4 billion years.

The sun's tides have locked Mercury's rotation into a very slow spin: one day requires two-thirds of its year. Its rotation, relative to the stars, takes 59 days, while its orbit around the sun takes 88 days. The combination of motions means that the sun moves very slowly through the sky. On average, 176 Earth-days elapse between one sunrise and the next.

The sun's "movement" in Mercury's sky is not only slow, but also weird. Again, because of the combination of rotational and orbital properties, the sun moves at an irregular rate from one horizon to the other. A visitor, like legendary Joshua, would watch the sun come to a complete halt. It would appear to move backwards for a time before continuing in its original direction, having performed a complete loop in the sky. At other positions on Mercury, you can see *two* sunrises and *two* sunsets each Mercury "day."

Mercury's closeness to the sun and its long afternoons make its surface very hot during the daytime, while the equally long nights get very cold. Afternoon soil temperatures can rise well above 227°C (441°F); at night, the temperature can drop to around −173°C (−279°F). The surface of Mercury closely resembles a sun-blasted, copper-colored version of our own moon. Dust is abundant, created not only by micrometeorite impacts but also from thermal erosion of rocks: chips flake off as the rocks expand and contract from the extreme day-to-night temperature changes. As old rocks erode, new ones are blasted out by fresh meteorite impacts.

Below: *Mercury's rugged surface nearly saturated with impact craters.*

NASA

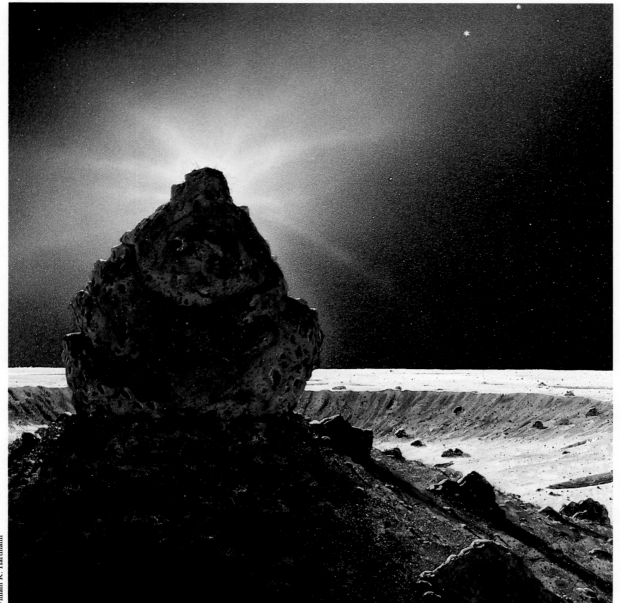

William K. Hartmann

Left: *By stepping into the shadow of a boulder thrown onto the rim of a small crater, we can block out the deadly glare of the sun itself, enabling us to see the delicate streamers of the solar corona, the sun's outer atmosphere. This, like the sun itself, is three times closer—and three times bigger—than on Earth. Jets of ionized gas ejected from the sun are molded by the sun's powerful magnetic field on their way to Earth to disrupt radio broadcasts and power the flickering northern and southern lights, or auroras.*

The large, faint glow across the sky is the zodiacal light—interplanetary dust lit by the sun. In the upper right are two "stars." The brighter one is Venus, and the other is Earth.

93

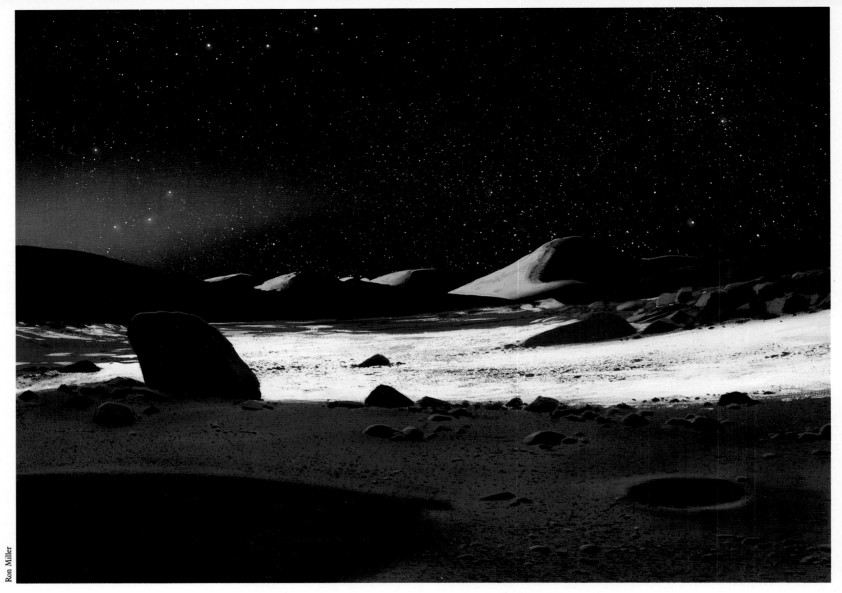

Ron Miller

Above: *Although its name has become almost synonymous with great heat, Mercury's poles may be hiding small ice caps, hidden in craters and low spots that are perpetually shaded from the sun. Observations made by bouncing radar off Mercury in 1991 suggested possible ice deposits in these locations, surprising scientists around the world. Further studies show that the sun hovers on the horizon in these areas, casting the long shadows that may keep the surface cold enough for ice to exist.*

Above: *A cliff, or scarp, more than 300 kilometers (190 miles) long stretches diagonally across Mercury, splitting more than one crater in two.*

Above: *Nothing got in the way of the great shifting blocks of Mercury's crust. The scarps split mountains and craters alike. Here, one large fault bisects a crater (demonstrating neatly that the scarps are younger than this crater). One half of the crater has been pushed up two kilometers above the other half, making the crater resemble a broken dinner plate.*

Above: Mariner *photographed one-half of Mercury's Caloris Basin, the series of concentric mountains and ridges on the left side. It is the 1,300-kilometer (800-mile) result of the collision of Mercury with a moderate-sized asteroid. It has relatives on both our moon and Callisto.*

Mercury, unlike our moon, has no friendly blue globe to dominate its black, virtually airless skies. But it makes up for this with two unique sights. In Mercury's night sky, Venus and Earth often appear as brilliant stars—bright enough to cast faint shadows. The sharp-eyed may try to see if they can find our moon, a faint pinprick next to Earth. And, with the sun so very close, Mercury gets singular sunrises and sunsets. There is no atmosphere, so there are no reds and oranges, but the sun's corona, or outer atmosphere, extends well above the horizon just before sunrise and after sunset. A dim glow extends outward from the pearly yellow corona, the faint band of *zodiacal light*: dust concentrated in the plane of the solar system and illuminated by the sun. It is sometimes visible from Earth as well.

Mercury's surface shows interesting distinctive features, including at least one huge multi-ringed impact basin, 1,300 kilometers (800 miles) in diameter, named Caloris Basin.

Cutting through Mercury's pocked surface like cracks in shattered glass are several enormous cliffs. Up to 500 kilometers (310 miles) or more in length and 2 to 4 kilometers (6,500 to 13,000 feet) high, they pierce mountains, valleys, and craters alike. They are the result of a crumpling of the landscape—a type of feature geologists call a *thrust fault*— that happened when the planet's surface was cooling and contracting. On one side of the cliff the land has been raised, while on the other side it has been lowered. You can see huge craters that have been split in two, one half rising two or three kilometers (6,500 to 9,800 feet) above the other.

The whole history of Mercury and its interior is something of an enigma. Scientists in the 1980s realized that the early solar system was a more violent place then hitherto thought. As planets grew, they underwent many collisions with asteroid-like neighbors. One leading researcher suggested that the reason for Mercury's unusually high proportion of metal is that a large asteroid blasted off much of its rocky mantle after its iron core formed. Another suggested that Mercury may have formed in a somewhat different orbit, having been deflected to its current location by near-miss encounters with larger planets. A Soviet scientist proposed in

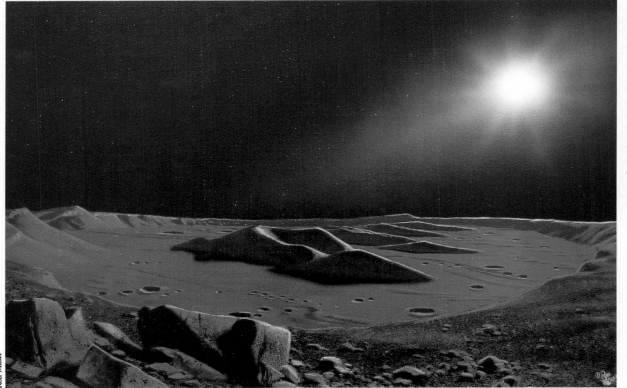

Ron Miller

Left: *Mercury's stark, sun-ravaged landscape is one of the least hospitable in the solar system. Although the proximity of the sun makes the surface one of the hottest known, this will prove to be little more than an inconvenience to future explorers because there is no atmosphere to transmit this heat. Simple umbrella-like sunshades and insulated boots are all the protection astronauts will need.*

MERCURY

U.S. Geological Survey

CALORIS BASIN

(Blank areas not photographed)

Wang Meng

equator

Kuiper

Renoir

Raphael

Beethoven

Discovery Rupes

Mercury as mapped by Mariner 10.

1991 that Mercury is a displaced satellite of Venus. Precise sampling of the mineralogy of Venus may someday confirm or refute some of these ideas.

Lastly, an amazing paradox of Mercury: this sun-blasted inferno may have polar ice caps! Most scientists would have laughed at this idea in the 1980s, but in 1991 radar signals bounced off Mercury indicated small areas of unusual radar reflection at the poles, explainable by ice. The sun is so precisely aligned over Mercury's equator that it never shines into cracks or deep crater floors at the pole. Thus soils in polar low spots are always in deep freeze. If a comet impact, for example, produced local water vapor, the vapor could condense into ice in these permanent cold spots. Frost fields of Mercury? In the solar system, there are many surprises!

CALLISTO JUPITER'S BATTERED MOON

SATELLITE OF JUPITER
Distance from Jupiter: 1,882,600 km
Revolution: 16 days 16 hours
Diameter: 4,840 km
Composition: ice, carbonaceous silicates

With a diameter of 5,000 kilometers (3,100 miles), Callisto is a slightly smaller sister of Ganymede. Like Ganymede, it keeps one face toward Jupiter.

Callisto seems to have lacked the internal energy to drive complex geological processes or fracture the surface. Instead, Callisto's surface is almost completely covered by old craters and has not been broken by eruptions of fresh ice, as has happened on Ganymede. Here and there, huge bull's-eyes mark the sites of the largest ancient impacts that made concentric fractures in the crust.

The bulk density of Callisto is greater than that of ice, indicating a rocky component in addition to the ice. Data indicate that Callisto consists of about half ice and half black, carbon-rich rock or soil. The surface has a concentration of the dark soil, but wherever an asteroid has hit, it has blown away the dark soil and left a bright scar exposing the fresher ice underneath. This effect is prominent in photos of Callisto. The dark surface soil probably becomes concentrated in the surface layer as micro-meteorite impacts vaporize the ice component.

The multi-ring systems on Callisto are virtually flat; its bigger craters are shallow. The reason for this probably involves Callisto's icy composition. Because these craters are formed of ice, and because ice flows (as glaciers do), the deepest craters have leveled out. This means relief on Callisto is rarely more than a kilometer. The biggest impact sites, originally marked by deep basins and surrounding vaulted cliffs, have filled out to the point where only ghostly ring scars remain. Small craters preserve their nearly original profiles because they aren't big enough to deform. To put it another way, the ice is rigid enough to hold up small crater

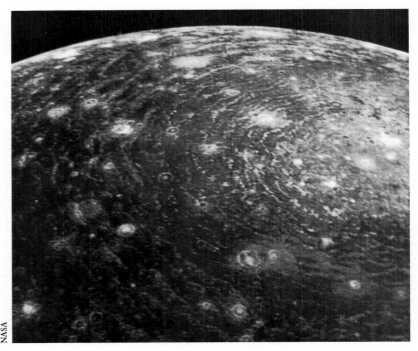

NASA

rims but not large ones.

Callisto seems to be the best example of a world not quite big enough to be deformed by internal energy, and not quite close enough to another planet to be repeatedly stretched and heated by tidal forces. Callisto is one of the largest worlds that has survived from the planet-forming era with little internal modification.

Above: *An enormous bull's-eye, created by the impact of a small asteroid. Stresses fractured the brittle surface ice layer for hundreds of kilometers around.*

Below: *Callisto's surface is saturated with craters; Callisto literally could not be more cratered. New craters could not be formed without destroying old ones. Far from the crust-twisting influences of Jupiter's gravity, Callisto's icy surface froze early;* *with the exception of the impact of the occasional meteorite, little has happened on Callisto since it was formed.*

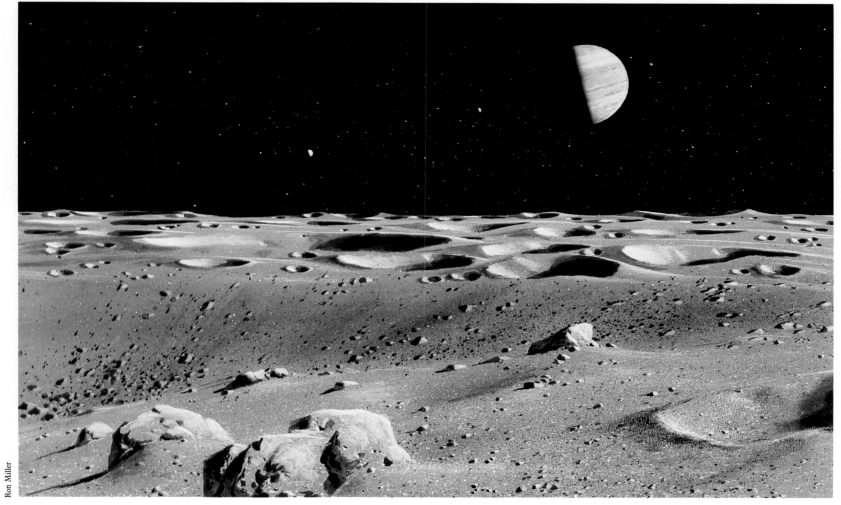

Ron Miller

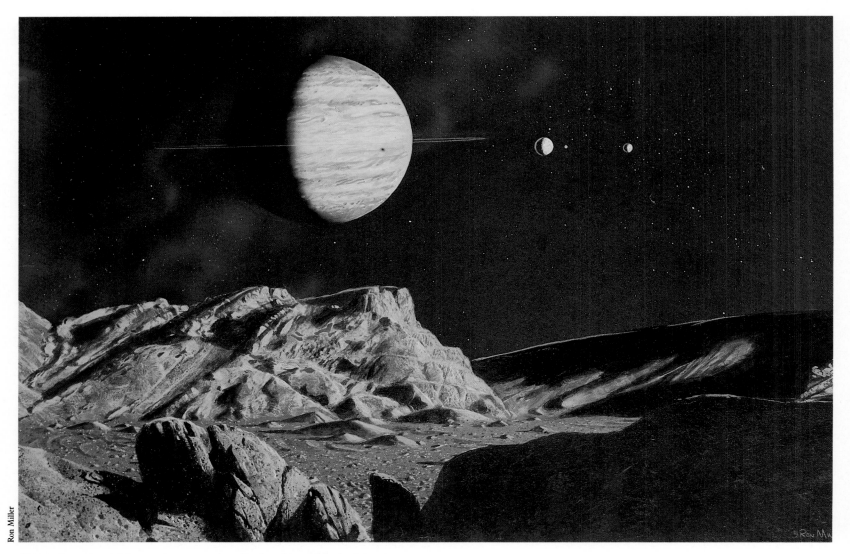

Ron Miller

Above: *Dirty ice and bare rock surround us, mixed into a muddy slurry by one of the enormous impacts that scarred Callisto's surface and then, almost instantly, froze.*

Jupiter, bisected by its faint ring, accompanies Europa, Ganymede, and Io in Callisto's dark sky.

CALLISTO

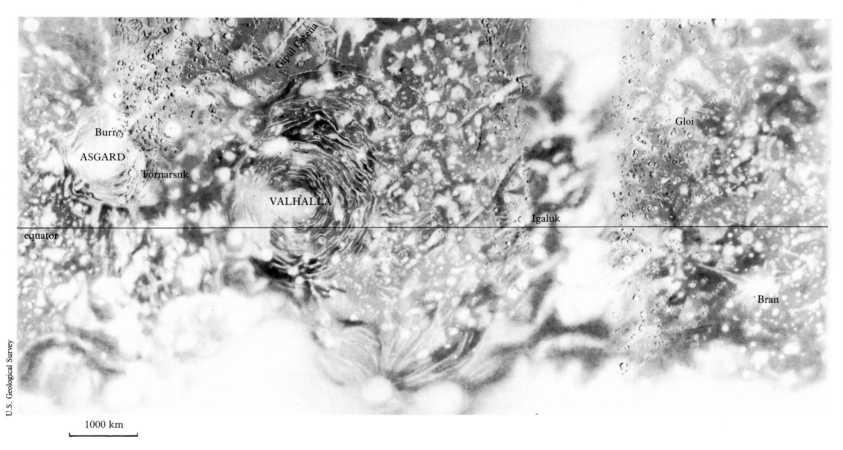

U.S. Geological Survey

1000 km

A map of Callisto, showing features discovered by the Voyager *space probes. Valhalla is the most prominent multi-ring impact basin. Blank areas are regions not well photographed by either* Voyager *probe.*

IO A WORLD TURNING INSIDE OUT

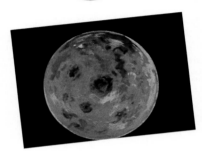

SATELLITE OF JUPITER
Distance from Jupiter: 421,800 km
Revolution: 1 day 19 hours
Diameter: 3,630 km
Composition: silicates, sulfur

To those of us who grew up walking on soil derived from silicate minerals, watching trees sway in the breeze under a blue sky, dangling our toes in liquid water pools, throwing snowballs, and watching astronauts play in the rocky deserts of our sister world, the moon, Jupiter's satellite Io must appear to be the most bizarre world in the solar system. Io (pronounced *EYE-oh**) is almost exactly the same size as our moon, yet its geology and chemistry are dominated neither

*Also pronounced *EE-oh* by some authorities, but never "ten" as occasionally heard from ill-informed newscasters.

by the silicate soils of the inner planets nor by the ices of the moons of the giant planets, but rather by volcanic, sulfur-rich compounds.

The first close-up pictures by *Voyagers 1* and *2* in 1979 showed Io to be mottled with orange, yellow, red, and white patches, and pocked with blackish spots. *Voyager* team scientists remarked that they didn't know what was wrong with Io, but it looked as though it might be helped by a shot of penicillin: Io resembled one of those planets we used to laugh at when it appeared outside spaceship windows in grade-C science fiction movies.

One of the great triumphs of theoretical astronomy came at this time. Just one week *before Voyager 1* got to Io, California planetologist Stan Peale and colleagues published a *prediction* of volcanoes on Io. Their reasoning was as follows. Any satellite close to a planet is slightly stretched into a sort of football shape with the long axis toward the planet, because of the gravitational pull of the planet. In Io's case, the additional gravitational attractions of neighboring moons keep forcing Io to vary its distance from Jupiter, causing the stretching to increase and decrease. This

constant flexing of Io heats its interior, just as a tennis ball will get warm if you keep flexing it. The unique action of neighboring moons on a given moon explains some unusual geologic features on certain other moons as well, as we will see later.

Prior to Dr. Peale's prediction, most researchers had expected icy moons such as Io to be geologically dead. But Io, far from being dead, is a volcanic powerhouse! When *Voyager 2* flew by, four months after *Voyager 1*, at least six of the eight vents discovered earlier were still active, and two new ones had started. Close-up photos revealed that most of the blackish spots were volcanic calderas, the irregularly shaped craters left by volcanic eruptions. Io maintains continuous simultaneous major eruptions— a level of volcanic activity unheard of on Earth, where violent eruptions occur only sporadically.

While the normal surface of Io has a daytime temperature of about −148°C (−234°F), numerous warm spots have temperatures about 27°C (81°F), while frequent eruptions have temperatures around 327°C (621°F). *Voyager* data suggest

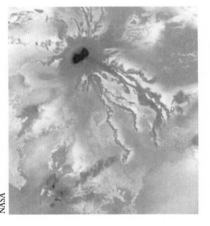

NASA

Above: *A volcanic caldera with radiating flows of lava.*

outbursts as hot as 427°C (801°F). These outbursts could thus involve molten sulfur (melting point 112°C, or 234°F), but would be a few hundred degrees cooler than the temperature of familiar molten silicate lava on Earth.

The volcanism of Io explains a fact that had puzzled pre-*Voyager* scientists: the absence of ice on its surface. Jupiter's other big moons are all ice-rich. All these moons probably formed from a mixture of frozen water and rocky material, with minor amounts of sulfur and other compounds. Apparently, Io's volcanism has been so intense

Ron Miller

that most of the crustal materials have melted, erupted, been covered by later eruptive debris, and perhaps been recycled through this sequence again and again. Volatile materials, such as water, boiled off long ago. This is why Io lacks the ice-rich surface of its neighbor worlds, such as Europa.

Heavy materials, such as silicate rock, sank into the lower layers of Io. The retention of the heavy material and "boil-off" of light volatiles accounts for the fact that Io's density is higher than the other moons' densities. Sulfur compounds, the lightest materials that would not boil away, ended up as the dominant "lavas" on the surface.

Interestingly, after the volcanoes were discovered by *Voyager*, observers at Mauna Kea Observatory in Hawaii were able to detect them with advanced,

Below: *Io photographed by* Voyager 1. *The feature at the right is an erupting volcano.*

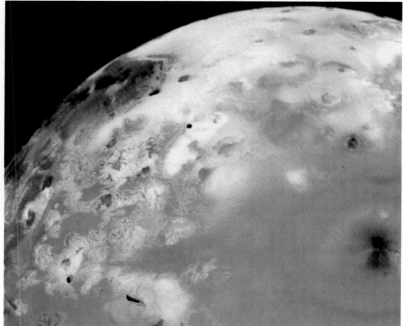

NASA

Above: *Debris is being spewed a thousand kilometers (622 miles) per hour at us as we hover a few score kilometers above one of Io's violently active volcanoes. The entire visible surface of Io has been buried to an unknown depth beneath the ejecta from its almost continually erupting volcanoes. Molten sulfur has poured in streams from wounds in the dome's side, while blue gases fume from a caldera at the summit, filled with black, molten sulfur.*

A DAY ON IO

 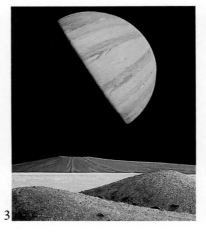 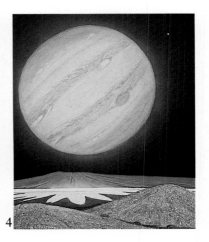

1 2 3 4

heat-sensitive, infrared detectors. This technique confirms that volcanoes continue to erupt at different vents on Io, year after year.

Io has some of the most stunning visual effects in the solar system. Imagine a full "day" on Io, experienced from a single point on its surface. One side of Io always faces Jupiter. On that side, Jupiter dominates the sky, always hanging in the same place. Jupiter subtends an angle of about 20 degrees—40 times the angular size of the moon in our sky.

Because Jupiter covers a large part of Io's sky, the sun spends nearly two and a half hours of each day in total eclipse behind Jupiter. When the eclipse ends, the sun comes out from behind Jupiter and begins to warm the landscape, which has cooled markedly during the eclipse. At this moment, another of Io's unusual phenomena occasionally becomes visible: the so-called post-eclipse brightening.

In the mid-1960s astronomers monitored the brightness of Io before and after these eclipses, hoping to discover whether Io had an atmosphere. They hoped that during the cold eclipse period, frost might condense and form whitish deposits if the temperature dropped low enough. Calculations suggested that if several large volcanoes are erupting during an eclipse, enough sulfur dioxide might condense on orange or red backgrounds to brighten the overall appearance of Io during the few minutes after the eclipse ends. Sure enough, astronomers observed a brightening of Io, which faded about 15 to 20 minutes after the eclipse ended, as the surface warmed. A mystery surrounds these observations. The post-eclipse brightening is seen after some eclipses, but not after all of them. Some astronomers claim the whole thing is due to faulty data; others suspect it may depend on the state of volcanic eruptions and the abundance of vapors they produce.

Some 10½ hours later, when Io has moved a quarter of the way around Jupiter, its sky develops a faint yellowish glow. This effect was first seen from Earth. The explanation is that a large, thin gas cloud of sodium, sulfur, and other atoms surrounds Io. The presence of this cloud has to do with Io's location inside Van Allen radiation belts around Jupiter.

Energetic atoms trapped in

These six pictures show events during one 42-hour "day" as Io moves around Jupiter, as seen from a single place on Io. In the first view, the sun is obscured by Jupiter during a morning eclipse. Jupiter's atmosphere glows red as the sun starts to emerge. In the

second view, 18 minutes later, sunlight is evaporating the last traces of a whitish frost of sulfur dioxide formed on the landscape during the cold eclipse. The third view shows the scene

5

10½ hours later. Io has moved a quarter of the way around Jupiter, and the yellow auroral glow of Io's sodium cloud is visible in the sky. The bright colors of Io's sulfurous surface are not prominent.

In the fourth view, after another 10½ hours, the sun is setting behind us and Jupiter is fully illuminated. Shadows stretch toward the horizon. In the fifth view, 10½ hours later, we have moved three-quarters of the way around Jupiter, and the sodium aurora is again visible in the sky. In the sixth view, shortly before dawn, the volcano on the horizon has erupted. Delicate traceries of debris follow parabolic trajectories in Io's near-vacuum instead of forming the puffy clouds of Earth's volcanoes. The highest parts of the parabola are lit by the sun, just below the horizon to the left; the lower part of the parabola is in Io's own shadow.

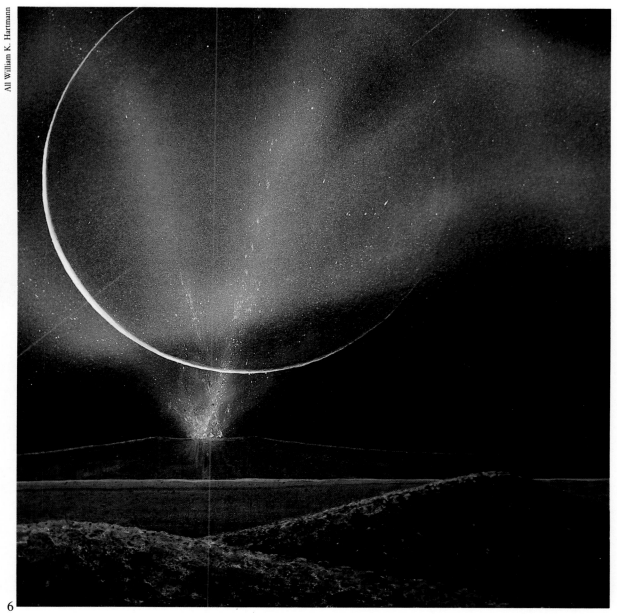

6

105

IO

these belts strike Io's surface and knock other atoms loose. More may "come unglued" due to Io's volcanic eruptions. As these atoms escape Io, they diffuse into a cloud many Io-diameters wide, stretching forward and backward along Io's orbit. Sunlight striking the atoms excites them. In particular, if sunlight of a certain wavelength strikes the sodium atoms, they absorb and then re-emit this color—a glow called the *sodium "D" line*, familiar to us as the yellow color in most candle flames. The sodium cloud around Io glows with a faint yellow light—a sodium aurora that resembles a moderate aurora on Earth.

About 10½ hours later, Io is halfway around its orbit, between Jupiter and the sun. The sodium glow has slowly faded from the sky. Now Jupiter is in its "full"

Below: *Blue gases are venting from a caldera filled with black, molten sulfur.*

Above: *Io's eerily glowing sodium torus lights the moon's night sky. Sodium atoms dislodged from Io form a cloud that surrounds Io and stretches out along its orbit around Jupiter, forming a doughnut-like torus around Jupiter. The portions of this cloud that move toward or away from the sun as they move around Jupiter give off a faint yellow glow, the same glow that is prominent in candlelight. We stand on a plain on the night side of Io; Io is 90 degrees from the Jupiter-sun line, and the landscape is lit by Jupiter in half phase. We are looking at the sky along*

Io's orbital path—a direction 90 degrees away from Jupiter, which is out of the picture to the upper right. This means we are looking down the axis of the glowing torus, and we see the brightest part of it. In the distance, the glow curves off to the right along the orbital path around Jupiter.

A red sulfur glow can be seen in the background. The neighboring outer moons, Europa (lower left) and Ganymede (upper right), hover in the sky. The visual width of this wide-angle view is about 80 degrees.

Above: *A scene along the terminator, photographed by* Voyager 2. *The sun is shining from the lower left to the upper right. The blade-shaped valley at the top is 300 kilometers (190 miles) long and 50 kilometers (30 miles) wide.*

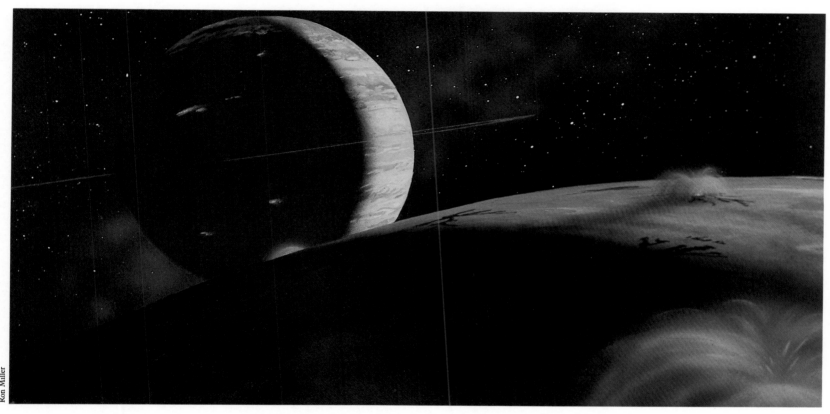

Ron Miller

phase—a dazzling yellow, orange, red, and tan disk with brightly colored cloud patterns, such as the famous Red Spot storm system.

The sun has set at our location after another 10½ hours. Io has carried us three-quarters of the way around Jupiter, and the planet is in its "third quarter" phase. The yellow sodium glow is back in the sky, perhaps a bit brighter now, depending on the amount of volcanic gases emitted in the last few hours. In the cold of night, the sulfur dioxide frost may have formed again, and the landscape is dully illuminated by the yellow light of Jupiter itself.

So far, no one has stood on the plains of Io to see these views or feel the seismic tremors as its volcanoes explode. But if we humans manage to establish viable interplanetary travel before we imprison ourselves forever on a resource-exhausted planet, the day may come when, heavily shielded from Jupiter's radiation, we will see the sights of Io not through spacecraft instruments or paintings, but with our own eyes.

Above: *The plumes of Io's volcanoes squat on this moon's marbled surface. The force behind these titanic eruptions blows debris hundreds of kilometers into space. Some of it spirals in toward Jupiter, eventually coating the tiny innermost satellite, Amalthea, with dull orange deposits.*

IO

Right: *We are standing on the brink of an enormous lake of molten sulfur, a dark fluid filling one of Io's volcanic calderas. In the distance, on the horizon, one of Io's numerous volcanoes spews its blue-gray umbrella of debris miles into the vanishingly thin atmosphere. Io is not only the most volcanically active body in the solar system, but also one of the most violent. Its unstable surface, twisted and tortured by the powerful tides caused by Jupiter's gravity, is constantly reshaped as huge calderas collapse, lava lakes form, and volcanoes erupt.*

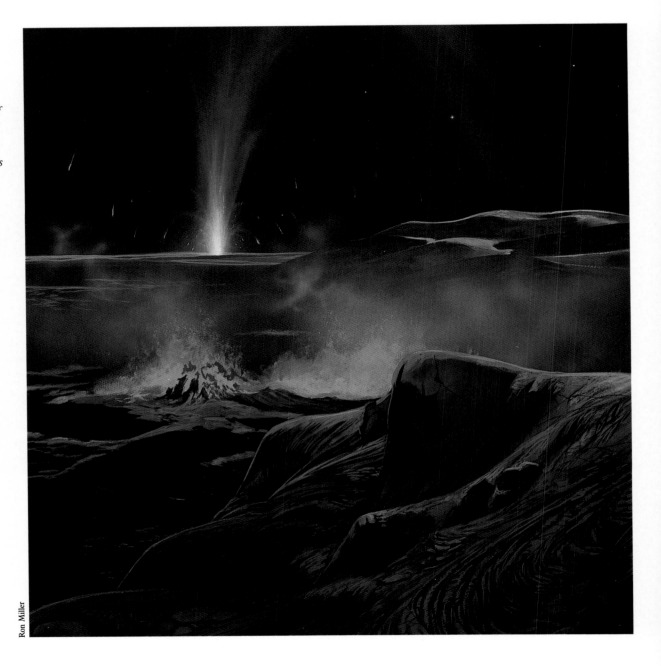

Ron Miller

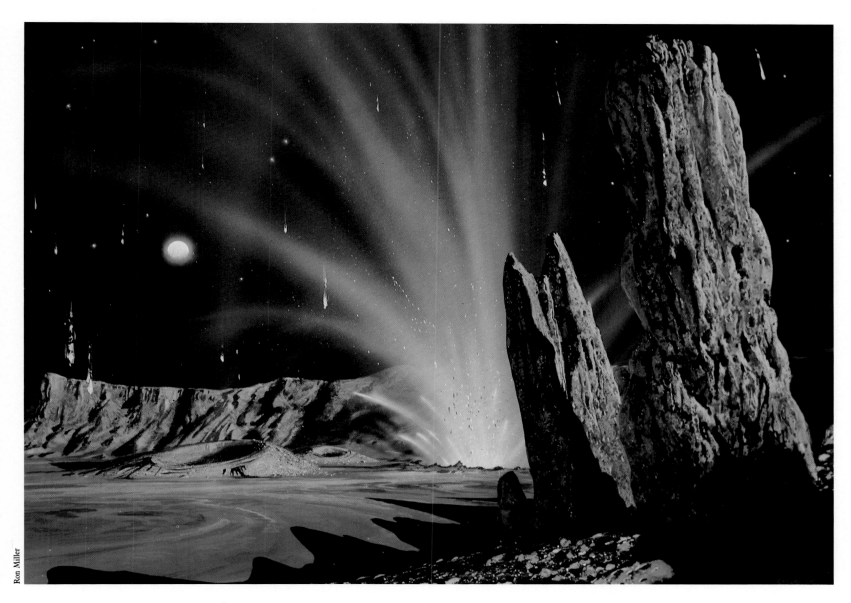

Ron Miller

Above: *Without an atmosphere to suspend gases and dust in the cauliflower-like billows familiar to* *terrestrial volcano-watchers, volcanoes on Io look like vast garden sprinklers, blowing debris in graceful arcs for* *hundreds of kilometers. Standing inside the caldera of an active volcano, near chunks of raw sulfur blown from* *previous eruptions, we watch the enormous plumes as they thunder from the vent with explosive violence.*

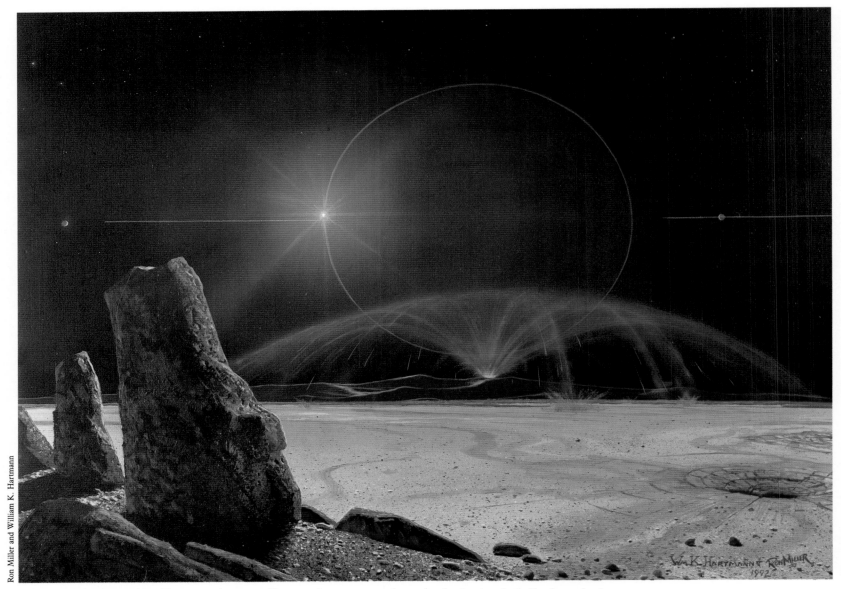

Above: *On the plains of Io. Even on an ordinary day, Io offers some of the most dramatic vistas in the solar system. Here, as the sun emerges from behind Jupiter, a distant volcano on the horizon sends up an umbrella-cloud of volcanic ash. Sulfur fumerole pits and rocky slopes colored by sulfurous compounds mark the foreground.*

Io, as mapped by Voyagers 1 *and* 2.

THE MOON EARTH'S COMPANION

SATELLITE OF EARTH
Distance from Earth: 381,575 km
Revolution: 27 days 7 hours
Diameter: 3,476 km
Composition: rock, silicates

NASA

The moon has come to be one of the best-known worlds. On July 20, 1969, *Apollo 11* astronauts became the first human beings to set foot on the moon. The samples they and several Russian automated landers brought back have revealed a great deal about the evolution of the moon.

Lunar rocks are generally older than those found on Earth. For this reason, lunar exploration has been geologically valuable, helping to fill in the gaps in the first billion years of the Earth-moon system's history.

What the moon rocks tell us is that the moon (and probably Earth) began its history 4.5 billion years ago with a surface layer that was molten. This molten layer—or *magma ocean,* as it is called—was a few hundred kilometers deep. As it cooled, various minerals solidified and a crust of lower-density minerals aggregated on the surface, accounting for the low-density rock types known as *anorthosites,*

Above: *A small lunar crater photographed by* Apollo 12 *astronauts.*

which form much of the ancient lunar highlands. By 4.4 billion years ago, much of the magma ocean had solidified, although deep pockets of molten material existed under the surface.

Counts of lunar impact craters and determination of rock ages tell us that the rate of meteorite impact was extremely high between 4.4 and 4 billion years ago. This was probably true on

all planets throughout the solar system. Meteorite debris was left over from the formation of planets 4.5 billion years ago; scattered through interplanetary space, this debris often collided with them. But by 4 billion years ago, much of the debris had been "collected" by the planets. The impact rate was so great before then that only chips and pieces of lunar rock survive from that time.

Around 3.9 billion years ago, heat generated by radioactivity had accumulated inside the moon, melting a layer several hundred kilometers beneath the surface. The largest meteorite impacts, which formed huge craters of a type known as multi-ring basins, caused fractures that penetrated into this magma layer. Lava ascended to the surface and erupted, covering the floors of the huge basins and some of the larger craters. These lava flows are darker-colored than the ancient highlands and form the dark plains that we see from Earth—the "man in the moon." Galileo and other early astronomers erroneously thought that these flat areas were oceans and gave them the Latin name for sea, *mare* (plural *maria*).

Thus these features bear such colorful names as Mare Tranquillitatis (Sea of Tranquillity) and Mare Imbrium (Sea of Showers).

Most of the prominent maria, or lava plains, formed between 3.8 and 3.2 billion years ago. Their rocks are basaltic lavas, similar to the volcanic lavas found in Hawaii, California, Arizona, and elsewhere.

As life-forms evolved on the fertile Earth (starting at least 3.5 billion years ago), the airless moon continued to be belted by a rain of meteorites. Numerous small ones sandblasted the surfaces of the rugged lava flows into smooth, undulating layers of fine dust and rock chips about 10 meters (30 feet) deep. This was the surface our astronauts trod, kicking up dust that dirtied their space suits and sprayed from their rovers' tires in graceful arcs. This dusty layer is called the lunar *regolith*.

Larger meteorites fell at a rate only one one-thousandth as often as they did a billion years before. Their occasional impacts excavated craters through the regolith and ejected rock fragments from the lava layers below, accounting for scattered

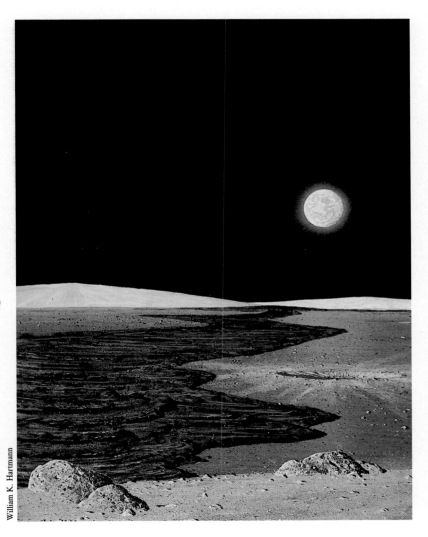

William K. Hartmann

Left: *We see a relatively fresh lava flow on the moon. Dates of numerous rock samples from the lava plains of the moon show that eruptions of lunar lavas were strongly concentrated between 3.2 and 3.8 billion years ago. The outer layers of the moon probably cooled to below molten rock temperatures around 3 billion years ago. Lava flows as old as that have been 'sandblasted' by the impact of small meteorites until their surface textures are obliterated in a layer of dust and rocky rubble.*

It seems unlikely, however, that all pockets of underground lava disappeared in all regions of the moon 3 billion years ago. Some researchers have estimated that certain fresher-looking flows are only about 2 billion years old. Other researchers suspect that vestiges of volcanic activity, such as gas emission, occur even today. Perhaps we will eventually locate some lunar region where a small, localized flow only 1 billion or .5 billion years old has been relatively well preserved.

No large volcanoes occur on the moon; instead, lava flows appear to originate from fissures and low ridges. The lunar lavas were probably too hot and too fluid to pile up into steep-sided mountains.

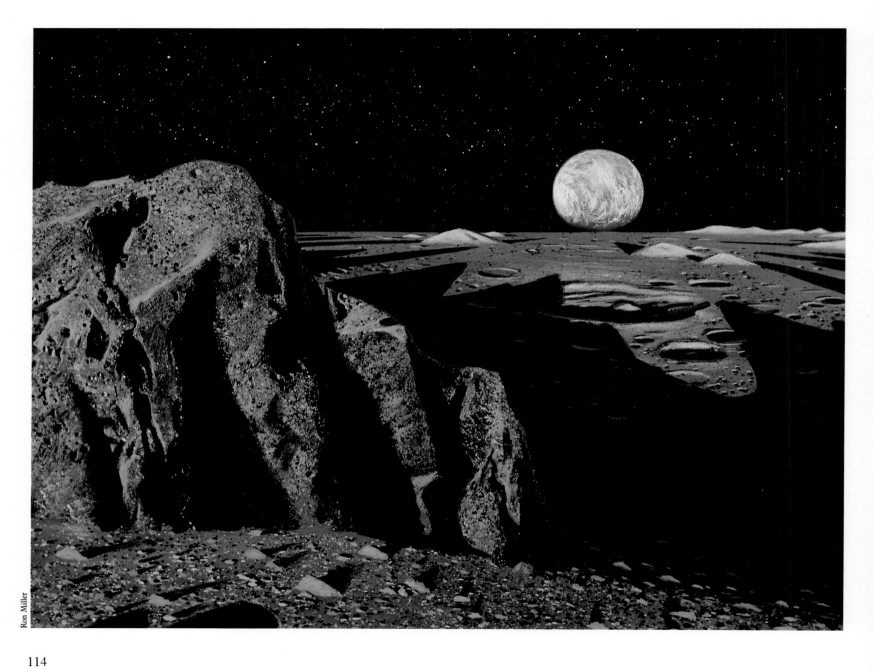

rocks in the maria plains and the uplands.

Very large impacts blasted out rare, large young craters such as Tycho, whose rays of bright ejected debris stretch outward across the moon. Interiors of such craters have not been sandblasted enough to be smooth, and so are marked by chaotic rubble that must form landscapes far rougher than any we have seen.

Until 1965, heavily cratered landscapes like those of the moon were unknown elsewhere in the solar system because our ships had not yet reached other planets. Today, we know that virtually all the 20 or so planetary surfaces we have seen at close range are cratered, and that the moon displays the effects of processes that have acted on many worlds throughout the solar system. Orbiting spacecraft have shown us that even Earth is more heavily cratered than had been suspected; but erosion and plant life have made even enormous craters difficult to detect from the ground.

We have landed on the moon in only a few places, and those have been relatively flat. We have not yet seen the rugged areas, the fresh craters, the nighttime surface illuminated by Earth-light, or the lunar landscape bathed in the fiery red light transmitted through Earth's atmosphere during an eclipse, when Earth passes between the moon and sun. Many vistas remain for us to admire on our neighboring world.

Left: *Shadows cast by the setting sun point toward a nearly full Earth, sitting on the lunar horizon like a marbled bowling ball. The elongated, jagged shadows of the mountains demonstrate why for so many years people—astronomers and laymen alike—were misled into thinking that the mountains themselves were craggy and jagged. This impression was created by low lighting angles. The sun rises and sets, although a lunar day seems intolerably long—14 Earth-days from dawn to dusk—but Earth never moves from its place in the sky since the moon always keeps one face toward us.*

Right: *Zooming in on Tycho (above, middle, below),* the final photograph covers an area about 5 by 6.5 kilometers.

NASA

Overleaf: *Forbidding badlands convolute the floor of the crater Tycho, bound by the distant, towering cliffs of the crater walls. This ruggedness is an indication of Tycho's relative youth— it has yet to be sandblasted by micrometeorites to match the rolling smoothness of much of the rest of the moon. The three photographs (left) zoom us into Tycho, to show us the area in which we're now standing. The crater, the result of a meteorite collision, is the size of Yellowstone National Park. Tycho's central peak is a mountain about 1,800 meters (6,000 feet) high. The crater walls, which rise in a series of stepped terraces, loom 3,600 meters (12,000 feet).*

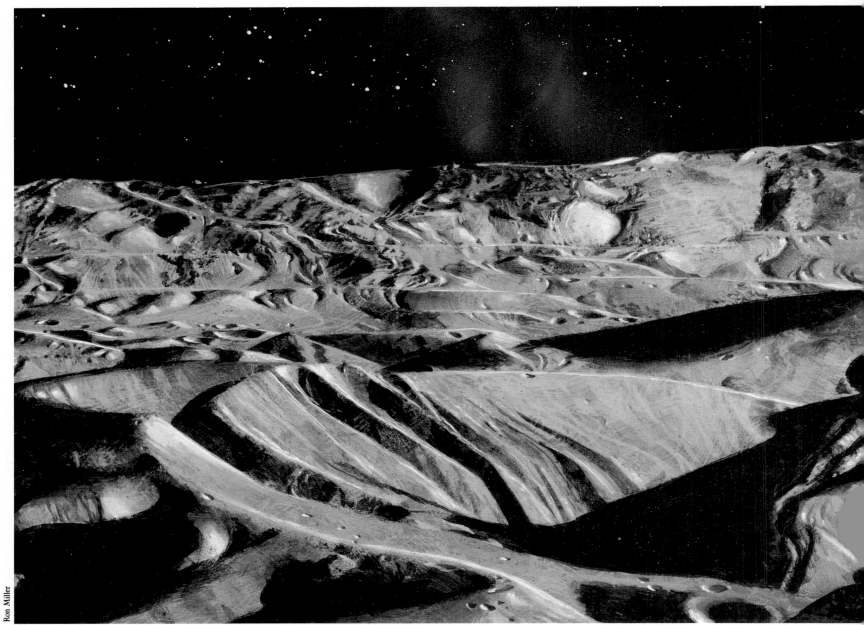

Interior of the crater Tycho.

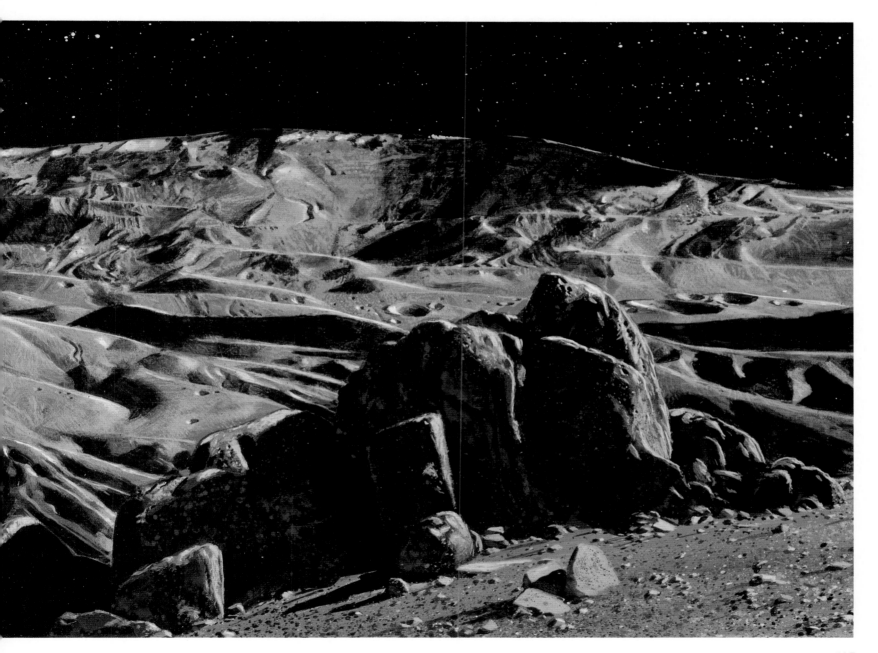

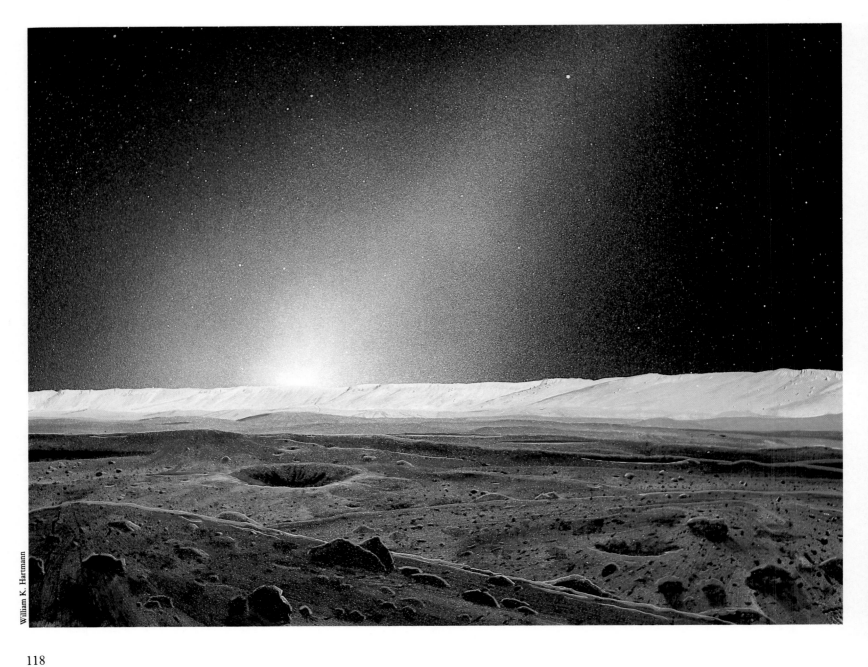

William K. Hartmann

118

Right: *Rubble at the foot of Mt. Hadley, photographed by Apollo 15 astronauts.*

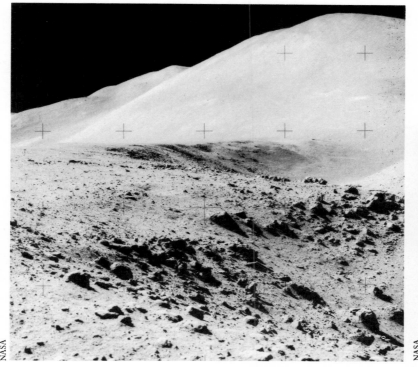

NASA

Left: *In the rough country around the Orientale impact basin, Earth always hangs low over the eastern horizon. Once the sun sets, eerie blue Earth-light is the only source of illumination. Here it catches the top of one of the huge cliff-rings that surround the Orientale Basin. Because this basin is hundreds of kilometers across, we do not have the sense of standing in a crater; rather, the fault-ring appears more like a long, scalloped mountain range. The sun is just below the western horizon, which we face. Since there is no air, there are no glorious sunset colors; but the moon offers a different kind of sunset display. The horizon glows with the outer parts of the sun's corona and a faint band of zodiacal light—the dust of the inner solar system lit by the sun.*

Because the moon turns in 29½ days (relative to the sun) instead of 24 hours, the sunset is very slow. The sun actually hangs just below the horizon for an entire Earth-day of twilight before the full, 14-day lunar night sets in. But the cliffs are still lit by Earth. They will fade as Earth goes from its full phase (which it is in now, since it is opposite the sun) to a much fainter crescent illumination just before sunrise.

NASA

Above: *A close-up view of a crater wall. The distance from the crater's central peak, at the bottom, to the rim is about 30 kilometers (19 miles). Material has slumped from the wall onto the crater floor, which is covered with domes and low ridges.*

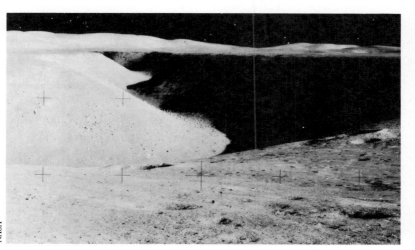

NASA

Left: *Looking northwest up Hadley Rille, a relatively shallow, meandering valley like many others on the moon.*

119

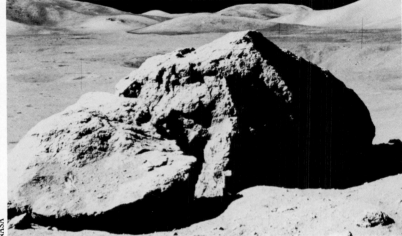

Below: Apollo 15 *astronauts photographed this boulder, thrown out of a nearby crater when it was formed, as were most of the other rocks around it.*

NASA

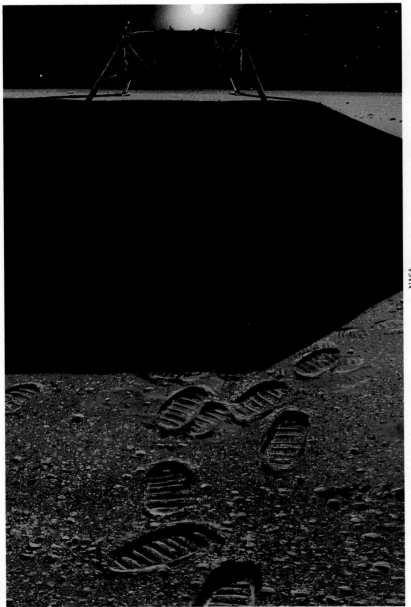

Ron Miller

Left: *The most historic site on the moon. It is here that humanity, through its emissaries, first reached out and touched another world. On July 20, 1969, Neil Armstrong and Edwin Aldrin, Jr., made the first human footprints on an unearthly landscape, while Michael Collins patiently orbited overhead in the command module. When they departed one and a half days later, with scores of photographs and rock and soil samples, they left this monument on the lava plains of Mare Tranquillitatis. Barring accident, it will last for eons. Even something as fragile as the astronauts' footprints will remain unchanged for millennia, only filling in imperceptibly via the unending dusting of micrometeorites. The spider-like structure behind which the sun is setting is the lower stage of the lunar module* Eagle.

Right: *We see a face of the moon never visible from Earth as we hover 8,000 kilometers (5,000 miles) above the lunar far side. We miss the familiar maria—the dark patches that make up the "man in the moon." Instead, there are only endless, wall-to-wall craters. The one with the prominent dark floor is Tsiolkovsky, named for the great Russian rocket pioneer. In this view we are positioned beyond the orbit of the moon, with Earth looking four times larger than the moon does from Earth.*

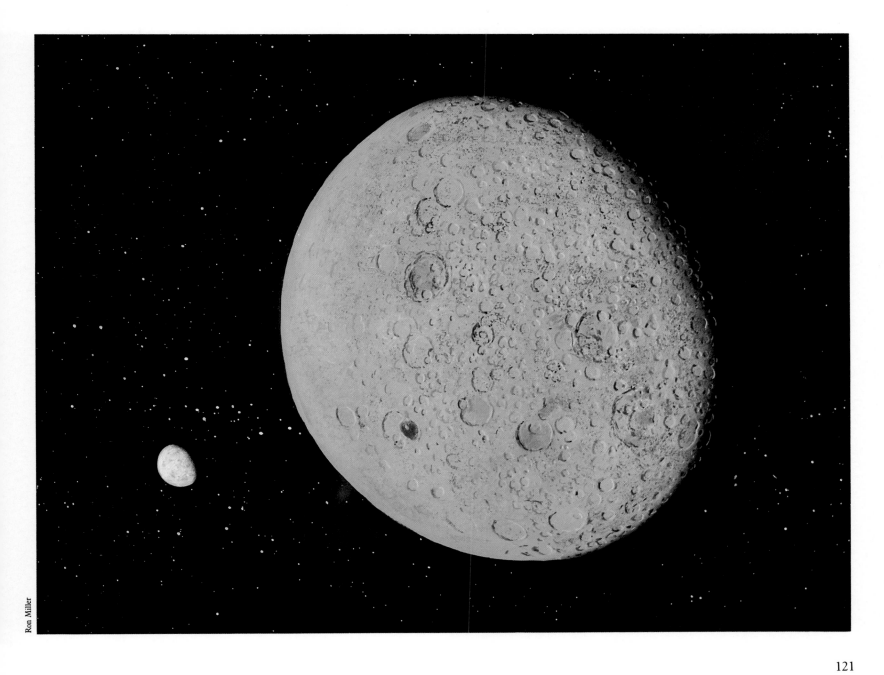

THE MOON

Below: *This large crater is on the far side of the moon, and is about 80 kilometers (50 miles) wide.*

Below: *Rugged boulders at Taurus-Littrow.*

Right: *The surface of the moon has turned to copper as the bloodred light from an eclipsing Earth washes over the landscape. The backlit atmosphere of Earth, as it passes in front of the sun, is illuminated in an orange-red ring. Sunlight, passing through the atmosphere at such a low angle, turns red just as it does at sunrise and sunset. The reddened sunlight refracted through Earth's atmosphere is what is lighting everything around us.*

Pale streamers of the sun's corona fan out from behind Earth while the even paler zodiacal light extends beyond them in a faint band. The sun is about to pass out of eclipse; in fact, the first sunlight is just striking the horizon beyond Earth's shadow.

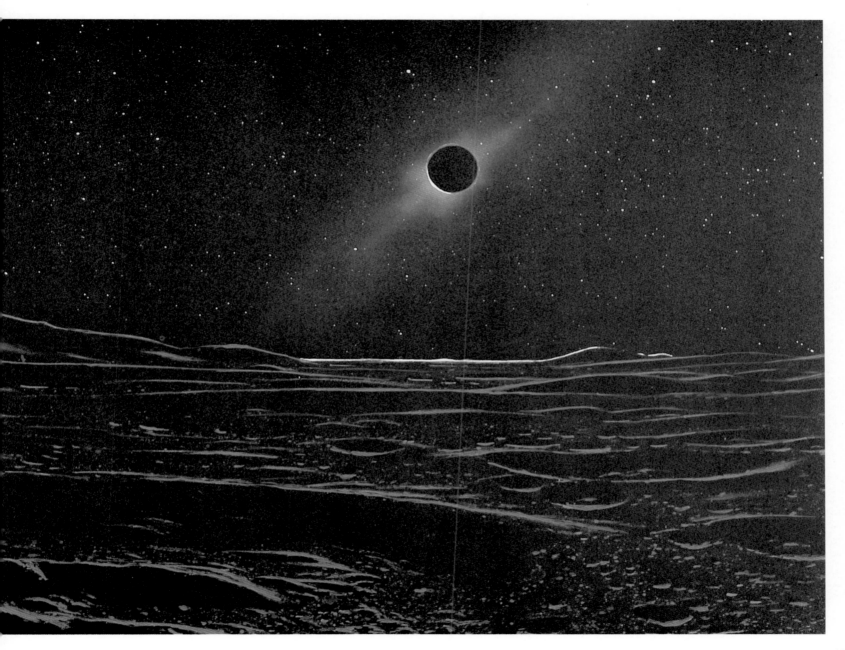

Left: *The Mare Orientale basin as photographed by* Lunar Orbiter. *Its outer ring, the Cordillera Mountains, is over 965 kilometers (600 miles) in diameter. Mare Orientale is probably the result of the impact of a small asteroid.*

NASA

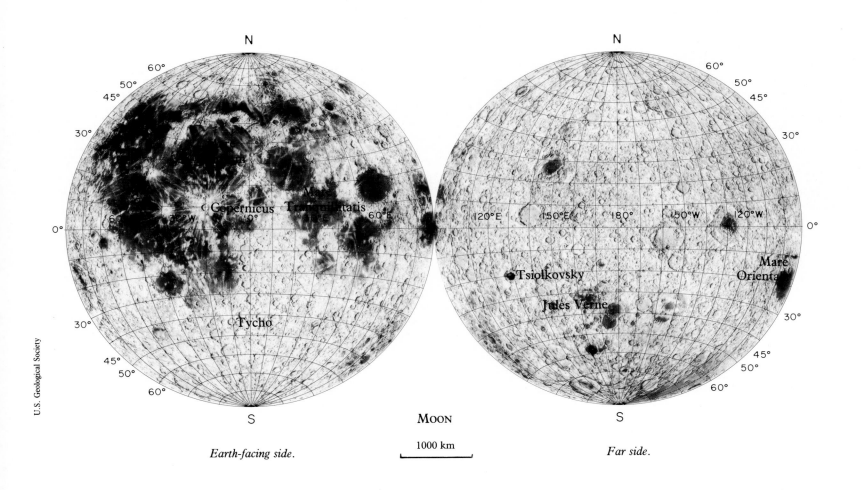

MOON

1000 km

Earth-facing side.

Far side.

EUROPA AN ICY CUE BALL

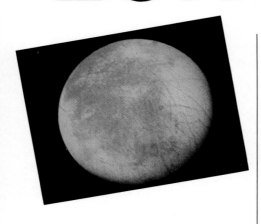

SATELLITE OF JUPITER
Distance from Jupiter: 671,000 km
Revolution: 3.6 days
Diameter: 3,130 km
Composition: ice

With a diameter of 3,130 kilometers, or about 1,946 miles (slightly smaller than our moon), Europa is the fourth-largest of Jupiter's satellites. Even before *Voyagers 1* and *2* sailed by, spectra obtained by Earthbound astronomers showed that Europa's surface is composed mostly of frozen water. These spectra and other observations indicated that Europa's surface is brighter and richer in ice than the surfaces of other satellites, which (in the cases of Ganymede and Callisto) are made of a mixture of ice and rocky soil.

The *Voyager* mission revealed that Europa is the most nearly featureless world known in the solar system. It looks like a mottled, cream-colored cue ball, with only faint markings and virtually no large impact craters. The markings are primarily a set of tan streaks with so little relief that they look as if they had been drawn on Europa with a pale, felt-tipped pen. The streaks are only about 10 percent darker than the surface—enough contrast to be clearly visible but not bold; many *Voyager* images that show the markings as prominent dark streaks have been processed for contrast. Europa's streaks actually resemble the fictitious "canals" that Percival Lowell erroneously drew on Mars. A *Voyager* scientist, seeing the first images of Europa, asked plaintively, "Where is Percival Lowell now that we need him?"

What are the streaks of Europa? Many seem to be broad, shallow valleys, about 5 to 70 kilometers (3 to 43 miles) across and stretching as far as 3,000 kilometers (1,860 miles) in straight or curved paths across Europa's plains. Some of the wider ones have brighter central strips, perhaps flat valley floors. To explain this, *Voyager* scientists studied photos of Europa's terminator—the zone dividing day from night, where even gentle relief can cast long shadows. Even here, most streaks revealed no visible shadows, suggesting that the valleys (if they are valleys) are less than a few hundred meters deep. Among the darker streaks along the terminator, one can see bright ridges about 10 kilometers (6 miles) wide, which rise no more than a few hundred meters above the surface. These low ridges often have scalloped patterns, with each scalloped curve running a hundred kilometers or so along the plains.

The explanation of these features involves both the composition and the history of Europa. Although Europa's *surface* is essentially ice, the mean density of Europa's *interior* is much greater than that of ice—it is about that of silicate rocks, such as volcanic lavas on Earth or the moon. This implies that Europa is mostly a rocky world, with only a layer of ice (perhaps as much as 100 kilometers, or 62 miles thick) covering the surface. The absence of large craters (only three larger than 20 kilometers, or 12 miles across have been mapped) implies that Europa's surface does not date back to the era of intense cratering, 4 to 4.5 billion years ago, when the planets were formed. The icy surface layer was probably created more recently, perhaps less than a billion years ago, according to some estimates.

Like Ganymede and Callisto, Europa probably formed from a mixture of icy and rocky dust in the cold, primordial cloud of debris orbiting around newly formed Jupiter. But Europa received more heat, from two sources. Radiant heat came from nearby proto-Jupiter, and additional heat came from tidal flexing—the mechanism that causes the volcanoes on Io. The heat melted portions of Europa's interior, allowing watery "lava" to erupt and coat the surface. Calculations indicate that under current conditions, tidal heating *may* maintain a melted layer of liquid water under the surface ice—a sort of buried ocean. The

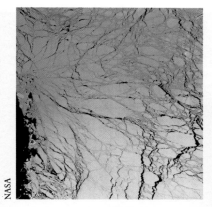

Above: *Sea ice breaking up off the coast of Antarctica may be analogous to the fracturing of Europa's early frozen crust.*

Below: *Veined like a cracked ivory ball, Europa presents the flattest surface known in the solar system. The lines are grooves, or fractures, in the icy crust.*

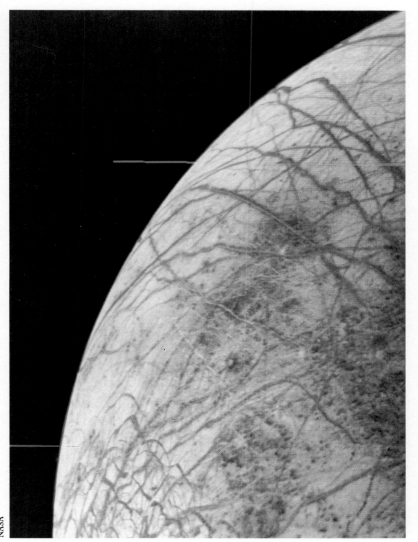

surface may thus be analogous to our Arctic Ocean, with pack ice floating on a water sea. Currents in the sea stressed the ice, causing fractures. Indeed, close-up photos of Europa are strikingly reminiscent of aerial photos of cracked ice sheets in the Arctic. Over the years, eruptions of fresh water through the cracks froze, converting the fracture system into a pattern of shallow valleys and bright ridges. The processes were similar to those that made the fractured zones of neighboring Ganymede. However, there was less heat than on neighboring Io, so volcanic eruptions did not drive off all the water, build volcanic mountains, or create sulfurous lava flows.

Overleaf: *As the sun rises from behind Jupiter, the icy landscape of Europa seems transformed into a wrinkled sheet of copper. The deep atmosphere of the giant planet is backlit by the distant sun, giving it a sunset-red glow. Because Europa keeps the same side toward Jupiter, the giant planet hangs perpetually on the horizon as seen from this spot on Europa, and this sunrise from behind Jupiter is repeated each morning of Europa's 85-hour day/night cycle. Just above Jupiter's arc we can see a segment of Jupiter's dim ring, the remainder lost in the shadow of the planet. Just touching the ring segment on this particular morning is the neighboring satellite Io.*

Far below this quiet icy surface may be a layer of liquid water. Arthur C. Clarke, in his book 2010, speculated that alien life-forms may have evolved in that dark, hidden ocean. In support of this idea of buried life, scientists have recently found microbes flourishing nearly three kilometers (two miles) in sediments below Earth's surface. It is unsettling to think that unknown creatures might exist far beneath our feet as we stand in this barren, alien landscape.

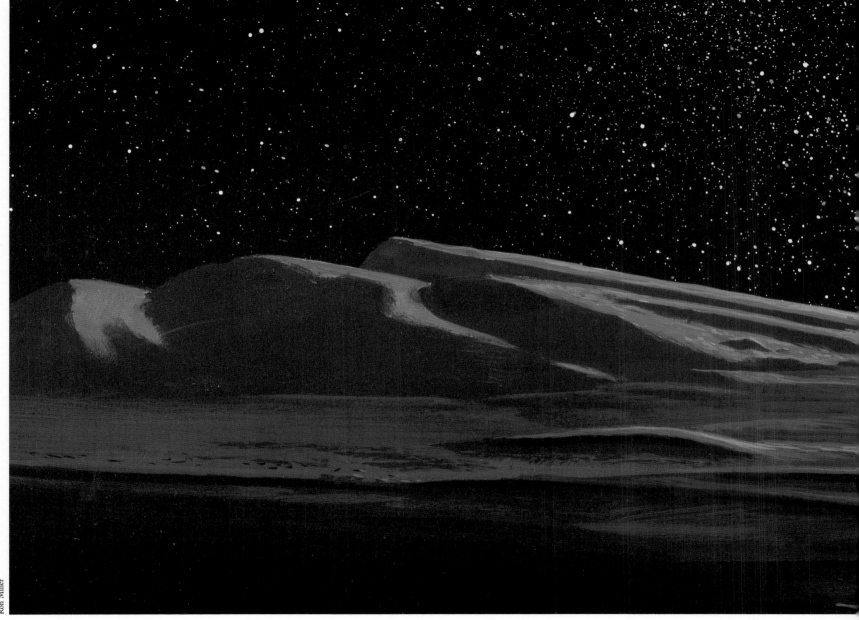

Jupiter seen from Europa

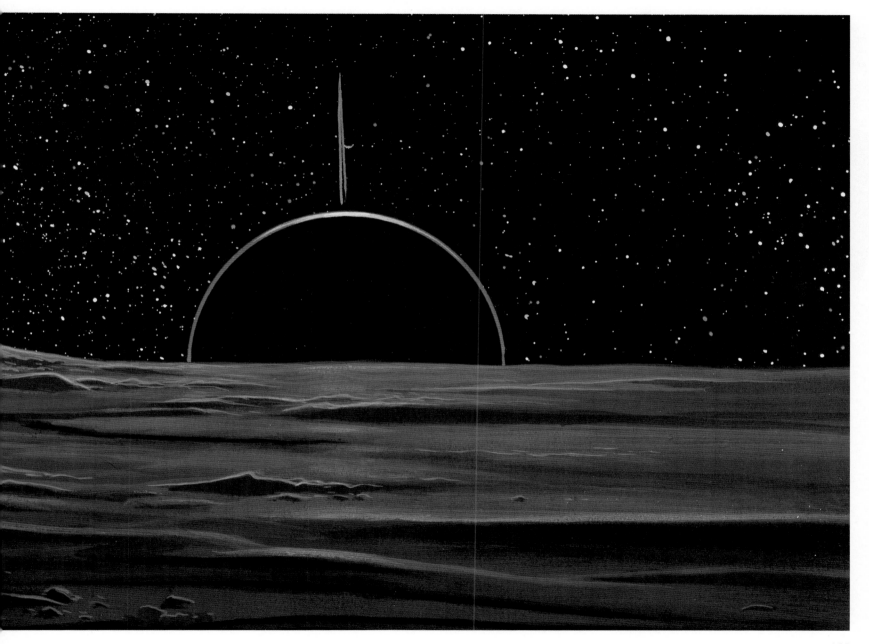

TRITON A WORLD OUT OF PLACE

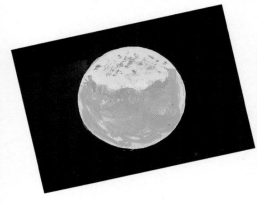

SATELLITE OF NEPTUNE
Distance from Neptune: 355,000 km
Revolution: 5 days 21 hours
Diameter: 2,700 km
Composition: 2-3 rock, 1-3 ices

Neptune's largest moon, Triton, is only a bit smaller than our moon and Jupiter's moon, Europa; but it is as different from each of them as smooth, icy Europa is from our rock-strewn, cratered moon.

Even before *Voyager 2*'s 1989 exploration of the distant Neptune system, Triton was recognized as unusual. But, just as happened with each other satellite system, planetary scientists were unprepared for the surprising features that *Voyager* revealed.

The main reason Triton was expected to be unusual stems from its orbit. It is the largest moon of Neptune, and it is the only large satellite with retrograde orbital motion (east to west, or clockwise as seen from above). This means its direction of motion in its orbit is "backwards," compared to all other major satellites. Not only that. Its orbit also has an uncommonly high 23-degree tilt off the plane of the planet's equator (see below). Most major moons move over their planet's equator, with 0-degree tilt of the orbit.

All this suggests that Triton had a different origin from most other major satellites. Many scientists believe it originated as a separate planetary body, outside the Neptune system, and then was captured by Neptune. In support of this, recent work shows that Triton is quite a bit like Pluto in general properties (see Pluto chapter). Probably there were many Pluto-like bodies in the early outer solar system, and one of them approached near enough to Neptune to be captured into an orbit, which, by a 50-50 chance, was in the "backwards" instead of the forward direction.

Such a capture is no easy thing. Triton would have needed to be slowed down, just as it passed Neptune, to go into orbit around the planet instead of sailing on by. Perhaps it was slowed by skimming through Neptune's outer atmosphere, or perhaps it hit one of Neptune's original moons, smashing it and adding debris to Neptune's system of rings and small moons.

Another unusual property of Triton attracted attention in 1979, 10 years before *Voyager 2*'s fly-by. Astronomers announced that spectroscopic observations through telescopes had revealed faint traces of a thin methane atmosphere. Although the atmosphere was barely thick enough to be noticed by an astronaut, it still made Triton only the second satellite (after Titan) known to have a substantial gaseous envelope. Observations indicating possible changes in thin hazes over Triton

added to the sense of anticipation as *Voyager 2* approached in 1989. What would the camera tell us?

Once again, we were in for a surprise. Not only was a thin haze layer visible above the surface; the surface itself had totally unexpected erupting geyser-like vents, emitting columns of dark smoke that rise vertically and shear off in high-altitude winds, making long, horizontal streamers. Instead of an ancient, cratered surface, the *Voyager* pictures revealed a peculiar surface of winding fissures, flat-floored frozen "ice lakes," and knobby-surfaced plains called "cantaloupe terrain," since the texture looked strikingly like the skin of that fruit. The surface seems composed mainly of methane and nitrogen ices, with a seasonal bright winter polar cap of nitrogen frost (frozen nitrogen). In places, the geyser

TRITON

20°

NEPTUNE

vents are accompanied by black streaks, all running the same direction across the surface; these probably mark deposits of dark dust erupted from the geyser and then blown in a fixed direction by prevailing winds.

Voyager confirmed the existence of methane in the atmosphere but showed that the dominant constituent is nitrogen, as on Earth and Titan. Yet the surface pressure is less than one-hundredth of a percent of Earth's, and less than one percent of Mars's.

Voyager 2 also showed that Triton's surface has a daytime temperature of $-235°C$, or $-391°F$, the coldest daytime temperature of any world. (Note that Triton is currently farther from the sun than Pluto, explaining in part why it is colder.)

The absence of impact craters meant that the surface was relatively young, perhaps only a few hundred million years old. If the surface were older, it would have absorbed more asteroid hits, as seen on the heavily cratered surfaces of other moons of Neptune and Uranus.

What energy source could have provided heat to resurface a cold ice world so far from the sun? Triton's unusual history of capture by Neptune may provide the answer. Triton's initial orbit after capture was most likely elliptical. Tidal forces from Neptune would have circularized

this orbit within a few hundred million years. According to calculations in the 1980s by Washington University researcher William McKinnon, Cal Tech dynamicist Peter Goldreich, and others, accompanying forces could have heated Triton as strongly as modern-day Io and kept its interior molten for a billion years. Resulting eruptions would have created a fresh surface.

But does this explain today's smoking vents? If the capture occurred when the planets formed, 4.5 billion years ago, Triton should be cool by now. Did the capture occur more recently? Or does Triton have unknown energy sources? No one knows.

Triton, last of the large worlds to be explored by space probes, gives one more proof of the unexpected fact revealed to humanity in the 1980s: the worlds of the solar system are surprisingly distinct in their personalities.

Below: *The biggest mystery of Triton is the nature of the dark smoke plumes; the most surprising discovery on the Voyager 2 photographs of this cold, remote moon. We may not fully understand them or their energy sources until we peer into the maw of one of the vents, measure the composition of the emerging gases, and make seismic measurements of the surrounding underground structure. In the distance, another plume displays its characteristic form— rising vertically, and shearing off in a horizontal smoke trail due to stratospheric winds in the extremely thin atmosphere.*

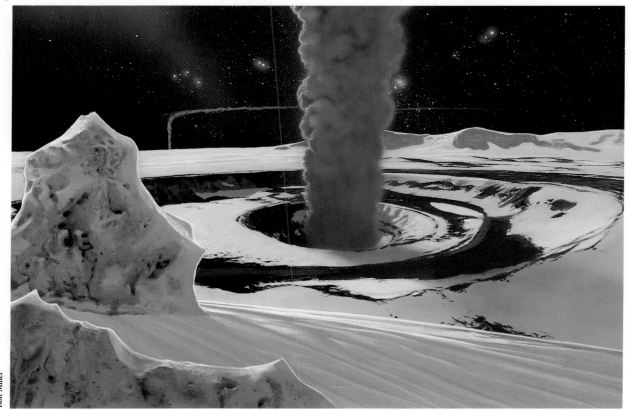

Ron Miller

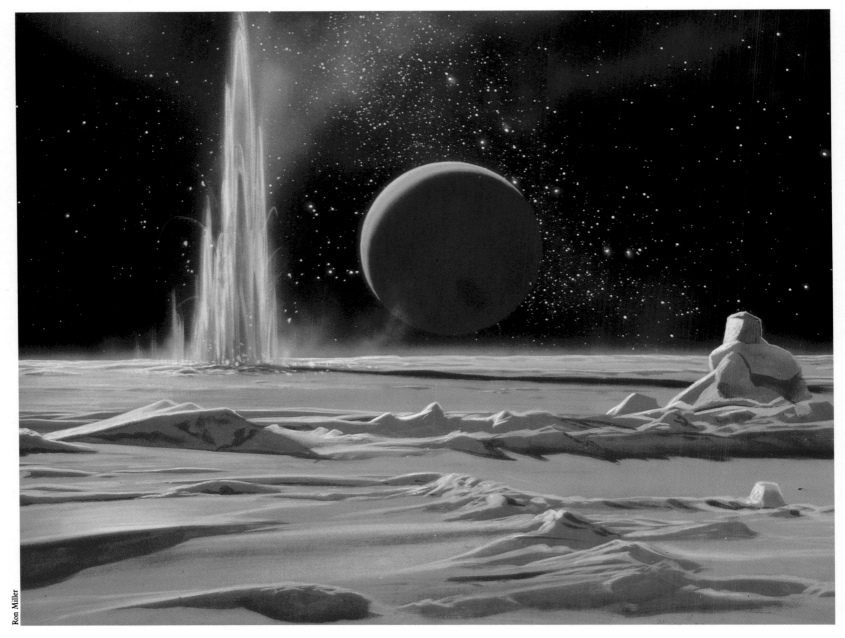

Left: *The icy, barren landscape of Triton is far from the monotonous world that scientists expected before the Voyager mission. Here, we stand in a field of bright frost deposited during Triton's long winter season. At this distance from the sun, sunlight is less than one one-thousandth as bright as on Earth, matching that in a dimly lit room. Neptune looks 16 times as big as the moon looks from Earth.*

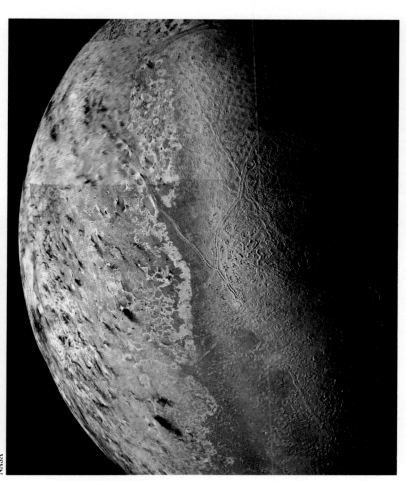

Above: *The "Cantaloupe terrain" of Triton is totally unfamiliar and has not been seen on any other worlds. Mode of formation is unknown, although ridges may mark fractures with squeeze-ups of ice. Lack of accumulated impact craters implies that the surface is geologically young. Smallest details in these Voyager 2 photos are about 2.5 kilometers (1.5 miles) across.*

Above: *Voyager 2 snapped close-up photos of Triton as it passed close by in 1989; a dozen were used to make this mosaic of the alien terrain on this distant, frozen moon. Due to Triton's high axial tilt, the south polar region (left) is facing the sun. It may consist of nitrogen ice that is slowly evaporating due to solar heat. Frost may be condensing on the colder, nightward side, creating the bluish-white deposit along the right portions of the image. Dark parallel streaks (prominent in lower left) are probably deposits from geyser-like vents, oriented by prevailing winds in the extremely thin atmosphere.*

Above: *The forbidding and complexly layered ice hills of Triton include depressed "ice lakes," which can be seen in this Voyager 2 photo. The large, roughly circular feature at the right edge is the clearest example; it is about 250 kilometers (150 miles) across with a smooth floor that lies about 300 meters (900 feet) below its rim. Such "ice lakes" may have formed when liquid flooded low spots and froze into smooth ponds. A rare feature on Triton is the prominent, fresh impact crater about 20 kilometers (12 miles) across (right center), inside the large "ice lake."*

NASA

NASA

NASA

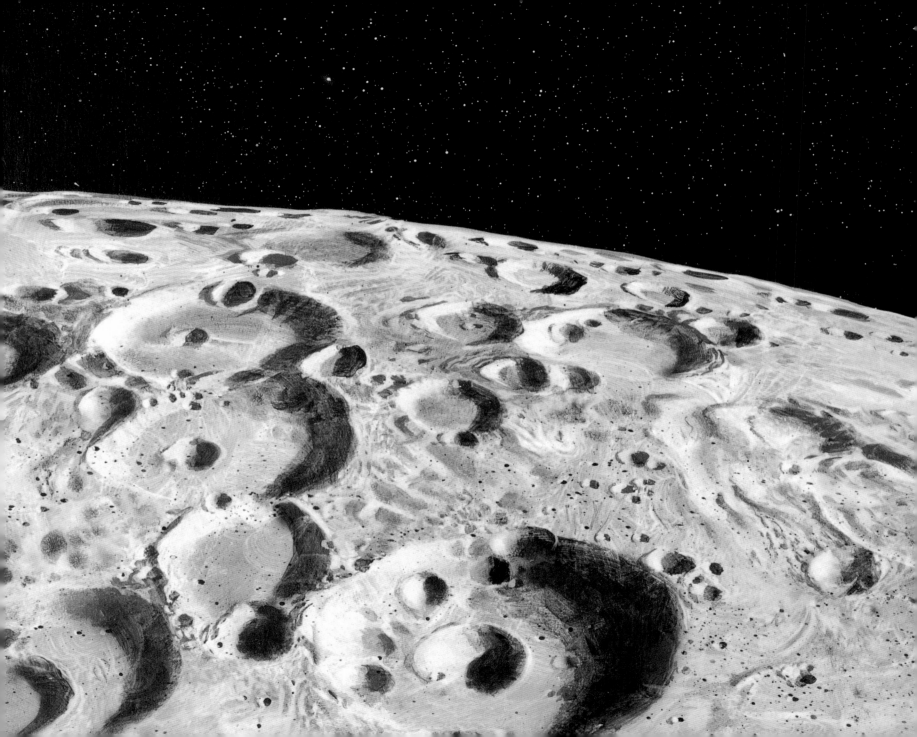

PART 2.
SELECTED SMALLER WORLDS

PLUTO AND CHARON
A DOUBLE WORLD

Ron Miller

Pluto was discovered in 1930 by Clyde Tombaugh, an astronomer at Lowell Observatory in Flagstaff, Arizona. It was immediately hailed as the ninth planet, the only planet to have been discovered in the 20th century—a designation it has maintained in astronomy textbooks until today. However, some interesting properties of Pluto have recently come to light, calling into question whether or not it shares the same mechanisms of origin and evolution as the other planets.

For one thing, Pluto is smaller than any other planet, about the size of our moon. It is only the 16th-largest body in the solar system. Present estimates put it close to 2,300 kilometers (1,430 miles) in diameter, only two-thirds the size of our own moon, and less than two and a half times the size of the largest asteroid, Ceres. At first classified as a planet, Ceres was later downgraded because it was so small, and because it is accompanied by numerous smaller objects in nearby orbits. Pluto may undergo the same fate.

Increasing evidence suggests that Pluto may be only one of many modest-sized bodies on the fringe of the solar system. Many comet nuclei are located in Pluto's realm, but they are typically only a percent the size of Pluto. In 1977, astronomers discovered a larger body—the unusual object Chiron, about 10 percent as big as Pluto—in the region between Uranus and Saturn. In 1992 other astronomers reported a similar-sized body in an uncertain orbit somewhat beyond Pluto. More such discoveries are expected.

Unlike "true planets," Pluto

Above: *A ridge of ice has been extruded like lava from a fissure in Pluto's surface. Tidal stresses associated with the motions of Pluto's moon, Charon, may have fractured the ice, which is now frozen as hard as a rock in the cold of the outermost solar system.*

and Charon have orbits crossing the orbits of other planets. Pluto sometimes comes inside the orbit of Neptune. In fact, Pluto will be closer to the sun than Neptune during the 1990s.

Thus, in terms of its small size, its neighbors, and its orbit, Pluto should perhaps be viewed not as a planet but merely as the largest known example of the interplanetary interlopers of the outermost solar system.

In 1978, an astronomer at the U.S. Naval Observatory discovered that Pluto has a satellite, which they named Charon (pronounced *CARE-on*) after the mythical Pluto's underworld associate.

With a diameter of 1,170 to 1,210 kilometers (725 to 750 miles), the satellite is nearly half Pluto's size. This is unique in the solar system. Our own moon is only a quarter of Earth's size, and all other moons are *much* smaller, only a few percent or less of their "parent" planet's size. Most researchers conclude that Charon is not a homegrown moon, accreted in orbit around Pluto. It may have been captured or, more likely, generated in a giant collision between Pluto and some interplanetary interloper.

Whatever Charon's origin, it makes Pluto a more interesting

Ron Miller

Above: *As pale as a moonlit skull, gray Pluto hangs in the sky of frigid Charon, its giant moon and only companion as it ponderously rolls through the comet-haunted darkness at the edge of the solar system. So close do the two huddle that Pluto appears 17 times the size of a terrestrial full moon.*

place—a true double world. Viewed from afar, Pluto and Charon do a stately dance around each other every 6.4 days—like a ballet couple performing a slow pas de deux.

Viewed from Pluto's surface, Charon offers the largest angular size of any moon seen from its planet. From Pluto, Charon looks about 4 degrees wide, eight times the size of a full moon on Earth.

In this sense, Charon makes up for the lackluster appearance of the sun as seen from Pluto. Averaging some 40 times our distance from the sun, Pluto is so remote that the sun's disk seen from its surface covers less than a minute of arc—so small

that it looks like an intensely bright star or a distant street lamp. Its light is only one fifteen-hundredth the brightness of sunlight on Earth, but is still 250 times brighter than the light of a full moon on Earth. On Pluto, it is easy to believe that the sun is only one more of the many stars in the night sky.

The fact that Pluto has its own satellite might seem to elevate it back toward planetary status, because no interplanetary bodies are *known* to have satellites (although suspicions have been raised in the case of a few asteroids). However, if the satellite is the product of a random collision, the "original" Pluto can still be thought of as merely the largest known interplanetary body.

The mean density of material in the Pluto-Charon system is higher than that of the ice moons of Saturn and Uranus. The figures indicate about 70 percent rock and only 30 percent ice. This is odd, because Pluto-Charon are farther from the sun and might be expected to be icier. Washington University researcher William McKinnon attributes the ice loss to the large collision hypothesized to create Charon. If this collision occurred after Pluto's rocky material

PLUTO AND CHARON

settled to the planet's center, then the explosion blew off mostly the outer icy material. Some was blown clear out of the system, depleting the system of ice.

In this scenario, Charon would have been made mostly of the icy debris, while Pluto would have retained more of the rocky material. This is supported by recent evidence from the Hubble Space Telescope, indicating that Charon has lower density and is more ice-rich than Pluto.

No spacecraft has visited Pluto and Charon, but nature came to astronomers' aid in the 1980s. Due to the changing perspective as Pluto moved around the sun, a series of eclipses began in 1985, in which Charon passed behind Pluto and then in front of Pluto, as seen from Earth. This allowed scientists to measure many of their properties. For example, the length of time it took for Charon to move behind Pluto helped establish Pluto's size. Spectra taken when Charon was hidden from sight allowed scientists to distinguish between Pluto's spectrum and Charon's, thus revealing clues about the surface composition of each individual world.

If both Pluto and Charon have ice surfaces, wouldn't you expect the ices to be the same? Observations from Mauna Kea Observatory in Hawaii, from 1976 to 1992, showed that Pluto is covered mostly with frozen nitrogen ice, mixed with a few percent of frozen methane and carbon monoxide. However, observations of Charon show that the methane component is virtually absent there, while frozen water is seen in its place. Pluto's surface averages 50% times brighter than Charon's and is faintly orange; Charon's surface is more a neutral dark gray.

Why the differences?

The current theory involves the slow loss of gas molecules from the surfaces of each world, due partly to meteorite impacts and partly to normal sublimation of the ice. Suppose Pluto and Charon started with equal components of frozen water and methane. The methane molecules, liberated by impacts or sublimation, are lighter and faster-moving than the water molecules, and thus would escape more quickly from

The Pluto-Charon distance to scale.

Charon's weak gravity than from Pluto. As they fly off into space, some would hit Pluto and accumulate there. In other words, low-gravity Charon is constantly losing its methane, relative to its water and dark soil. Over eons of 'sandblasting' by small meteorites, Charon's surface has been depleted of methane ice, leaving water ice and dark soil behind. Amazingly, Pluto's surface has actually accumulated some of Charon's methane molecules, and is relatively enriched in methane. A cosmic transfer has gone on between these two worlds as they dance around each other.

Pluto's orbit is so elliptical that the ice is warmed much more when Pluto is closest to the sun than when it is farthest away. At maximum heating (which is still incredibly cold by our standards), more ice sublimes and creates a transient atmosphere that may reach an appreciable fraction of the surface pressure of Mar's atmosphere. As on Triton, a major constituent of this atmosphere is nitrogen. But during Pluto's "winter," when

the planet is far from the sun, the gas recondenses into ice and Pluto seems almost as airless as the moon.

A similar cycle would have worked on initially icy Charon, but Charon's gravity is too weak to hold on to the gas in the form of an atmosphere. As described above, Charon's gas molecules leaked off into space, and some fraction of them transferred to Pluto.

This process may have ended on Charon, but it continues on Pluto. In this sense, Pluto acts like a giant comet, producing a gas halo at its closest approach to the sun.

The seasonal recondensation

Right: *We are hovering behind the unlit night side of Charon—surely one of the most cheerless places in the solar system. The sun, just outside our field of view, is a virtually heatless point of dazzling light, 1,600 times fainter than when seen from Earth.*

Charon and Pluto swing through space like a pair of ponderous waltzers. Locked face-to-face, neither ever appears to move from its place in each other's sky. Only the stars in the background seem to move, coming full cycle every 6.26 Earth-days. Charon, in proportion to Pluto, is an enormous moon, about half the size of the planet; about 19,000 kilometers (11,800 miles) separate the two.

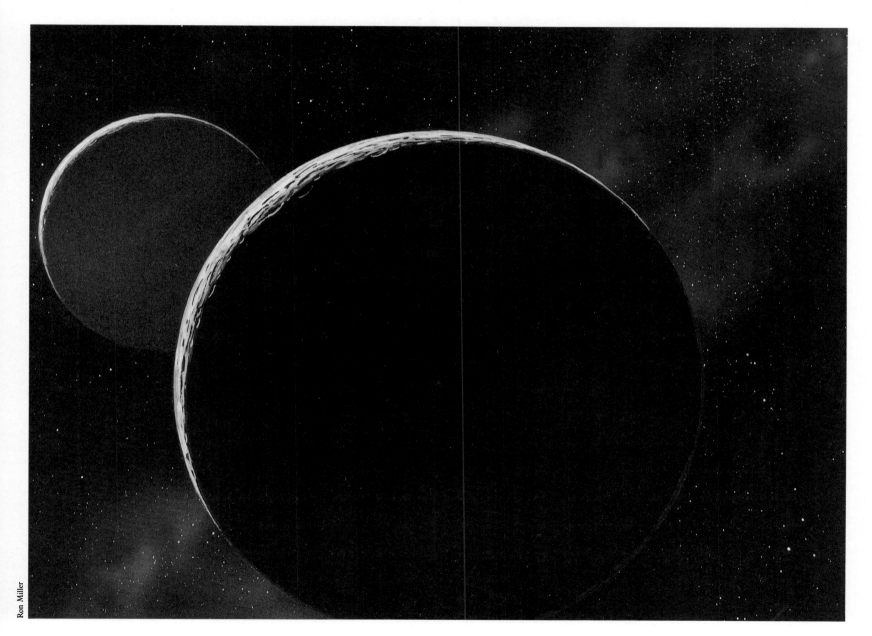

of the atmosphere into fresh frost on the surface may help explain why Pluto is so much brighter than virtually airless Charon.

Intriguingly, Pluto (or the Pluto-Charon system) and Triton may be linked in terms of their origins. Pluto and Triton have similar sizes and densities. They both probably have rocky cores and mantles of frozen water, and surface frosts involving methane, ammonia, carbon dioxide, and water in various proportions. Pluto is classed as a planet, and Triton as a satellite, but both should probably be visualized as unusual interplanetary bodies, Triton having been captured into its present Neptunian orbit.

If you are offended by downgrading Pluto to a comet-like body, remember that it is smaller than our own moon. In fact, it is literally interplanetary, as its orbit crosses Neptune's; it is presently between Neptune and Uranus. In this sense, Pluto is also reminiscent of the still-smaller icy world, Chiron, which orbits between Uranus and Saturn, and which we will discuss later.

Instead of saying that our solar system has nine planets and a number of lesser moons, it seems in the 1990s more realistic to say it has eight planets and a number of icy Pluto-, Triton-, Charon-, and Chiron-class worlds, not to mention the host of still smaller asteroids and comets.

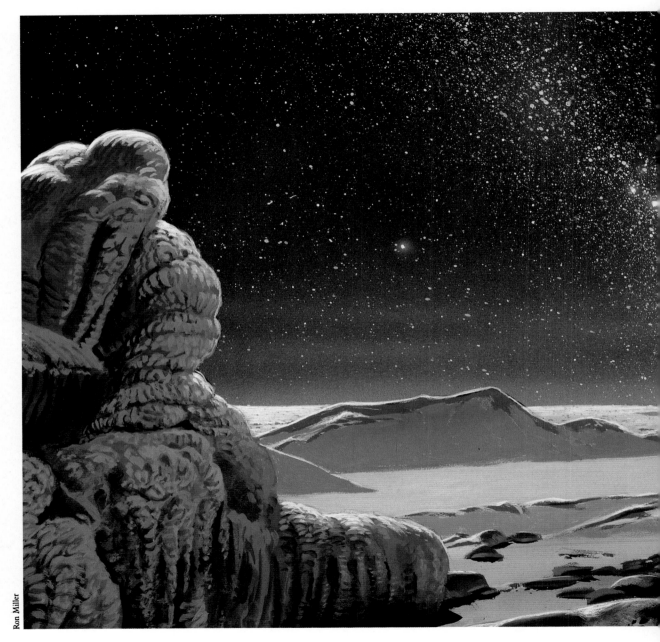

Ron Miller

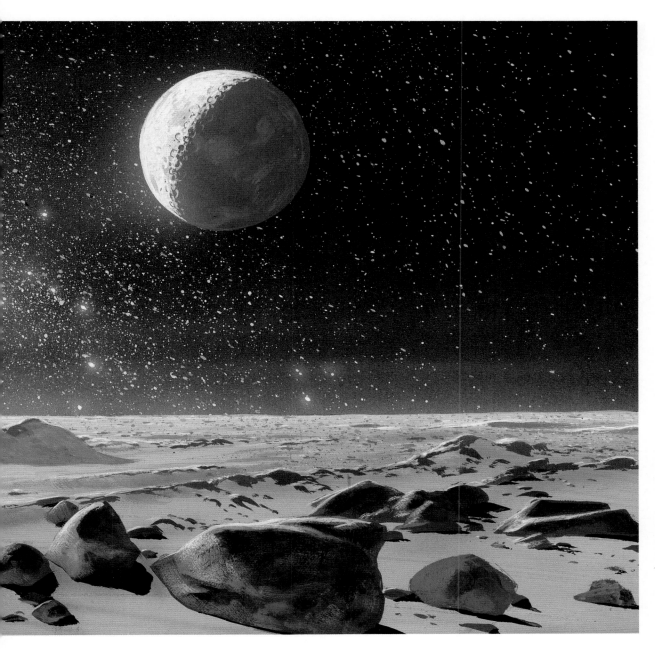

Left: *Pluto is a bleak outpost on the frontier of the solar system. For much of its 248-year circuit of the sun, its atmosphere lies frozen on the ground, as hard and brittle as steel or glass. From here the sun is little more than an intensely bright point of light, providing as little warmth as the full moon does back on Earth. Only during a brief "summer" does the tiny planet come close enough to the sun for it to vaporize some of the ice on its surface, creating a temporary atmosphere of thin, frigid nitrogen and methane gas.*

TITANIA AND OBERON
LARGEST MOONS OF URANUS

Titania and Oberon are the largest of Uranus's moons and the outermost two of the system, which includes 5 large moons discovered from Earth and 10 more small ones discovered by *Voyager 2*.

The diameters of Titania and Oberon are 1,580 and 1,520 kilometers (982 and 945 miles), respectively, compared to 470–1,170 kilometers for the next biggest three moons and a mere 30–150 for the 10 small moons found by *Voyager 2*.

The surfaces of these two moons are moderately bright and heavily cratered. Spectroscopic studies indicate that they are composed of a mixture of water ice and darker soil, probably carbonaceous in character. The geology of these moons is not very distinctive—they resemble some of Saturn's moons. (For once, we encounter worlds that do not seem unique!) Some fractures arc across the side of Titania that was photographed by *Voyager 2* cameras, and some of Oberon's display dark floors, as if they were flooded by dirt-laden melted ice.

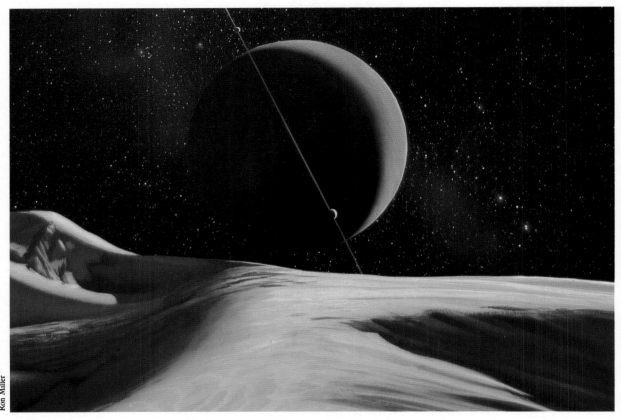

Ron Miller

Above: *A view of the crescent-lit Uranus from the snowfields of its most distant moon, Oberon. This is a "telephoto view," with an angular width of only 16 degrees, comparable to a photo taken with a moderate telephoto lens. Uranus covers 5 degrees in Oberon's sky—about 10 times the size that our moon appears from Earth. Several of the inner moons can be seen in front of the planet and rings.*

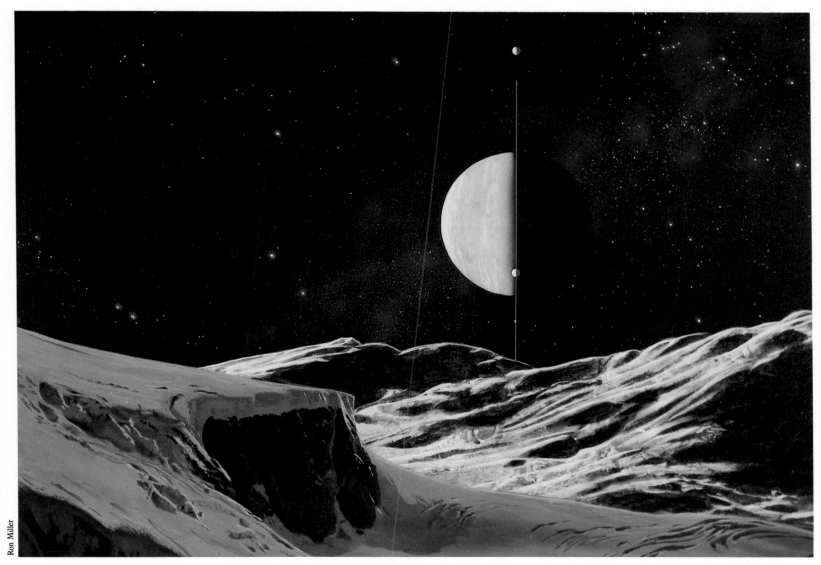

Ron Miller

Above: *A view of half-lit Uranus from icy Titania shows a more normal snapshot field of view. The angular width of this scene is 36 degrees and Uranus covers just under 7 degrees in the sky. Three of the inner moons lie along the plane of the faint rings.*

Uranus's tipped axis creates some unusual phases. Here, we are in the part of Uranus's orbit where the north hemisphere of the planet is in summer sunlight and the south hemisphere is in winter darkness. The terminator, dividing day from night, runs around the equator, in line with the rings.

RHEA
AN ICY MOON OF SATURN

Rhea is a little less than half the size of our own moon—only 1,530 kilometers (950 miles) in diameter. It is in the middle of Saturn's satellite system, one in from Titan. Spectroscopic observations show that is has no atmosphere at all and that its surface is a bright material reflecting 60 percent of the sunlight falling on it—mostly frozen water and a small amount of darker soil. On a scale of inches, this surface, eroded by meteorites' "sandblasting," may look like creamy white, finely crushed ice.

Close-up photos taken by *Voyager 1* reveal a wilderness of craters; Rhea is one of the most crater-crowded of any world in the solar system. It looks as though the bombardment has gone on at random since the formation of the planets 4.5 billion years ago. The surface appears as if it has been hardly disrupted by internally generated geologic activity or tidal heating. It lacks Ganymede's swaths of grooves, Europa's resurfaced ice plains, Io's volcanoes, and Triton's geysers. Nonetheless, there are a few narrow, sinuous fissures and ragged rays of bright white material, like sprays of spilt kitchen flour. Some investigators think these may be frost deposits from water vapor emitted along narrow fractures.

The density of Rhea is low, only 1.3 grams/cm³, compared to densities of 1.0 grams/cm³ for pure ice and around 3 grams/cm³ for rock. The numbers imply that Rhea is a giant snowball! Saturn's moons, generally, have the lowest density of any moons. In this zone of the solar system, the world-building material was mainly ice, not rock. Rhea gives us a good opportunity to learn about the evolution of a fairly large world whose geology is controlled by frozen water instead of familiar lavas and soils.

Below: *One of the most heavily cratered regions on Rhea is visible in this photograph. The smallest features seen are about 2.5 kilometers (1.6 miles) across. Sun glints off fresh ice exposed in the walls of some of the craters.*

Below: *The heavily cratered surface of Rhea. Some of the craters are as large as 75 kilometers (47 miles). Many have sharp rims and appear to be fresh, while others are shallow and degraded and are probably very old.*

NASA

Right: *The remote calm of the icy moons of the outer solar system is shattered on rare occasions by collisions with interplanetary debris. Though rare, such collisions are inescapable as comets and asteroids circulate among the planets. Here, a flash of light illumines the night side of Rhea as a bit of cometary material crashes onto the surface, adding one more crater to the heavily cratered ice world.*

RHEA 500 km

USGS

IZANAGI

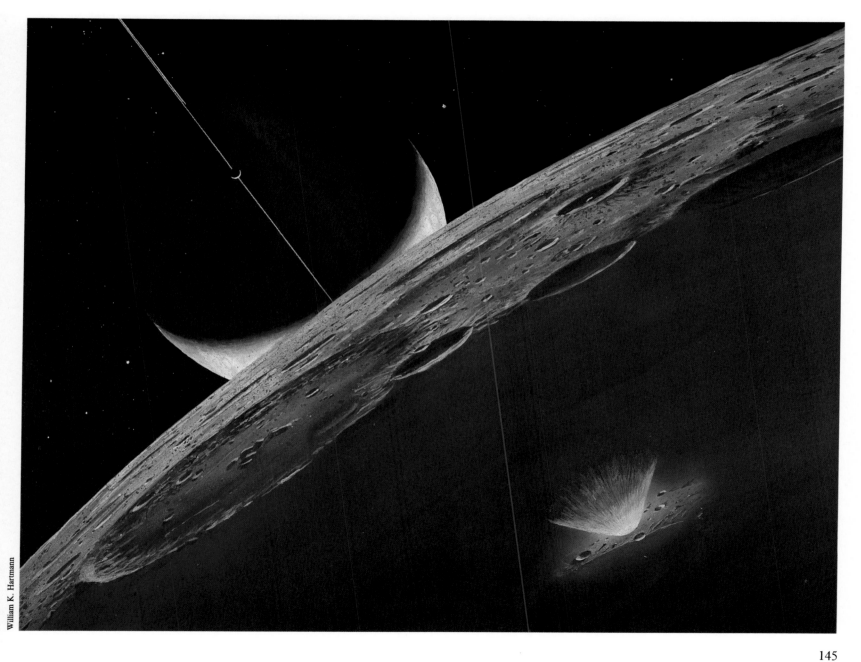

RHEA

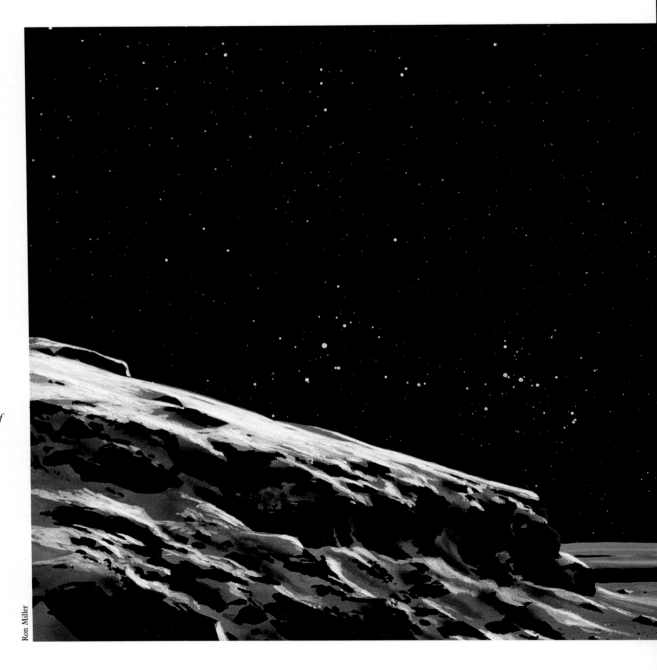

Ron Miller

Right: *Saturn, seen from the surface of Rhea, is a huge globe nearly 26 times the size of a full moon back on Earth. Wreathed in its brilliant rings, Saturn presents an ever-changing display unparalleled anywhere else in the solar system. Like most of its sister moons, some of which can be seen in the plane of the rings, Rhea's surface is made of frozen water. Walking across its crunchy, undulating landscape would be like crossing a glacier on Earth—though this glacier covers the entire world. There are 16 moons circling Saturn. If you lived there, you could choose among 16 different lengths of month, ranging from less than an Earth-day to more than a year.*

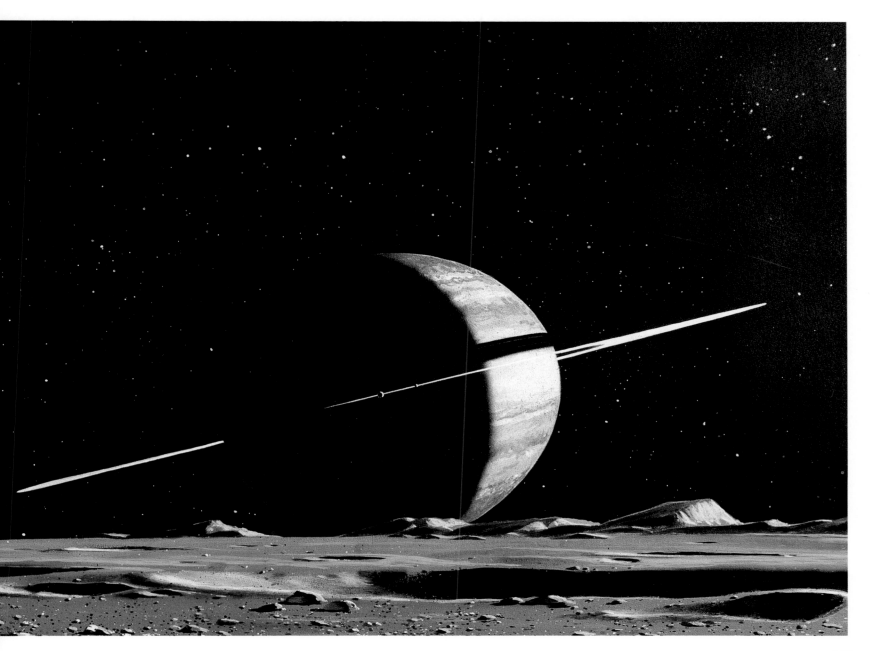

IAPETUS
THE TWO-FACED MOON OF SATURN

NASA

Iapetus (pronounced *eye-AP-i-tus*), an outer satellite of Saturn, has been a puzzle since its discovery in the 1600s. Early telescopic observers were astonished to find that they could see the 1,440-kilometer (870-mile) moon when it was on one side of Saturn, but not when its orbit carried it around to the other side of the planet. Later observations revealed why. Like our own moon, and indeed most satellites, this 1,440-kilometer moon keeps one face toward its parent planet. Iapetus's trailing hemisphere, which faces Earth when it is on one side of Saturn, is as bright as ice and very visible. But the leading hemisphere is only one-fifth as bright—as dark as bare rock. It is simply too dark and faint to have been seen in early telescopes.

Visiting Iapetus is visiting a world divided. One side is surfaced with frozen water, the other with blackish, rocky material. The boundary between the two is ragged but sharply defined, as seen in the photo at right. From either side, Saturn provides a magnificent sight: a pale yellow ball, four times larger than a full moon back on Earth, surrounded by dazzling white rings. With the exception of even more distant Phoebe, Iapetus is the only one of Saturn's moons that allows the visitor to see the rings as a wide band, rather than as a thin white line. This is because Iapetus's orbit is tipped almost 15 degrees, so that it passes well above and below the plane of the rings. Traveling across Iapetus, we see Saturn above a landscape of rolling ice. Then, suddenly, we cross the border into the other hemisphere, and Saturn seems to glow even brighter in contrast with Iapetus's dark, brownish soil.

A possible explanation for this two-faced moon involves dust blown off Phoebe, the next and farthest moon out. Phoebe is dark gray and, alone among Saturn's moons, moves in a retrograde orbit. This means that any debris knocked off it by meteorites circles Saturn in the same clockwise direction. Dust from Phoebe tends to spiral inward and eventually encounter Iapetus. But the encounter is at high speeds because of their opposing directions. Thus, Iapetus gets hit by high-speed dark dust coming at its leading side. This probably coats that hemisphere with dark dust and also vaporizes the ice in the original soil.

One puzzle is that the color of Iapetus's dark soil is browner or more reddish than the neutral black soil of Phoebe. The color may come from chemical reactions between ices and soils, possibly induced by the energy of the impacts, creating reddish organic compounds. Reddish tints also appear in the dark soils of some other moons, asteroids, and comets in the outer solar system. Iapetus offers a good chance to understand the chemical relation of the soils and ices.

Ron Miller

Above: *One whole hemisphere of Iapetus's icy surface is covered with a mysterious dark substance, whose hue may come from carbon-rich organic compounds. Here, we view the sharply defined contact zone between the dark material and the bright ice—perhaps the most peculiarly contrasty landscape in the solar system.*

Iapetus's 79-day orbit, unlike the orbits of most other satellites of Saturn, is inclined to the plane of the rings so that the little moon frequently gets a spectacular look "up" or "down" into the wide-open ring system, as seen here. We are nearly 10 times as far from Saturn as Earth is from the moon, yet still the giant planet's disk takes up nearly as much sky as a full Earth as seen from the moon.

UMBRIEL AND ARIEL
TWO MID-SIZED MOONS OF URANUS

Ariel and Umbriel are the two mid-sized moons of the five Uranian moons that were discovered from Earth. They are heavily cratered and covered with water ice.

Umbriel's claim to uniqueness lies in the fact that it is much darker than the other four large moons. Its surface structures, mainly craters, show no other peculiarities, and so the reason one moon should be darker than its neighbors remains a puzzle.

As is common among satellites, the moons closer to Uranus have suffered heating and geologic disturbance, probably due to the tidal forces mentioned in the case of Io. Tidal heating is most effective for the larger moons closest to the planet. In Ariel's case, it is manifested in large, fractured canyons, curving across the globe among the craters. Ariel's inner sister, Miranda, is even more intensely fractured, as we will see later.

NASA

Left: *One of* Voyager 2's *photos of Ariel shows the cratered landscape cut by broad canyon-like fracture systems. Generally, the moons closer to Uranus are more fractured than the outer moons. This may indicate that the fracturing is associated with heat from tidal forces, which are strongest close to the planet.*

Right: *Uranus and its edge-on rings loom over a heavily cratered portion of Ariel's landscape. Ariel (diameter 1,160 kilometers, or 720 miles) is only a third the size of our moon, and is named for the mischievous imp in Shakespeare's* The Tempest.

Uranus's sunlit hemisphere is in the middle of a twenty-one-year long summer. The other pole is in the midst of a 21-year winter night. The small, inner moon, Miranda, is skewered by the thin line of the ring system.

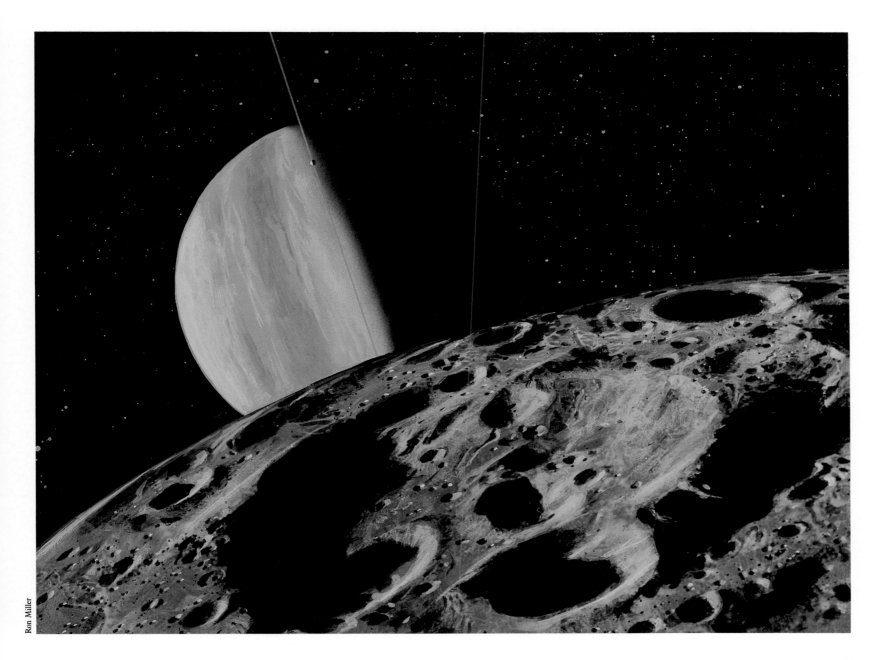

Ron Miller

151

DIONE AND TETHYS
MID-SIZED MOONS OF SATURN

Dione and Tethys, along with their larger sister, Rhea, are perhaps the most "typical" moons of Saturn—if such a diverse system can have typical members. They are bright, covered with water ice, and heavily cratered.

Their only remarkable features are patchy areas of darker tone, and some swaths of bright material that seems draped across the craters, like a thin veil of dust. The darker areas are probably regions of soil concentration, and the bright swaths may be frost deposits, although the cause of the brighter and darker areas is really not understood. Fractures have created a few sizable canyons, but geologically old impact craters dominate the landscape. In sum, these worlds seem less complexly evolved than most others we have considered so far. This is in keeping with our rough rule of thumb, that smaller worlds are less heated and less modified by internally generated geologic forces than larger worlds.

Below: *Large impact craters dominate this view of Dione. The bright radiating pattern may consist of ice deposits along fissures.*

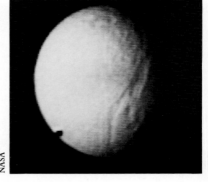

Above: *Tethys is a small moon (1,050 kilometers, or 653 miles, in diameter) orbiting between Dione and Enceladus, about 30,000 kilometers from Saturn. This is a* Voyager *photograph of the side of Tethys that faces Saturn. It is scarred by an enormous trench some 750 kilometers (470 miles) long and 60 kilometers (40 miles) wide.*

Above: *Dione is silhouetted against Saturn's russet clouds. Dione's trailing hemisphere is dark; wispy streaks make it look rather like a star sapphire.*

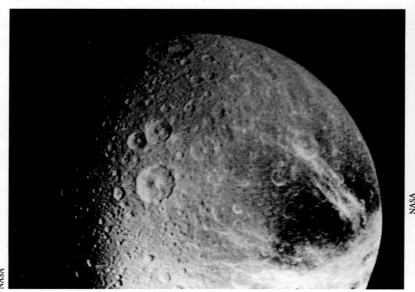

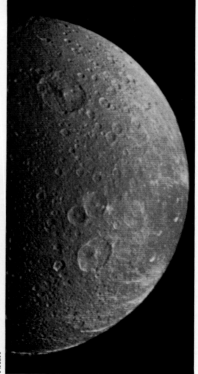

Above: *The largest crater in this* Voyager 1 *photograph of Dione is less than 100 kilometers (62 miles) across. Sinuous valleys are probably faults in the moon's icy crust. North is at the top.*

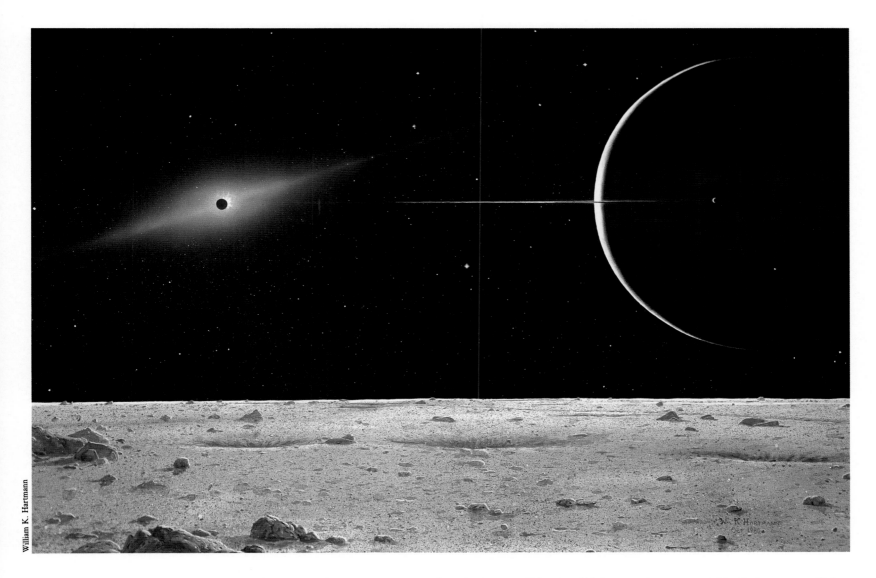

Above: *Twice during Saturn's 29-year trip around the sun, the sun is lined up with Saturn's ring plane and satellites. During this "season," the satellites can eclipse one another. In this view from the north pole of Dione, we see the next inner satellite, Tethys, passing before the sun. The glow around the sun is its corona, along with zodiacal light scattered off meteoritic dust out to the distance of the asteroid belt. Tethys subtends an angle of about two-thirds of a degree. To the right is the crescent Saturn, subtending 18 degrees. With the rings backlit and the solar glare shielded by Tethys, we can dimly see a faint sheet of dust extending beyond the main rings. Enceladus, in crescent phase, is in front of Saturn.*

153

1 CERES
THE LARGEST ASTEROID

Contrary to first impressions, "the world Ceres" is more than a dubious pun. It serves to point out that many planetary objects may not be planets according to traditional definitions, but are still large enough to be called worlds. Even small worlds turn out to have their own personalities. 1 Ceres, at about 914 kilometers (568 miles) across is a good example—almost twice as big as the next biggest asteroid. It has not yet been seen up close, but we already know it has some distinctive features.

Every newly discovered asteroid, if observed well enough to determine its orbit accurately, gets a number and a name. Its proper designation is this number and name together, such as 1 Ceres, but usually only the name is used.

We already know from spectra that asteroids have different compositions. Asteroids in the inner half of the asteroid belt are light-colored and like terrestrial rocks composed of different kinds of silicate minerals and metals. Some melted, due

Ron Miller

Ceres, largest of the asteroids.

154

to unknown processes and resolidified into lava-like rock or pure metal chunks. Others never melted. (Representatives of all these types fall on Earth as stony and iron meteorites.)

From the zone of Ceres outward, away from the sun, asteroids are of a different type, black in color. These are so-called carbonaceous asteroids, colored by soot-like carbon compounds that condensed in the cold temperatures of those regions. Ceres is of this type, and spectra have shown not only the black, carbonaceous material, but also water of hydration. This consists of water molecules trapped in the minerals, which could be driven off easily by heating. (Such water is also found in carbonaceous meteorites that fall on Earth.) It might become a water resource for future astronauts.

Because Ceres is so big, it was the first asteroid to be discovered, in 1801. It is located in the middle of the asteroid belt, among the thousands of asteroids between Mars and Jupiter. The next biggest asteroid (and second to be discovered) was Pallas, at 522 kilometers (324 miles) across. Asteroids formed by aggregation of dust in the same way that the planets aggregated, and at the same time. In fact, Ceres was well on its way to sweeping up the other asteroids and becoming a small planet.

What stopped the process? Jupiter. Jupiter, the next planet beyond the asteroid belt, was so big that its gravity disturbed the motions of the asteroids, making them crash into each other too fast to aggregate. Instead, the collisions shattered most of them. We are left with Ceres at 914 kilometers (568 miles) across, dozens of bodies from 100 to 522 kilometers (62 to 324 miles) across, and tens of thousands of smaller fragments, most too small to catalog. Together, they form the asteroid belt.

Some additional groups of modest-to-small-sized asteroids have been found in other parts of the solar system, from positions near Earth to positions near Jupiter (see later chapters).

Ceres and its neighbors in the asteroid belt provide a tableau of what was happening in the solar system 4.5 billion years ago, as planetesimals littered the spaceways. Although the asteroid belt contains thousands of asteroids, they are small enough and far enough apart so that an observer on Ceres sees a sky similar to our own. Ceres's sky is certainly not filled with moonlike, tumbling worlds—the way science fiction films often depict "asteroid swarms." Every few months, we might notice a bright "star" drifting across the sky from night to night; it would be a neighboring asteroid. And every million years or so, we might get a substantially closer look at an asteroid neighbor.

A landing on Ceres might give us an opportunity to investigate a world that was once on its way to becoming a planet, but was rudely interrupted by Jupiter. It is a fossil relic of the days of planet formation.

Below: The silhouette of our moon (background) compared with the estimated silhouettes of some selected asteroids, including the four largest ones: 1 Ceres, 2 Pallas, 4 Vesta, and 10 Hygiea. Smaller examples are chosen for their interesting shapes or other properties (see later chapters). The double-lobed asteroid 624, the oddest example, is described in a later chapter.

1. MOON
 3476 km
2. 10 HYGIEA
 430 km
3. 15 EUNOMIA
 272 km
4. 4 VESTA
 500 km
5. 1 CERES
 914 km
6. 3 JUNO
 244 km
7. 118 CAMILLA
 237 km
8. 951 GASPRA
 16 km
9. 1989 PB
10. 624 HEKTOR
 150 × 300 km
11. 2 PALLAS
 522 km

ENCELADUS
THE RESURFACED MOON OF SATURN

Considering that Enceladus's neighbor moons, Rhea, Dione, and Tethys, are heavily cratered iceballs, it is all the more surprising that this modest-sized moon shows the most complex structural geology in Saturn's system. At only 500 kilometers (311 miles) in diameter, Enceladus would just nestle between Los Angeles and San Francisco. It might have been expected to have cooled off and been saturated with impact craters long ago, and thus to show no more signs of internal stresses, thermal activity, or volcanic eruptions than an iceberg. Nonetheless, as shown in the accompanying *Voyager 2* photo, in widespread regions of Enceladus the old cratered terrain has been melted smooth or flooded with watery material that has frozen into smooth ice plains. The lack of craters on the plains shows that they are not nearly as ancient as the cratered surfaces; they must have formed in the last half or last quarter of Enceladus's history. Long, straight fracture lines cross these plains, as if they were scribed at random with a giant's pen. Such flooding and fracturing must have required a heat source in recent times.

The source of the heat is uncertain. Probably it involves the same kind of tidal flexing that drives the volcanoes of Io and heated up the inside of Triton. However, calculations of these forces in the Saturn system have indicated that they are barely able to do the job because of the particulars of the satellite orbits. So Enceladus's resurfaced plains confront us with a mystery.

Another odd aspect is that the icy surface is extraordinarily bright, reflecting more than 90 percent of the sunlight that hits it. This is the most reflective ice in the solar system. Is it unusually pure, unsullied by the sooty carbonaceous dirt component that is common in outer solar system ices? Or does it have some unusual crystal-like structure that affects the reflectivity? Answers may come only when humans or machines land on the frozen plains and look at the ice at close range.

The landing might be risky because of a third unusual property of Enceladus. A tenuous ring of tiny particles has been discovered moving around Saturn, along the orbit of Enceladus. It is called the E ring, and the concentration of particles along Enceladus's orbit suggests the particles may have come off the satellite itself. Were they blasted off by a chance meteorite hit? There is a more exciting possibility. The

NASA

Above: *Saturn's modest-sized moon Enceladus surprised scientists with its geological complexity. This* Voyager 2 *photo shows not only ancient, cratered regions, but also much younger, uncratered plains, cut by fractures, grooves, and strange swaths of contorted, ridged terrain. North is at the top.*

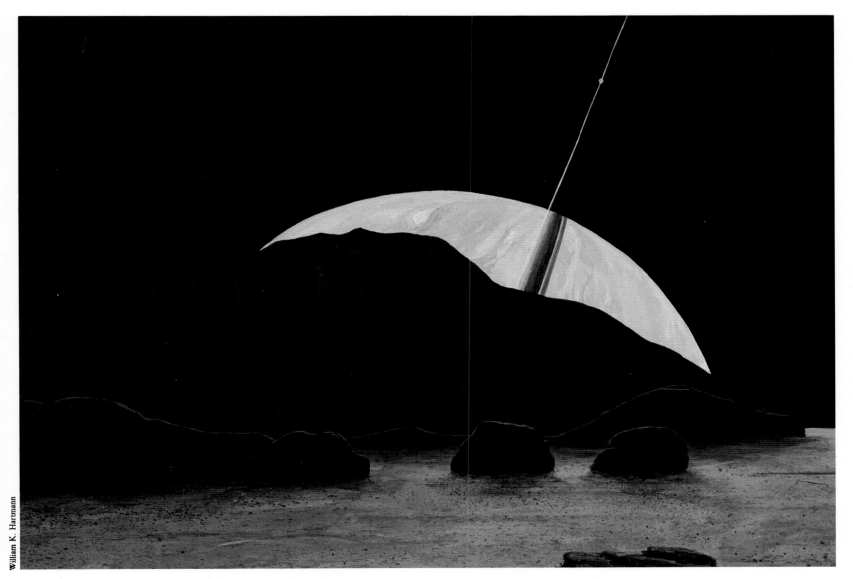

William K. Hartmann

Above: *Enceladus offers more vistas of broad plains than any other Saturn satellite. Here, we are standing on some remnant hills in a region flooded* *by erupted water that has frozen into a bright prairie of ice. The lack of craters shows that this plain is relatively young, geologically speaking. This* *could mean anywhere from a million to several hundred million years old! Majestic Saturn peeks over the hills in the distance.*

youthful, uncratered appearance of some of the plains suggests that parts of the surface may be very young, and that eruptive activity may ocasionally occur. The last *Voyager 2* picture of Enceladus, looking back as the spacecraft receded, shows a faint bright smudge that some researchers think might be an eruption—like one of the plumes on Io. But the data are not good enough to confirm this. Possibly the E-ring particles are blown off Enceladus by occasional volcanic or geyser-like outbursts. In Enceladus's low gravity, debris could easily escape from the moon and go into orbit around Saturn, creating the thin E ring. Thus, future landers may have to approach with caution, on the lookout for debris near the moon—or even for erupting vents. Perhaps some of the smoothest resurfaced plains have been formed in modern times! Among icy moons, once obscure Enceladus may give us our best chance to observe, on a single world, various stages of the cryptic processes that produced the range of icy bodies of the outer solar system, from solid-frozen cratered worlds to geologically active worlds. One day, Enceladus might even display these processes in action on a local scale, as watery eruptions burst forth, flooding craters, undermining cliffs, and reducing cratered uplands to fresh, glistening plains of ice.

Below: Enceladus, a Saturnian moon, has the best view of a flock of neighboring satellites. If we turn away from Saturn and look in the opposite direction, we will occasionally see conjunctions, or groupings, of Saturn's outer satellites. In this view, the sun is behind us. We see the next outer moon, Tethys, subtending an angle of 1.2 degrees, over twice the size of our moon seen from Earth. Beyond Tethys are the moons Dione (upper right) and Rhea (lower left), each about half the apparent size of our moon. In the distance is massive Titan, with its dense atmosphere of ruddy clouds. On the horizon is the rim of an impact crater that has penetrated into subsurface ice and blown-out bright, icy rubble. The visual angle of this "telephoto" view is a narrow 20 degrees.

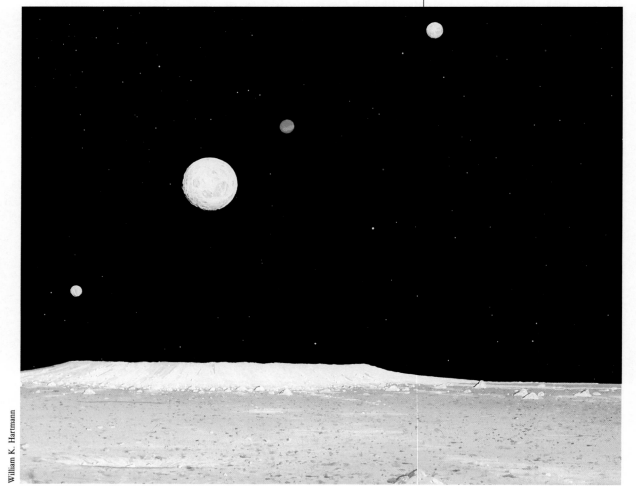

William K. Hartmann

On Enceladus, looking away from Saturn.

Below: *Turning our backs on the satellites, we find Saturn looming behind us—filling the sky in this 20-degree view. We're standing at the brink of a crater in Enceladus's icy surface. The night side of Saturn is dimly illuminated by light reflected from the rings. Since we are in the same plane, the broad, brilliant ring system is reduced to a bright, narrow line.*

The complex shadow of the rings covers the upper quarter of Saturn's crescent.

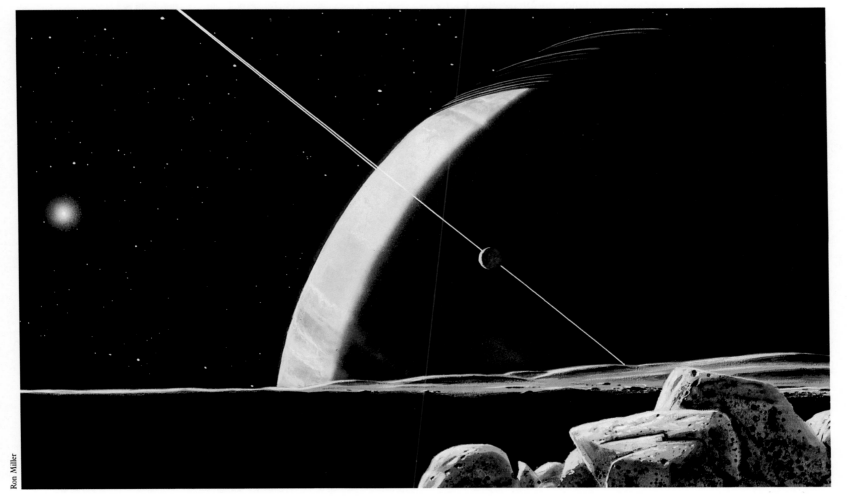

On Enceladus, facing the other way from the preceding picture.

Ron Miller

4 VESTA
A LAVA-COVERED ASTEROID

Figure 1

Figure 2

Figure 3

The most peculiar large asteroid is 4 Vesta, the fourth asteroid to be discovered, first seen in 1807. Telescopic observations of its spectrum indicate that among the 100 or more largest asteroids, Vesta is the only one with a surface of lava-like rock. This produces a puzzle. And to see why it is such a puzzle, let us review ideas of asteroid evolution.

The thousands of asteroids in the asteroid belt display several different types. As noted before, the outer belt contains soot-black carbonaceous types, most of which seem never to have melted. In the inner half of the belt are a variety of silicate-rich types. One is a primitive type that never melted (Figure 1 in the accompanying illustration). Other asteroids did melt, creating different internal zones. Metals, being heaviest, drained to the middle (red in Figure 2). Dense rocks, rich in the greenish silicate mineral olivine, formed a thick, rocky layer around the core, called the mantle (olive in Figure 2). The lightest materials rose toward the surface, and

formed a thin crust resembling basaltic lavas on Earth and the moon.

The heating phase ended long ago, as shown by the 4.5-billion-year-old dates of solidification among most meteorites. After that, asteroids chipped away at each other as they collided, many of them shattering, the basaltic crusts from most others eroding away (Figure 3). In fact, basalt-surfaced asteroids are rare, mostly confined to a handful of small fragments.

But Vesta, the third-largest asteroid at 500 kilometers (311 miles) across, appears covered with basaltic rock. Why? Why didn't the basalt layer get blasted away, as was the case with asteroids? Telescopic data show a rather patchy surface, as if darker lava might be concentrated in some regions. But otherwise, there is nothing unusual about this nearly spherical worldlet to reveal why it should be the only melted one to retain a lava surface.

Was Vesta's lava crust thicker than on other asteroids for some reason, allowing it to survive longer? Or is there something unusual about Vesta's bulk composition that produced this surface? Or is Vesta merely a statistical fluke—surviving the

odds to escape the large collisions that might have blasted away its outer layer?

In any case, Vesta is the only asteroid among the hundred or more largest asteroids that has a lava-like crust, and we may have to wait for serious exploration missions to the asteroid belt before we can learn why it is unique in this regard.

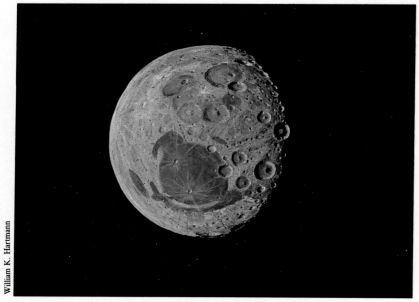

William K. Hartmann

Above: *Observations have shown that asteroid 4 Vesta is relatively spherical but has a surface flooded with lavas. The distribution of lavas may be patchy, since one side shows stronger spectral evidence of lava rocks than the other. This view shows a large region flooded with darker lavas, similar to the lava plains on the moon.*

MIRANDA
URANUS'S REASSEMBLED MOON?

The story of surprising discoveries about Uranus's small moon, Miranda, may sound familiar to readers of this book. When the *Voyager 2* spacecraft got all the way to Uranus, researchers expected that surely at that distance a small moon like Miranda— 470 kilometers (292 miles) across—would be merely another cratered iceball. At the same time, by this point in the mission, they could expect the unexpected! And they were not disappointed. Miranda brought the (now expected) unexpected surprise of the Uranus system. The larger moons of Uranus (Titania, Oberon, Umbriel, and Ariel) turned out to be blandly cratered, with a few fractures, but little Miranda displayed bizarre contorted terrain as strange as any surface in the solar system.

Bits of old cratered terrain are seen, but they are broken by winding swaths of parallel fractures and grooves. Sharply defined segments of crust seem to have been converted from rolling craters to furrowed rock gardens, as if they had been run

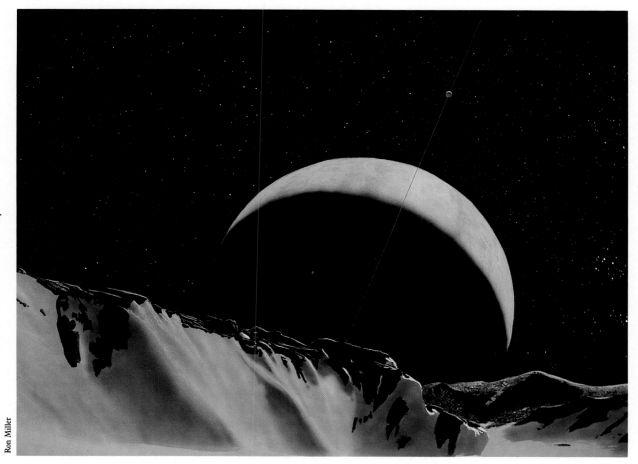

Ron Miller

Above: *Uranus swells like a green balloon above the frigid surface of Miranda. The tiny moon is a sphere of ice and dark, carbon-rich rock, 470 kilometers (292 miles) in diameter.*

We view Uranus from the floor of one of Miranda's faulted, twisting valley systems. Uranus is in midspring, when its phases most resemble those of the other planets. Its rings and equator are nearly at right angles to the plane of the solar system. Its crescent *runs from north pole to south pole. For the next decade, both northern and southern hemispheres will enjoy both light and darkness. Then will come the unusual Uranian season when the sun shines down on one pole.*

MIRANDA

through an egg slicer. Some of these swaths are discolored, being darker or lighter than the background. Parts of the surface have been described as "jumbled" or "chaotic," as if scientists have thrown up their hands at reconstructing the geologic history that produced them.

The single outstanding feature is the most dramatic cliff discovered so far in the solar system. A fractured segment has dropped, apparently as the crust split along two fractures. The drop created a beautiful scarp, running dozens of kilometers across the planet and rising as much as 5 kilometers (15,000 feet) above the valley floor! Many descriptions give the false impression that this cliff rises vertically, but if the photos are properly oriented with the horizon horizontal, the cliff can be seen to be a breathtaking smooth slope, descending at about 45 degrees into the valley below.

The beautiful and puzzling swaths of wavy, contorted, parallel ridges, valleys, and cliffs should remind us of features we've seen before. Similar swaths of fractures and grooves appear on Ganymede and on Enceladus. They suggest different stages of

development of the same process. Apparently, when inner stresses begin to break up the icy crusts of these bodies, one of the first stages is the production of the swaths of parallel ridges. If heating continues, watery material may erupt later and flood the surface, obliterating the ridges with fresh, smooth plains.

What caused the stresses? The closeness of Miranda to Uranus indicates that the tidal flexing mechanism, which we discussed in the cases of Io, Triton, and Enceladus, is probably involved.

However, Miranda has an additional complexity that may also be involved. *Voyager 2* team scientists calculated the cratering rates at different distances from each giant planet. To understand the result, imagine 1,000 asteroids approaching a giant planet from different directions. The planet's gravity attracts them, and they fall toward the planet, ultimately to crash into its atmosphere. The closer to the planet, the more concentrated the asteroids. An outer moon would have only a small chance of being hit by one of them, but an inner moon, near the target planet, would receive a much greater concentration of hits.

Voyager 2 scientists found that this concentration effect is

Above: *The extraordinary sheer cliff of Miranda, rising about 5 kilometers (15,000 feet) above a shadow-shrouded, faulted valley. The photo has been oriented with the horizon flat (out of frame, at top) to show the true slope of the smooth cliff face. Smallest details are about 700 meters (700 yards) across.*

especially strong in the case of Miranda. Miranda receives an estimated 14 times as many hits per square kilometer as the outer moon, Oberon. Amazingly, the calculations revealed that, based on the number of larger craters on Oberon, Miranda has probably been hit by objects large enough to smash it to smithereens!

Then why is it there? The pieces would go into orbit around Uranus and eventually reassemble. According to the calculations, this may have

happened several times! So, some of Miranda's strange structure might relate to its strange history.

Imagine wandering down the twisting canyons, bordered by giant cliffs broken here and there by craggy ice squeeze-ups, with the turquoise globe of Uranus overhead and the distant sun's cold glare hiding tiny Earth. To paraphrase Dorothy, Miranda is a far cry from Kansas.

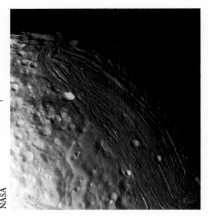

Above: Voyager 2 *photos surprised scientists by revealing intensely contorted, fractured terrain on the small moon, Miranda. Old, heavily cratered terrain (lower left) is broken by swaths of parallel fractures a few kilometers or miles apart (upper right), which are less cratered and therefore must be younger. The exact cause of the fractures is uncertain.*

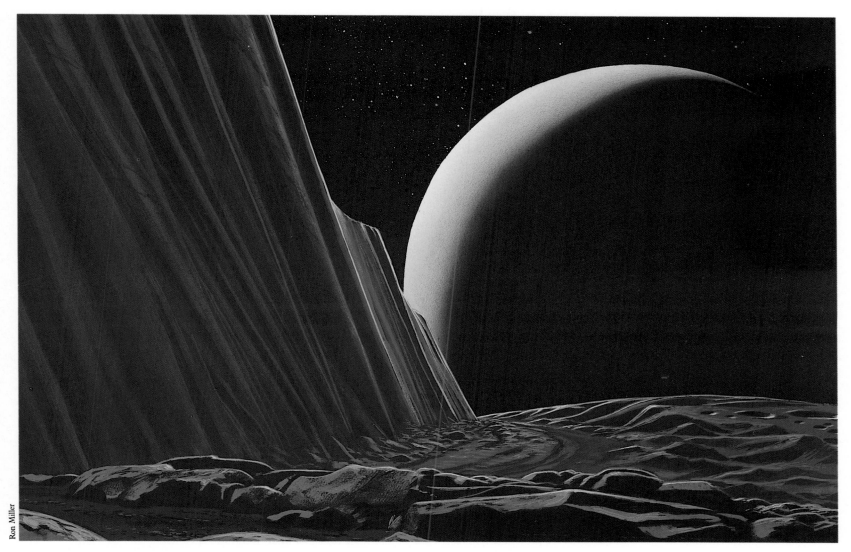

Ron Miller

Above: *Among the tortured fractures, faults, and blocks of Miranda, the most striking features is the Great Wall, an enormous cliff created when a many-mile-wide block of the surface was raised above the surrounding terrain.* Voyager 2 *photos showed a surprisingly smooth cliff-face, sloping at about 50 degrees to the horizontal. Boulders rolling down the slope would take many minutes to reach the bottom, where they would roll onto the valley at speeds of fast trains. Blue-misted Uranus, only 125,000 kilometers (78,000 miles) away, covers an angle 88 times greater than that of the full moon as seen from Earth.*

MIMAS
SATURN'S REASSEMBLED MOON

NASA

Mimas is the innermost of Saturn's large moons, an icy globe 390 kilometers (241 miles) wide. Seen from Earth, it is very faint in the glare of nearby Saturn, and yet it was discovered as early as 1789 by Sir William Herschel.

Before the days of space missions, the mass and density of Mimas were hard to measure. Some researchers thought the density was less than that of ice, and that Mimas might have an unusual porous texture. But the *Voyager 2* flights confirmed that Mimas, like its neighbor satellites, consists mostly of solid ice. Like Rhea, Dione, and Tethys, it is very heavily cratered, and it lacks the resurfaced plains and possible geologic activity of its neighbor Enceladus. Mimas isn't big enough to have generated high internal temperatures or developed dramatic volcanic features. But one of the impact craters is truly striking. Named Herschel, after the early astronomer, it is about one-third the diameter of Mimas itself. It appears to be moderately fresh,

Above: The 130-kilometer (81-mile) crater Herschel makes Mimas look like a giant eye. This feature is more than a quarter of the moon's diameter—one of the largest crater diameter-satellite diameter ratios in the solar system. The impact that made it was almost big enough to blow Mimas apart.

is well-formed, and lies on the leading side of the moon. About 130 kilometers (80 miles) across and 9 kilometers (5.6 miles) deep, it has a broad central peak 4 kilometers (13,000 feet) high. It is similar in form to but slightly larger than the familiar lunar craters Tycho and Copernicus—both of which are about the size of Yellowstone National Park. It is so large in relation to Mimas that it must have severely damaged the satellite when it formed.

This gives us a clue to Mima's history. Like Uranus's moon Miranda, Mimas suffers concentrated bombardment, because it is close to giant Saturn, which attracts impactors with its strong gravity. *Voyager 2* scientists calculated that Mimas gets about 12 times as many hits as the outermost moon of Saturn, and that there is a good chance that Mimas has been blown apart and reassembled. Indeed, such smash-ups of Mimas or other (now destroyed) inner moons may have contributed the debris that forms Saturn's famous rings. Herschel itself was almost big enough to do the job, confirming that such smash-ups are not merely wild speculations of the theorists!

Mimas is of further interest because of its gravitational influence on particles in Saturn's rings—an effect called *resonance*. Mimas goes around Saturn in 22.6 hours. Particles in the *central* part of the rings go around Saturn twice in this time. This means that particles in that particular region of the rings encounter Mimas—and its gravitational pull—every other trip around Saturn. The repeated pull due to gravity (resonance) makes the particles move farther and farther from Saturn; random pulls would not have this effect. This effect clears ring particles out of the region in question, clearing a gap in the ring, called Cassini's Division.

Right: Cliffs nearly 10 kilometers (32,800 feet) high form the ramparts of Mimas's enormous crater Herschel. In the distance is the crater's central mountain peak. The crater, more than a quarter of Mimas's diameter in size, is the site of an ancient impact almost violent enough to shatter the little satellite.

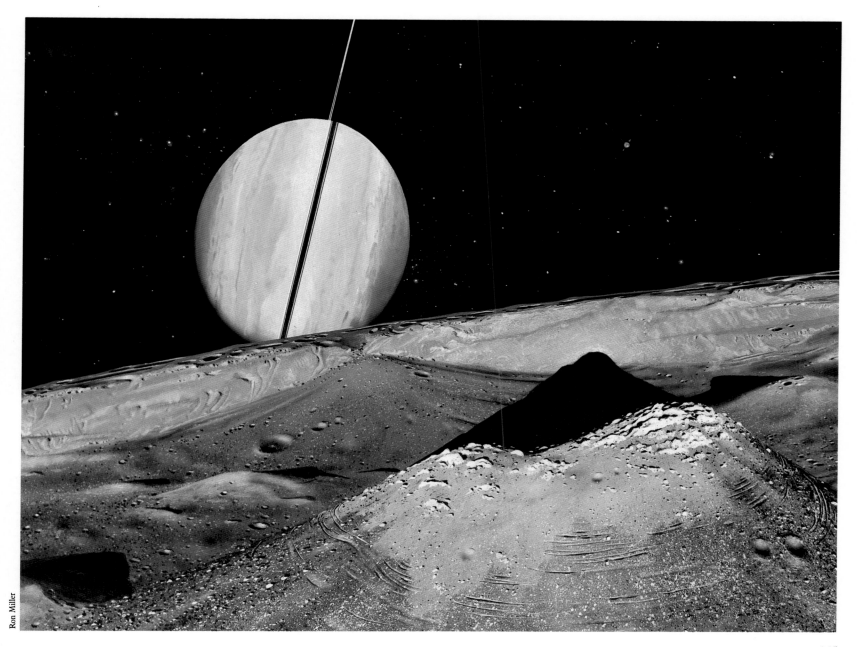

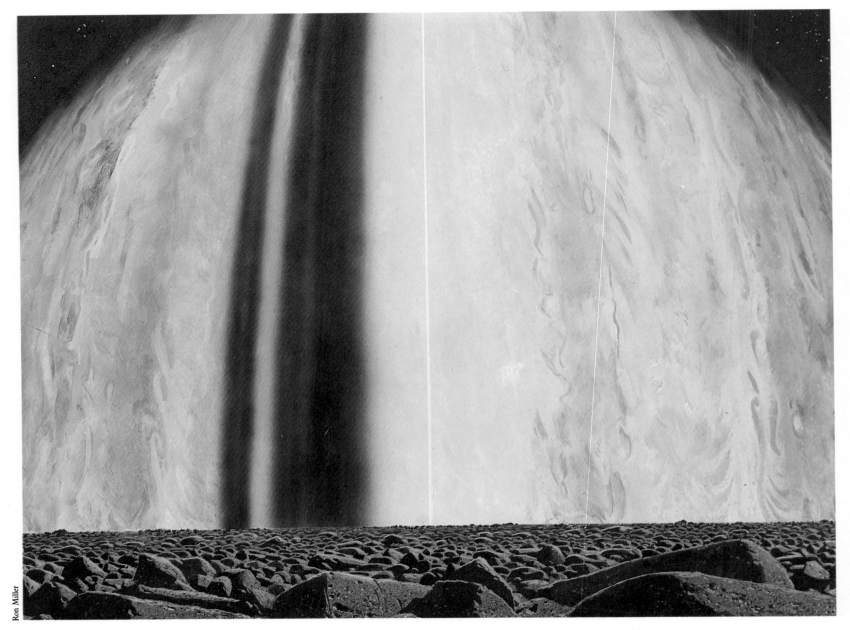

Ron Miller

The view from Mimas.

NEREID
A CAPTURED MOON OF NEPTUNE?

Nereid is the outermost moon of Neptune. This 340-kilometer (210-mile) moon was discovered in 1949 by the Dutch-American astronomer G.P. Kuiper.

Like the outermost moons of Jupiter and Saturn, Nereid may be a captured interplanetary body. The evidence comes not from a retrograde, or backwards, orbit, as in the other cases, but from the extreme elliptical shape of the orbit, and its great distance from Neptune, where a capture would be relatively easy. The elliptical orbit takes Nereid from nearly 10 million kilometers (6,200,000 miles) to only 1.4 million kilometers (868,000 miles) from Neptune.

Not much is known about Nereid. In a sense, this makes it more intriguing than the well-photographed worlds. *Voyager 2* obtained a distant picture, showing the moon only as a fuzzy blob. Spectra show a neutral gray color, about as reflective as our moon. Nereid might have some similarity to the slightly smaller world Chiron which we will come to later.

Ron Miller

Close to Neptune.

William K. Hartmann

Far from Neptune, looking toward the sun.

Left: *Two views of Neptune from a spot above Nereid, Neptune's most distant moon. One view shows the scene when Nereid is at closest approach, 1.4 million kilometers (870,000 miles) from the planet. Neptune would cover 2.1 degrees, looking four times as big as the moon in our own sky. The other view shows the same scene when Nereid is farthest away, a whopping 10 million kilometers (6 million miles), when Neptune subtends only 0.3 degrees, looking only about half as big as our moon (below). Nereid's orbit inclination of 29 degrees allows us to look "up" and "down" into the ring system.*

624 HEKTOR
LARGEST COMPOUND ASTEROID?

Although most asteroids are located in the asteroid belt between Mars and Jupiter, some, ranging in size from small to moderate, orbit the sun in other parts of the solar system. Among the most interesting of these mavericks are two groups that follow the same orbit as Jupiter—one 60 degrees ahead of Jupiter and the other 60 degrees behind. The gravitational forces of both the sun and Jupiter conspire to hold them in place.

Since astronomers named these asteroids after heroes in the Trojan Wars, they have become known as the Trojan asteroids.

The largest Trojan is 624 Hektor, which has an unusual property: when viewed from Earth, it varies in brightness by a factor of three. Such variations are not unprecedented, but in this case some strange conclusions resulted.

When other asteroids vary in brightness (and usually by much smaller amounts), there are generally one or two suggested explanations. First, the asteroid might be elongated, tumbling end over end and presenting first

a broad side and then a small end. This theory has proven correct in some cases. These objects, usually much smaller than Hektor, are probably splinter-shaped fragments, broken off by collisions between larger "parent" asteroids. Second, the asteroid might be round but with one dark and one light hemisphere, much like Saturn's Iapetus.

In the mid-1970s, the author of this book (Hartmann) and astronomer Dale Cruikshank proved that the first theory applies: Hektor is strongly elongated. Since Hektor is the largest Trojan, and its neighbors are no more than half its size and are round, we suggested that Hektor might have formed in an unusual, low-speed collision where two "normal" Trojans stuck together in a "peanut" shape.

Other studies have suggested that, allowing for gravity, tidal stretching, rotation, and weak, fractured material, Hektor would have distorted into a shape like two eggs stuck end to end. We called this a "compound asteroid." Perhaps an initial collision produced a loosely consolidated, fragmented mass, which then deformed into the weird compound configuration.

Below: Asteroid 624 Hektor is 300 kilometers (186 miles) long; it is highly elongated. It may be a double object consisting of two egg-shaped lobes crushed together or just touching.

In these pictures, we see two different views of Hektor, about an hour apart in its rotation. The same craters are seen from different perspectives. The stars of the Big Dipper are in the background.

William K. Hartmann

Alternatively, Hektor may be *binary*, its two halves slightly separated and orbiting around one another. We may not truly understand the secrets of Hektor's strange shape until some man-made vehicle approaches it and takes photographs and samples. Perhaps when we do visit this odd little world, it will turn out to be twin-lobed. We'll be able to hike to the contact region, where a mountain of rock 150 kilometers (93 miles) wide will hang directly over our heads, and *leap* (in a gravity less

than 1 percent that of the moon) across the unearthly valley from one worldlet to another.

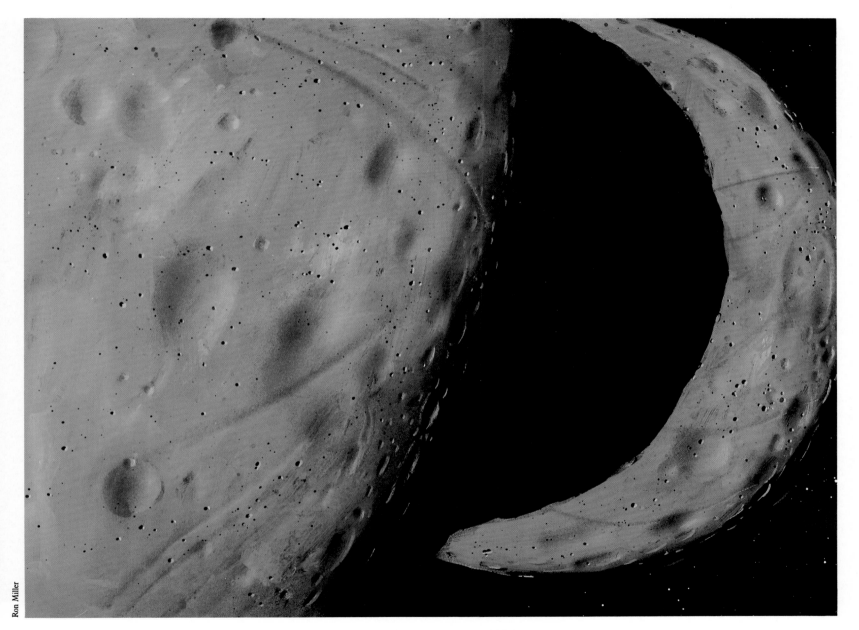

Close approach to Trojan asteroid Hektor.

AMALTHEA
FOOTBALL-SHAPED MOON OF JUPITER

Amalthea is a small moon, much closer to Jupiter than any of the larger Galilean satellites. In shape it is rather like a football, 270 by 170 by 155 kilometers (167 by 105 by 96 miles). Its long axis is lined up toward Jupiter, pulled like a compass needle by the powerful tidal forces, one end always pointing at the planet as it swings in its 12-hour orbit.

Amalthea is red only on the surface. A little digging might reveal a much lighter color. The scarlet coloring of Amalthea may be a layer of sulfur-rich contaminants blown off Io by meteorites and volcanic eruptions. Such volcanic debris would spiral in toward Jupiter, and some would be intercepted by Amalthea.

The rugged, irregular body of Amalthea may be the shattered remnant of an originally larger body, sculpted by meteorite impacts and coated by debris from Io—another uniquely evolved world in the solar system.

NASA

Above: *The images snapped by* Voyager 1 *as it went past Jupiter show Amalthea to be very elongated in shape and reddish in color. The color may be due to a coating of sulfur compounds transferred off the neighboring moon, Io. Bright spots are probably hills. Other images show scattered craters.*

Right: *A baleful dark eye gazes down on the brick-red surface of Amalthea. It is Jupiter's Great Red Spot, outlined in luminous clouds, only 180,000 kilometers (111,000 miles) away. Electrical storms—of hydrogen bomb intensity—flicker over the giant planet's night side.*

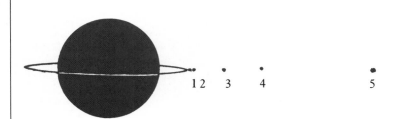

1 2 3 4 5

Above: *Edge-on drawing of the Jupiter system shows the relative sizes of the planet, the main ring system, and the inner satellites, including Amalthea. The sizes of Jupiter, the rings, Io, and the satellite distances are to scale, but* other moons are enlarged in order to show them. Their diameters are in parentheses and the order is as follows: 1, Metis (40 km); 2, Adrastea (24 km); 3, Amalthea (270 × 150 km); 4, Thebe (100 km); 5, Io (3630 km).

Ron Miller

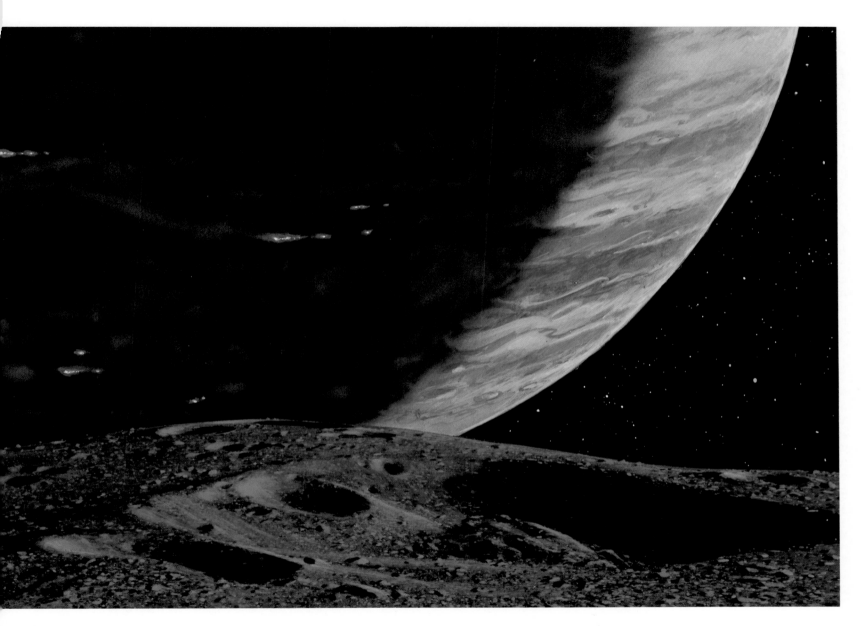

The view from Amalthea.

2060 CHIRON
THE LARGEST KNOWN COMET

Chiron (pronounced *KAI-ron*) is the oddest interplanetary body, and one of the most interesting targets for future exploration, although its distant orbit guarantees a wait of decades before we see it up close. Its story is full of unexpected twists.

Chiron was discovered in 1979 by astronomer Charles T. Kowal. Appearing only as a starlike point on the original photographs, it was cataloged as an asteroid, number 2060. However, "asteroid" 2060 Chiron was immediately recognized as unusual because its orbit, lying between Saturn and Uranus, is much farther from the sun than any other known asteroid.

Observations in following years established a neutral gray color for Chiron but gave slight discrepancies in brightness. This led several astronomers to keep an eye on it.

In February 1988, the author (Hartmann) and Hawaii astronomers Dave Tholen and

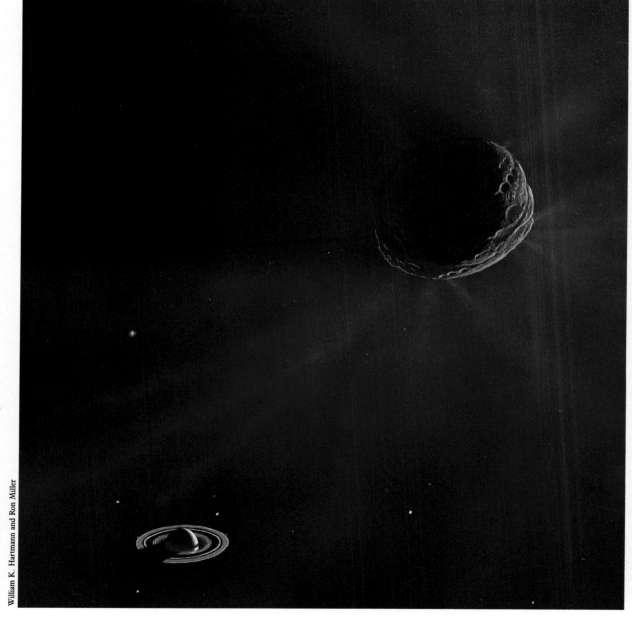

William K. Hartmann and Ron Miller

Left: Chiron is shown as it passes near the planet Saturn. At this point, it would be nearing the closest point to the sun possible in its present orbit. Solar warming maximizes Chiron's cometary activity, and jets of gas and dust are seen blowing off the dark surface. Saturn, in the distance, is backlit by the sun, displaying a pattern of light transmitted through the rings to their shaded side—a pattern never seen from Earth but photographed for the first time by Voyager probes in 1980 and 1981. Several of Saturn's moons, including the bright, orangish Titan, are visible.

Dale Cruikshank were spending several cold nights observing asteroids with a large NASA telescope atop 14,000-foot Mauna Kea, in Hawaii, when we discovered that Chiron was nearly twice as bright as it was supposed to be. We announced this surprising result at once, using the international network of astronomical telegrams. The brightening was confirmed by other observers during the following weeks.

The brightening continued for months, reaching nearly three times the "normal" brightness. What was causing this? We knew that Chiron was slowly moving toward the sun. Based on certain properties of the brightening, we concluded that Chiron contained ices and that as it warmed during its orbital motion toward the sun, some of the ices changed to gas, throwing off a cloud of gas molecules and dust. In other words, Chiron had turned into a comet. The bigger the cloud, the brighter the comet. Sure enough, in April 1989, astronomers Karen Meech and Michael Belton obtained images showing an expanding coma, or cloud of dust, around Chiron.

The unusual asteroid had become a full-fledged comet! Then, over many months, its brightness faded, as if the cometary eruptions had declined.

Various observations indicate that Chiron has a very dark surface of soot-blackened ice, like other comets, and that it must be fairly big to reflect the amount of light that is seen. The observations place the diameter at about 180 to 300 kilometers (110 to 190 miles), with 250 kilometers (160 miles) being a likely value. This turns out to be by far the largest comet known.

Reexamination of old photos suggests that Chiron underwent a similar eruption 10 years before, in 1979, just after it was discovered. Probably, gas is slowly released by the warming ice, and collects in the spaces between ice grains of the surface soil. When the pressure of this gas gets great enough, it may go *poof!* and erupt in a cloud of dust. This could explain the sporadic outbursts.

Because Chiron is larger than other comets, the dust and gas is not blown away immediately in a tail, as on other comets, but is held somewhat by Chiron's gravity. Michael Belton pointed out that the dust forms a long-term dust cloud around Chiron after each eruption.

As soon as Chiron was discovered, dynamicists checked its orbit and found another interesting fact. Its orbit is unstable. Every few thousand years it comes close to Saturn, and within a million years or so it may pass so close that Saturn's gravity will radically change Chiron's orbit. Chiron will eventually be thrown out of the solar system, or it might be thrown into the inner solar system, to pass by Earth as one of the brightest comets of all time.

By the same token, Chiron cannot have been in its present orbit for much of the solar system's 4,500-million-year history. Most comets are moving not in orbits between the planets, but in a swarm surrounding the sun beyond Neptune and Pluto. "New" comets appear when members of this swarm have their orbits disturbed (by a passing star, for example) and drop into the inner solar system, where their ices turn into gas. Chiron may be such a comet, coming partway into the solar system from the cold, remote cometary swarm.

This theory suggests that other Chiron-like bodies may lurk in the outer solar system, waiting to be discovered. Sure enough, in 1992, a second Chiron-like body, named 5145 Pholus, was found in an elongated orbit that stretches from just inside Saturn's orbit to beyond Uranus. Whereas Chiron is neutral gray, this object has the most reddish-brown color yet observed for an asteroid, suggesting an unusual composition. Astronomers have suggested that the colors come from organic compounds, based on spectral analysis. Observations are incomplete at the time of this writing, but it may be more than half as big as Chiron. Whether it displays cometary behavior is not yet known.

Some commentators have suggested Chiron's name should be changed from 2060 Chiron, to reflect its new status as a comet, demonstrating that the distinction between comets and asteroids is more semantic than physical. Asteroids are bodies of rock and dirt; comets simply have more ice. No new name has been accepted, and for now, as discoverer Kowal has said, "Chiron is simply . . . Chiron." In a few years, we may know more about such bodies.

JANUS AND EPIMETHEUS
CO-ORBITAL SATELLITES OF SATURN

Some of the smaller worlds are remarkable not so much for their own properties but because of their relationships to other worlds, either large or small. One of the most curious relationships exists between two of the small, innermost moons of Saturn, named Janus (pronounced *JAY-nus*) and Epimetheus (*ep-ee-MEE-thee-is*). They move in circular orbits around Saturn, at almost exactly the same distance from the planet. To put it another way, they occupy almost the same orbit, just on the fringes of the rings. They are called co-orbital satellites, or sometimes just "co-orbitals."

Janus was first observed from Earth in the 1960s by the intrepid French balloonist/astronomer Audouin Dollfus, and by astronomers in Arizona. Once *Voyagers 1* and *2* reached Saturn, it took some effort to determine which of the many small moonlets near the rings was the original "Janus" that had been spotted years earlier! Measurements suggest the two moons are made of ice, have low

density, and similar size. Janus is about 220 by 160 kilometers (137 by 99 miles) in size, and Epimetheus about 140 by 100 kilometers (87 by 62 miles).

Because they occupy virtually the same orbit, Janus and Epimetheus often come close together, and it is their motions at these times that make them remarkable. There is not much chance of their hitting; a 1989 study indicates that they don't get much closer than 21,000 kilometers (13,000 miles) apart, at which time Janus would look about 0.6 degrees in angular size from Epimetheus—a bit bigger than the apparent size of our moon. The reason they don't get much closer is that they do a fantastic dance around each other and end up exchanging paths!

To understand how this works, consider the two satellites approaching each other. By chance, one or the other will always be slightly closer to Saturn. As clarified by Johannes Kepler in the 1600s, a moon closer to a planet moves faster than one farther away. Thus, the inner moon catches up to the outer one. Imagine that Janus is closer to Saturn and is catching up to Epimetheus. It comes up from below and behind. As they approach each other, their

gravities attract. Janus is pulled upward toward Epimetheus, and Epimetheus is pulled downward toward Janus. Following Kepler's laws, Janus thus slows down (because it is now in a higher orbit), and Epimetheus speeds up. What was a gradual approach of the two bodies, as they moved around Saturn, comes to a standstill! But this is not all. Janus, now rising to a higher orbit, moves into a *slightly* higher orbit than Epimetheus, as Epimetheus drops to a *slightly* lower orbit. In fact, they have essentially exchanged orbits! Janus, now moving slower, drops back out of sight.

In other words, if you were

Right: *As we stand on the night side of Janus, the dark side of Saturn fills much of the sky. The rings of Saturn, seen edge on, are the only features of the scene illuminated by the sun, and they cast a dim light on our icy moonlet. The enormous bulk of Saturn, nearly 160,000 kilometers (99,000 miles) away, blocks the light of stars and the faint star-clouds of the Milky Way. Ring-light, reflected from the rings, faintly illuminates Saturn's cloud bands.*

Ron Miller

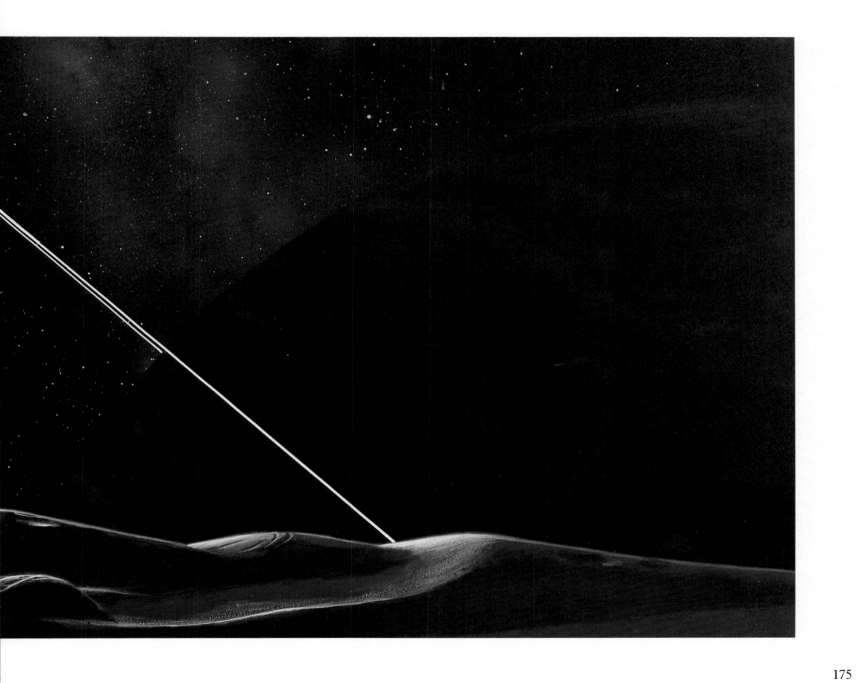

JANUS AND EPIMETHEUS

riding on Epimetheus, you would see Janus approach from below and behind, growing to the size of our moon but lumpy in shape. Then it would begin to drift away again, now in a slightly higher orbit. Conversely, if you were on Janus during this exchange, you would see lumpy Epimetheus approach from in front and above but then slow down, drop below the horizon formed by Saturn, and begin to recede into the distance.

Later, Epimetheus, now in the *lower* orbit, would move up to Janus from behind, and the roles would be exactly reversed. The two would exchange orbits a second time, bringing us back to the starting configuration.

Two independent dynamical studies suggest Janus and Epimetheus have extremely low densities—less than that of ice. They may be more like crushed ice: assemblages of fragments with empty space between the fragments.

Because Janus and Epimetheus are irregular in shape, low in density, and share the same orbit, some researchers think they are crushed fragments of a once-larger icy satellite, like nearby Mimas, that orbited in this vicinity. As described earlier, satellites so close to a giant planet are at risk of being fragmented by asteroids or comets attracted toward the planet. The ancient satellite may have been blasted apart, creating Janus, Epimetheus, and some of the other, smaller nearby moons.

These ideas expand our revolutionary new view of ring/moon systems. Instead of being leftovers from the beginning, they may evolve continuously. The number of moonlets on the outer edge of a ring system, and the brightness of the rings themselves, may depend on the amount of fragments and dust injected into the region by sporadic collisions within the last few hundred million years. This could explain why Saturn's rings are so much brighter than the rings of other giant planets.

Janus and Epimetheus are so close to the main ring system that the outer edges of the rings, as seen in the sky of either moonlet, would stretch about 135 degrees across the sky. Only the widest-angle lens could capture an image of Saturn and its ring system as seen from either Janus or Epimetheus.

NASA

NASA

Above: *A peculiar moment on Epimetheus was photographed by* Voyager 1. *The satellite passed through the straight-line shadow of the outer part of edge-on Saturn's rings. In this pair of photos, separated by 13 minutes, the shadow moves from one edge of the moon to the central part of its daylit side.*

Right: *We are standing on Epimetheus. The sun is eclipsed behind the rings, visible as a sinister dark band, dimly backlit by the sun. The darkest part of the shadow is only about 100 meters (or yards) wide, reflecting the thinness of the rings themselves. The glowing band of the zodiacal light, caused by dust in the inner solar system, extends at an angle on either side of the sun. The eclipse will repeat occasionally during the moon's 16½-hour trip around Saturn, but occurs only during the few weeks every 15 years when the sun aligns with Saturn's ring plane.*

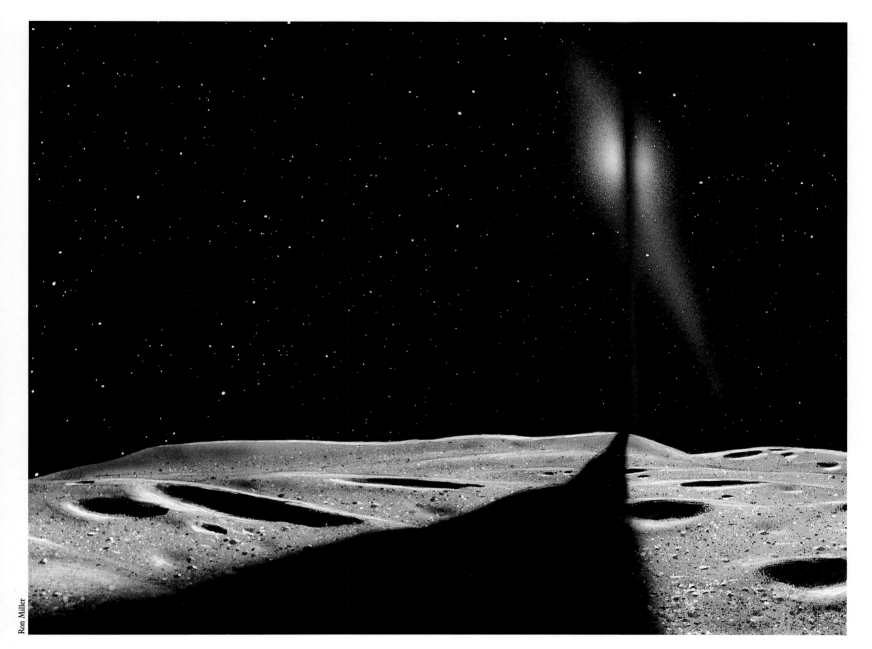

The shadow of Saturn's rings on Epimetheus.

THEBE
UNDER THE VOLCANOES

After *Voyagers 1* and *2* flew through Jupiter's satellite system in 1979, scientists studied the *Voyager* photos carefully and discovered three new moons. Thirteen moons had been previously charted. An image of an apparent 14th moon had been photographed from Earth in 1975 and was carried in books for a while as satellite "J14," but later searchers failed to recover it; it may have been only a temporarily captured comet.

Two of the small moons orbit at the edge of Jupiter's ring, are about 35 to 40 kilometers (21 to 25 miles) across, and may be the sources of some dust in the ring.

But Thebe (pronounced *THEE-bee*) is larger, about 100 kilometers (60 miles) across, and is located farther out from Jupiter, between the orbits of Amalthea and Io. The interesting thing about Thebe is that it is the satellite closest to Io and therefore offers a close look at the changing phenomena of that strange world. When Io is at its nearest approach to Thebe, it covers one degree in that moon's sky, and Io's patchy sulfur lava flows are easily visible. At this point, Thebe is just "under" Io, i.e., closer to Jupiter. When Io is

William K. Hartmann

Left: *Here we are standing on the shadowed floor of a three-kilometer (two-mile) crater on Thebe, looking away from Jupiter. We see the satellite Io passing by. Io is surrounded by the cloud of glowing sodium that stretches along its orbit. The sun is below the horizon, but the far crater rim is dimly lit by light from Jupiter, which is above the horizon behind us. In the farther distance, at the left, are Europa with its bright, icy surface and Callisto with its darker soil. The visual width of this telephoto-like view is 25 degrees.*

a crescent, flashes mark volcanic explosions on its dark side, and sunlight illuminates umbrellas of ash shooting out in clouds along the edge of Io's disk. At other times, Io's surrounding cloud of sodium atoms emits its characteristic yellow glow.

The surface properties of Thebe are uncertain because it was not photographed at close range by *Voyager 1* or *2*. However, Amalthea, the next moon inward from Thebe, has an unusual reddish color attributed to atoms and

molecules of sulfur and sulfur compounds that were blown off Io, spiraled inward, and were plastered on the neighboring inward satellites. Indeed, Thebe ought to be in an even better position to catch debris from Io and may have a similar crust of sulfurous material over the older rocky material from which it was originally formed.

Though it is interesting to speculate about visiting Thebe and the other innermost moons of Jupiter, we must remember one of the special perils of

Jupiter's system. Jupiter's magnetic field, which extends out to the region of its inner satellites, contains many high-energy atomic particles similar to those trapped in Earth's magnetic field in the Van Allen belts. A much higher concentration of them is trapped in Jupiter's belt.

NAIAD
WITHIN NEPTUNE'S RINGS

When *Voyager 2* flew through the Neptune system in 1989, it discovered a bountiful harvest of six previously unknown moons, too small and far away to be seen from Earth. All of the moons are close to Neptune, and some orbit within the system of thin rings and ring arcs. Suitably, names proposed for them came from mythical characters related to Neptune and the sea.

We choose Naiad to discuss here because it is closest to Neptune and offers extraordinary views of the giant bluish planet. In fact, along with three of the other new moons, it is well within Neptune's ring system. Such moons may act as "shepherds" that guide the ring particles into the complex system of thin rings with concentrated ring arcs (see discussion of Neptune). The other three new moons are somewhat outside the rings.

Two of the small new moons were photographed closely enough to show potato-like shapes and craters on their dark surfaces, which reflect only 5 or 6 percent of the incident sunlight. Naiad is believed to have a similar dark surface, and based on its observed brightness, it is believed to be a similar object, about 50 kilometers (31 miles) across.

Naiad takes only 7.2 hours to go around Neptune. Like many moons, it may keep one face toward Neptune, unless it has been set a-wobbling by a recent impact. The possibility of an impact is suggested by a peculiarity. Virtually all satellites close to ring systems have orbits in the same plane as the rings, which is also the equatorial plane of the planet. But Naiad has an orbit inclined about 4.5 degrees to that plane, so that it rises "above" the rings on one side of Neptune, then crosses the ring plane to orbit "below" the rings on the other side. Given enough time, such a moon would be expected to move into the ring plane; thus it is not unlikely that a recent impact may have bumped it into its present inclined orbit.

The view from Naiad would be stunning. Filling 54 degrees of the sky is the pale blue orb of Neptune, its translucent sky color broken here and there by whitish and darker blue clouds and storms, such as the Great Dark Spot. The storms develop and subside, coming and going over the course of years. Looking in the direction away from Neptune, we would see a double thin line crossing the sky—the outer two narrow rings, viewed from within. The best view would come every 3.6 hours, when Naiad climbs farthest "above" and "below" the ring plane. Between these times, as Naiad crosses the ring plane, the rings would merge into a thin, razor-straight line dividing the sky in two.

Below: *Neptune's innermost known moon, Naiad, viewed from a point 200 kilometers (120 miles) outside its orbit. This moon is so close to Neptune that the blue planet fills the background of this view, which has 40 degrees angular width. The Great Dark Spot, the large storm fringed with lighter clouds and lying at about 22 degrees south latitude, dominates this view.*

William K. Hartmann

COMET P/SCHWASSMANN-WACHMANN 1

A COMET WITH INTERMITTENT OUTBURSTS

One of the most intriguing comets in the sky is unknown to the general public but notorious among astronomers. It is Comet P/-Schwassmann-Wachmann 1, discovered by two German observers in 1908. In the official name, the "P/" designates that it is a periodic comet; that is, it orbits close enough to the sun that it repeatedly approaches a closest point to the sun at period intervals. (Many comets come from the most remote part of the solar system, beyond Pluto, dipping into the inner solar system only once and then returning to the depths of nearly interstellar space.) Periodic comets officially carry this "P/" designation before their names, though it is often dropped in informal discussions. The number "1" is given because the observing team of Schwassmann and Wachmann discovered three comets in all.

The reason Schwassmann-Wachmann 1 is so little known to the public is that it is too far away and too faint to be prominent. It moves around

Ron Miller

Left: Comet P/Schwassmann-Wachmann 1 as a "ring-tail snorter." Photos of this comet from Earth, taken soon after an outburst, often show a distinct apostrophe-shaped configuration. Apparently the solid nucleus of the comet is rotating, and the eruption of gas and dust occurs on one side. As the comet rotates, the jet of debris acquires a spiral curve, like the spray from a garden sprinkler. At the closest point to the sun in the near-circular orbit, the comet can pass not too far from Jupiter, which is seen in the distance with its four large moons.

the sun in a near-circular orbit, approximately at the distance of Jupiter, which is much farther than bright comets. The reason for its notoriety is its odd behavior in terms of brightness: usually it is extremely faint (about 18th magnitude on the astronomers' "magnitude" scale of brightness, where larger numbers imply fainter objects and 6th magnitude is the faintest the eye can see), requiring a huge telescope even to detect. But every year or so it suddenly erupts, throwing off a cloud of debris and brightening by as much as 300 times! At that time it can be seen in a modest telescope (being about 12th magnitude).

After it erupts, the cloud of debris dissipates, and the comet fades in a month or so, until the next unpredictable outburst many months later.

In its faint state, the comet somewhat resembles a black asteroid. Studies have placed its diameter at approximately 40 kilometers (25 miles), with some uncertainty. This comet completes one trip around the sun every 15 years.

The cause of the eruptions are the big mystery of Schwassmann-Wachmann 1. They are a

William K. Hartmann

challenging mystery, because they probably hold the key to the entire mechanism of comet activity. This comet is thus a keystone for comet studies; unlike comets that come by Earth only every few decades, it is always there, allowing us to study the start-up and fade-out stages of the repeated outbursts.

What is the recharge mechanism of these eruptions? Whatever theory we concoct,

it must provide a recharge mechanism, so that the outbursts can recur at quasi-periodic intervals. The best guess is that comets have a loose, porous surface layer of blackish debris—the so-called regolith—left behind as ices have sublimed from solid to gaseous phase, and then dissipate. This regolith may have a firm, crusty character, just as dried soil can weld into a firm, crusty dirt layer. As the

comet nucleus moves around the sun, sunlight heats the surface, and this heat eventually warms the ice beneath the surface, turning it to gas. The gas filters upward toward the surface, building up pressure in the pore spaces of the surface regolith. When the pressure is great enough to overcome the weak strength of the regolithic crust, the crust goes *poof!* It breaks open. The gas rushes out,

carrying loose dust particles. Under the weak microgravity of such a small body, the debris is carried clear off the comet and creates a so-called "coma" of floating debris around the comet. This is the brightest stage, as seen from Earth. The gas pressure has now been released, the gas eruption stops, and the virtually weightless debris drifts away in a month or so. Now the crust is depleted of gas pressure, but the cycle starts over again as new gas collects.

One of the most instructive ways to learn about comets would be to "park" a space vehicle on or near Comet P/-Schwassmann-Wachmann 1 and watch as its eruptions break forth, throw off a coma, and eventually die out. Some day in the future, we may hope, there will be money and public support to fund such a project!

PHOBOS AND DEIMOS
MOONLETS OF MARS

Phobos and Deimos are curious, potato-shaped lumps of dark, rocky material. Phobos is 27 by 21 by 19 kilometers in diameter (17 by 13 by 12 miles), and Deimos is a bit over half that size, 15 by 12 by 11 kilometers (9 by 7.4 by 7 miles). Both have nearly black surfaces that reflect only about 4 to 5 percent of the sun's light. They are darker than an asphalt parking lot. In composition, they are believed to resemble the dark, carbonaceous asteroids and carbonaceous meteorites, rich in carbon compounds and chemically bonded water. The Soviet *Phobos 2* probe, in 1989, showed that the surface of Phobos does not contain such water, but it may have been driven off by repeated impacts. If the subsurface layers contain water, it could be an important resource for astronauts studying Mars from orbit. The fact that carbonaceous bodies are native to the outer half of the asteroid belt suggests that Phobos and Deimos did not form in orbit around Mars, but were asteroids captured in a Martian orbit during the closing days of planetary formation.

Phobos is pocked and sculpted by craters. Large chunks of its surface have been blasted away by impacts. The largest crater, Stickney, stretches eight kilometers (five miles) across—one-third the diameter of Phobos itself. It's the result of an impact nearly large enough to have split Phobos in half. Grooves that stretch in parallel pattern around the little moon, and radiate from

Below: Phobos was photographed by Viking 1 from 612 kilometers (380 miles) away. This is the side that permanently faces Mars. The large crater is Stickney. The shadow of Kepler Ridge partially covers Hall Crater. Many grooves are also visible.

Stickney, may be evidence of the fracturing that must have resulted from this world-threatening impact.

Strangely, the grooves are not uniform, but are pocked by little craters with raised rims. Some grooves are essentially chains of craters. The craters don't seem to be simple collapses (which have flat rims) or impact sites (which happen at random). They look like the sites of minor eruptions. Perhaps Phobos once had enough water or ice in its interior to generate gas pressure. The Stickney fractures may have been the sites of eruptions that

blew away puffs of surface dust. Thus, there may have been a period in Phobos's history when it displayed comet-like activity. This might have been in the closing days of planet formation. At that time, Phobos and some other dark asteroids may have been kicked out of their original home in the outer asteroid belt by certain dynamical effects of Jupiter's gravity and probably first came into the inner solar system, soon to be captured by Mars. In any case, Phobos and Deimos will give future explorers of Mars an incredible "free bonus"—a chance on the way to

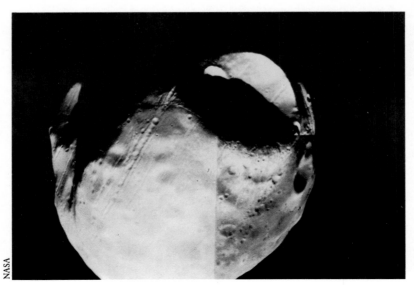

NASA

Right: Less than 6,000 kilometers (3,720 miles) away, Mars looms in the sky of Phobos, its nearer moon. We're standing in one of many shallow grooves that scar Phobos's surface. Mars's terminator, the dividing line between night and day, is sweeping from east to west, unveiling the giant canyon Valles Marineris and bisecting Pavonis Mons, an enormous volcano. Early morning clouds streak and mottle the dawn line as Mars is viewed from Venus.

The visitor must be very careful on this tiny moon. Its gravity has a tenuous hold on things. A hard leap could leave you literally hanging for several minutes, and a good swing with a bat could put a baseball into orbit.

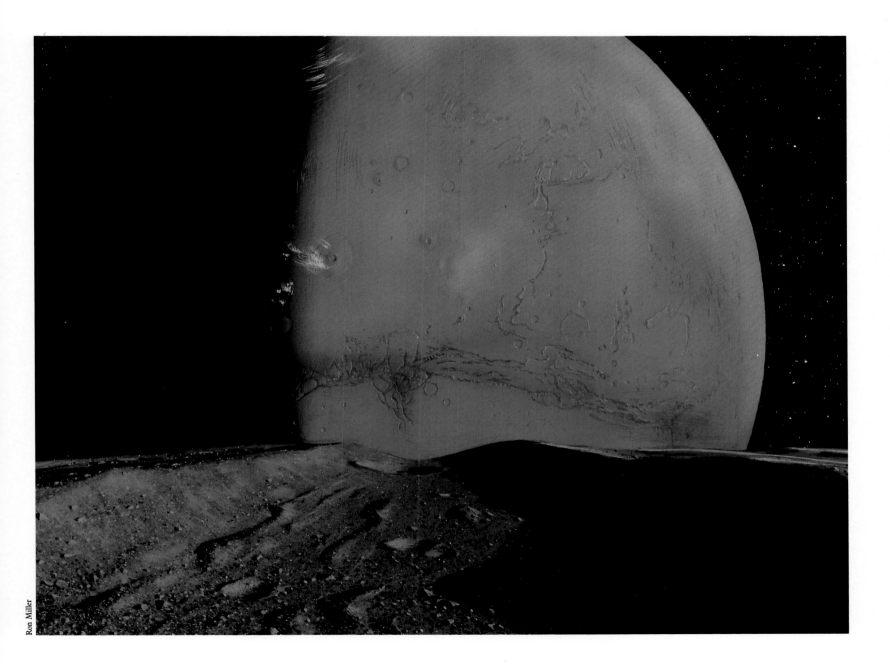

PHOBOS AND DEIMOS

Mars to learn about the history of asteroid-like bodies that originated much farther from Earth—and may hold clues to comet histories as well.

Although Phobos and Deimos seem to be made of the same sort of dark rock, their surface structures seem strangely different. Phobos has a lumpy shape, very large craters, and some small, sharp craters. Deimos is more muted, shaped somewhat like a potato, and its craters have lower rounded rims. It lacks crater chains. In the rolling tracts between its craters are scattered, house-sized boulders.

Why should two neighboring satellites, with nearly identical compositions and virtually no internally caused geologic activity, have such different-looking surfaces? One reason may be that debris knocked off the moons by meteorite impacts goes into orbit around Mars and ends up hitting each satellite again in 100 to 10,000 years. The reaccumulation rates and speeds are somewhat different for each moon and might explain their dissimilar surfaces.

Alternatively, one satellite may have been hit more recently, allowing less time to build up a smooth, powdery surface by means of micrometeorite sandblasting.

If you pick up a rock, hold it at eye level, and let it fall on Deimos, it won't plummet to the surface as it would on Earth. It also won't hang in front of you, as it would on board a free-floating spacecraft. In Deimos's weak gravity, it will settle slowly toward your feet, as though it were being lowered on an invisible thread. Some 30 seconds after you let it fall, it will reach the ground— 50 times longer than it would take back home.

Right: *The bland, micrometeorite-eroded surface of Deimos, photographed from 50 kilometers (31 miles) away by Viking 2. The smallest features visible are about 8 meters across.*

NASA

Below: *Dramatic color photo of Phobos hanging in front of the ruddy disk of Mars as taken by the Soviet* Phobos 2 *spacecraft, which rendezvoused with the satellite in 1989. The photo shows the startling color difference between the black carbonaceous material of Phobos and the red-rusted surface soils of the planet.*

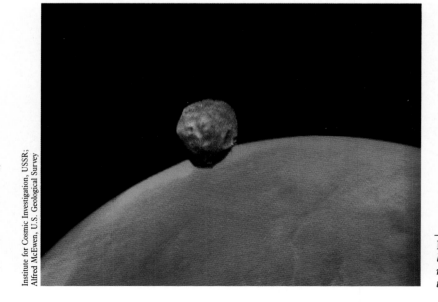

Institute for Cosmic Investigation, USSR; Alfred McEwen, U.S. Geological Survey

Right: *A landscape on Deimos, here lit by the glow of the red planet, may resemble that on Phobos, except that the planet is farther away.*

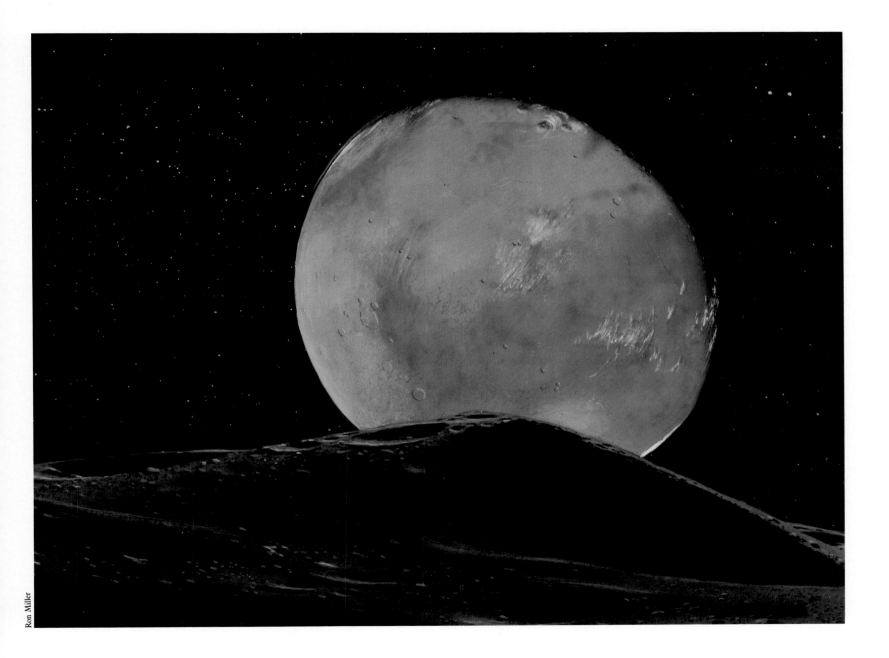

Ron Miller

951 GASPRA
FIRST ASTEROID STUDIED AT CLOSE RANGE

Throughout the 1970s and '80s, scientists speculated that asteroids must look something like Phobos, Deimos, and the plethora of small moons photographed in the outer solar system. Calculations had showed that most asteroids are broken-off fragments of larger "parent asteroids" that collided and broke apart. Thus, scientists expected asteroids to be lumpy, cratered bodies.

But no scientist had ever seen an asteroid close up until November 1991, when the accompanying picture was returned from the *Galileo* space-craft, which flew close to (16,000 kilometers, or 10,000 miles away!) 951 Gaspra, a hitherto obscure asteroid located in the asteroid belt. *Galileo* was on its way to Jupiter, and Gaspra happened to be positioned so that *Galileo*'s path could be chosen to make an encounter.

Knowing that *Galileo* would obtain close-up data, astronomers interested in asteroids focused on tiny Gaspra long before the encounter. For example, Hawaii graduate student Jeff Goldader,

working with several other observers and the author (Hartmann), obtained spectra and other data from Mauna Kea Observatory in Hawaii. In these spectra, we could see telltale features of minerals such as olivine and pyroxene, suggesting that Gaspra is an object that once melted—it may be a fragment of the mantle of a once-larger asteroid (see chapter on asteroid 4 Vesta). The brightness measurements and celestial positions measured by us, and other observers, showed that Gaspra rotates in 7.0 hours, which helped *Galileo* engineers target the spacecraft close enough to obtain the picture shown here.

The challenges of spacecraft missions are vividly evident by the story of this picture. *Galileo*'s main antenna, folded for launch, had failed to open properly. Thus, when *Galileo* flew by Gaspra on October 29, 1991, its antenna was stuck in a partially closed position. The spacecraft took many pictures and other data, but each picture, which should have taken only minutes to send back by radio, would take days because of the weak signal with the antenna partially closed. The plan, therefore, was to wait a year until *Galileo*'s

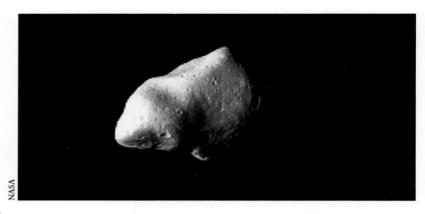

circuitous path brought it closer to Earth, and then to "read out" the pictures and other data at that time. The encounter went so well, though, that scientists could not wait. Permission was received to tie up powerful radio telescopes for several days, in order to send at least one picture back. *Galileo* team members were overjoyed when Gaspra's pocked visage appeared on their screens.

The photo gives dimensions of 20 by 12 by 11 kilometers (12 by 7.5 by 7 miles) for the lighted portion, agreeing well with the ground-based data. The photo also indicates that Gaspra has fewer craters than the 4-billion-year-old surfaces of many bodies. This was quickly explained by calculations showing that a Gaspra-sized object could not survive in the asteroid belt for more than some hundreds of millions of years without being smashed during a collision. In other words, as

Above: *The first close-up photo of an asteroid: the* Galileo *spacecraft's image of 951 Gaspra. The sketch below shows the direction of rotation, estimated from additional observations.*

Sunlight

Rotation Axis

we look at this asteroid, we are probably seeing a worldlet that was broken off a larger parent by a collision sometime in the last 10 percent of the history of the solar system—a relatively new worldlet, which may have been created when trilobites swam in Earth's seas, or when the first amphibians crawled out onto our land. Thousands more larger asteroids wait to be explored, each with its own story to tell about the history of the solar system.

HALLEY'S COMET
THE MOST FAMOUS OF THEM ALL

Although we have described two comets so far (the erupting "asteroid" 2060 Chiron and Comet P/Schwassmann-Wachmann 1), Halley's Comet is the first one in this book that is widely known and fits the popular image of a comet.

Physically, the other two are much larger bodies, but they stay so far out in the outer solar system that they are too faint to see except in the largest telescopes. Halley's Comet, or Comet P/Halley as it is technically known, travels in a more typical comet orbit; i.e., it travels from the outermost solar system into the inner solar system, crossing Earth's orbit, looping around the sun at about Venus's distance, and then returning to the outer solar system's depths. This trip takes about 76 years.

When the comet comes within the orbit of Jupiter, a glorious thing happens. The sunlight heats it, and its ice sublimes furiously into gas, creating a bright, glowing "coma" of gas and dust, and a long, streaming tail.

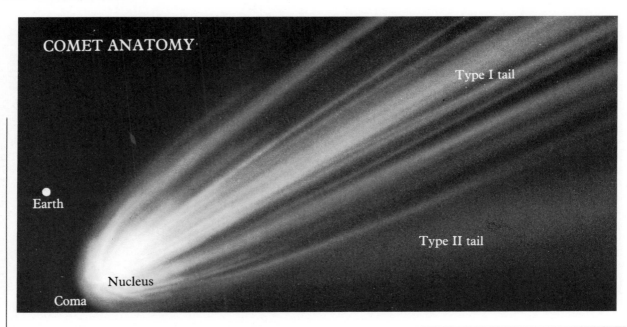

COMET ANATOMY

Type I tail

Type II tail

Earth

Nucleus

Coma

The tail, a comet's most famous structure, is created by an effect of the sun. Hydrogen gas streaming away from the sun, plus certain effects of sunlight itself, carries gas and dust from the coma in a direction away from the sun. Thus, contrary to appearances, the tail does not necessarily stream out behind the comet in its orbital motion. In fact, when the comet is returning to the outer solar system, the tail actually extends to the front, like the long hair of a girl riding a bike in a strong tailwind. Remote cometary bodies like Schwassmann-Wachmann 1 and

Chiron do not develop long, spectacular tails because they are too far from the sun. Their outbursts produce only a coma and, at best, a short, faint tail.

In short, bright comets such as Halley's consist of three parts, shown in the accompanying sketch: the tiny, solid nucleus (usually 1 to 20 kilometers, or roughly .5 to 12 miles, across, too small to be seen in a telescope), the thin coma (larger than Jupiter), and the vast tail (long enough to stretch from one planet's orbit to another).

Halley's Comet itself has three claims to fame. Historically,

Overleaf: *Caught in a celestial searchlight, Earth and the moon pass through the tail of a comet. The glittering head is a million kilometers away, and the tail continues on behind us for many more millions of kilometers. Our home planet and its satellite are in no danger. As one astronomer put it, comet tails are as close as you can get to nothing while still having something. For all of its enormous size—the end of the tail may extend as far back as Mars's orbit— the entire tail could be packed into a suitcase. It has so little gas and dust in it that any cubic meter of it is a more complete vacuum than we can make in a laboratory.*

Ron Miller

188

Comet, Earth and moon.

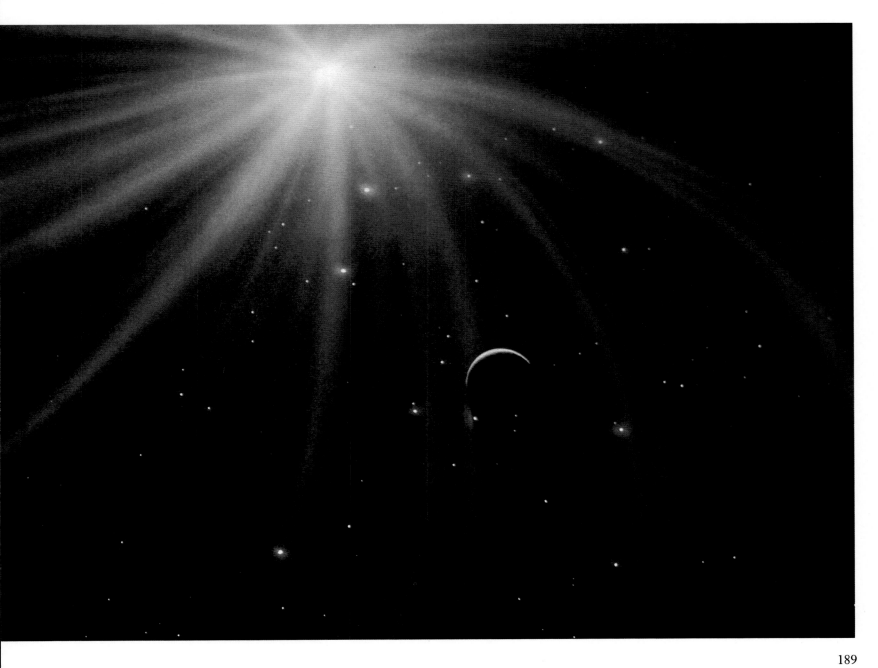

HALLEY'S COMET

Above: *Humanity waited centuries to see this image, which is the first clear, close-up photo of the nucleus of a comet— the first to show the actual physical processes operating on the nucleus. The picture was taken by Europe's* Giotto *probe as it sped by Halley's Comet in 1986. This image is a composite of 60 images, showing details as small as 100 meters across.*

William K. Hartmann

Left: *A few months after the* Giotto *encounter with Halley's Comet, another close-up view might have shown some intriguing changes. First, rotation and orbital movement have combined to change the solar lighting angle. The lighting chosen is close to that of the* Giotto *image, to facilitate comparison. Second, new gas vents have opened, creating new jet patterns. Some old vents have closed down. Third, some minor changes in surface topography have occurred as ice has sublimed and gas vents have changed.*

among the most spectacular comets, it has been recorded during many periods of history, like a faithful friend who drops in on humanity every 76 years.

Second, Halley's Comet played a pivotal role in the progress of knowledge. The English scientist Edmund Halley (rhymes with "valley," according to his descendants) observed the comet in 1682, at age 26, and plotted its positions from night to night. Years later, after conferring with the father of modern physics, Isaac Newton, Halley used Newton's theory of gravity to prove for the first time that this comet and other comets traveled in predictable, elliptical orbits around the sun. Halley realized that comets seen in 1531, 1607, and 1682 were all the same body, a comet moving around the sun with a period of 76 years! He correctly predicted its return in 1758, and it became the comet that bears his name. Halley's work established once and for all that comets were not weird atmospheric phenomena—or omens sent by the gods, as had been believed—but astronomical visitors.

Halley's Comet's third claim to fame is that, in our generation, it became the first comet to be photographed at close range by a spacecraft— the first to reveal the secrets of the cometary nucleus. This happened in 1986, when a flotilla of Japanese, Soviet, and European space probes flew past the comet. (The American Congress declined to fund such a mission.) For the first time, we saw the physical worldlet at the heart of a comet. Scientists for several generations had known that a comet nucleus was a body of soil and ice, and that the subliming ice blew off the gas and dust that formed the coma and tail, but no one knew the details of how the nucleus was shaped, its exact chemical composition, or how the gas blew off its surface. Amazing close-up photos from the two Soviet probes, and the even more sophisticated European probe, *Giotto,* revealed a dark-colored, peanut-shaped nucleus about 15 kilometers long and 7 to 10 kilometers wide (about 9 by 5 miles), immersed in a vast glowing cloud. The photos showed that the comet's gas does not stream off the surface uniformly, but shoots out in bright jets, apparently from isolated vents that may mark fractures.

The *Vega* and *Giotto* probes returned a treasure trove of information about the composition of the vapor and dust streaming off the comet. Most of the ice is apparently frozen water. The photos confirmed Earth-based indications that the material of the comet is not bright, like ice, but as black as black velvet. Apparently, this is because it is rich in carbon-based organic compounds, such as those found in carbonaceous meteorites. Chemical analyzers on the space probes found that the black dust coming off the comet was rich in organic chemical compounds made of the same elements that form living matter on Earth,

especially carbon, hydrogen, oxygen, and nitrogen. So rich were they in these elements that they came to be called CHON particles. No one thinks comets contain living organisms, but the CHON particles suggest that Halley and other comets may ultimately teach us something about the origins of organic chemicals in the solar system.

On any single pass around the sun, at a distance inside Earth's orbit, any given comet may lose about a meter (or a few feet) of ice, "burned" off its surface by solar heating. A periodic comet, like Halley's, undergoes this loss every time it goes around the sun. For this reason, astronomers believe that a typical Halley's-sized comet, one to 20 kilometers (12 miles) across, may last only a few thousand trips around the sun.

Then what happens to it? The ice may be depleted, leaving a loosely aggregated mass of rocky, carbonaceous debris. If sighted from Earth, this may end up being cataloged as an ordinary asteroid. One of the interesting goals of near-future space exploration is to find out if some asteroids on Earth-approaching orbits are really "burnt-out" comets, and, if so, what makes up their composition and structure. Are they porous and laced with twisting caves that once housed the ice? Or are they just "dustballs" of loosely compacted particles? Compositionally, are they like

carbonaceous meteorites or are they chock-full of strange minerals and organic compounds that we have not yet seen?

Based on our knowledge of Halley's and other comets, we can see that a trip around the sun on a comet would be an extraordinary ride. If we landed and began the trip at larger solar distance, e.g., beyond Uranus's orbit, the comet would be an inert iceball, like many other small, barren icy worlds. Then, as it approached the sun, the less stable ices, such as frozen carbon dioxide, would begin to sublime. The sky would fill with jets of glowing gas. By the time we passed inside the distance of the asteroid belt, sunlight would sublime frozen water—the main constituent of the "ground" beneath our feet. Jets of gas would spew from cracks and carry dust and debris into the sky for a period of many months. The comet we are riding, like some comets observed through history, might even split into several pieces as it rounds the sun. Eventually, as we head back toward the cold outer solar system, the activity would calm down, and we would wait through a long "winter" of many years, far from the sun, until the next exciting trip around the radiant globe at the solar system's heart.

William K. Hartmann

Above: *A strange view from the night side of Halley's Comet. Here, we are looking away from the sun, in a direction down the tail of the comet. Several alien phenomena are visible in the night sky. First, the ions of the gaseous part of the tail stream back toward a vanishing point, glowing with a faintly bluish light. Second, the dust from the comet moves in slightly* *different paths, forming its own, somewhat pinker tail, also streaming back toward a vanishing point. Third, the shadow of the comet nucleus itself, on which we are standing, is cast through the coma of gas and dust that surrounds the comet. This shadow forms a weird black presence in the sky above us.*

1221 AMOR AND 1862 APOLLO

PLANET-APPROACHING ASTEROIDS

Most asteroids are located in the asteroid belt between Mars and Jupiter, but others travel in regions well outside the belt and still others move at least partially in the inner solar system, inside the belt region. Members of a subgroup of these, *Amor asteroids*, follow orbits that bring them closer to the sun than the planet Mars—that is, their orbits actually cross over Mars's orbit. At their farthest from the sun, most of them follow paths that pass through the belt.

Amor asteroids are named after one of the prominent early members of their group to be recognized, the asteroid 1221 Amor, an estimated 33 kilometers (20 miles) across, discovered in 1932. Many dozen Amors—or "Mars-crossers," as they are sometimes called— are known. Among the largest are Ganymed (not to be confused with Jupiter's satellite Ganymede), 25 to 30 kilometers

(16 to 19 miles) in diameter, and the splinter-shaped Eros, measured at 7 by 19 by 30 kilometers, possibly a fragment from a large-scale collision. Other Mars-crossers are typically 5 to 10 kilometers (3 to 6 miles) across, but future surveys will surely turn up even smaller ones.

The fact that Amor asteroids cross the orbit of Mars doesn't necessarily mean that they all come very close to it or are likely to hit it in the next million years or so. At the points where they cross Mars's orbit, moving toward or away from the sun, many of them are far above or below the plane of the solar system and thus don't approach Mars. Some, however, do. In any case, gravitational disturbances by the planets are likely to change Amor orbits slowly over millions of years, so that eventually they will move into configurations in which close approaches and impacts *are* possible. Those that don't directly hit Mars may be thrown into new courses by close encounters with Mars; these new courses may take them on Earth-crossing orbits, or orbits that allow close approaches to some other planet. Therefore, Amor or

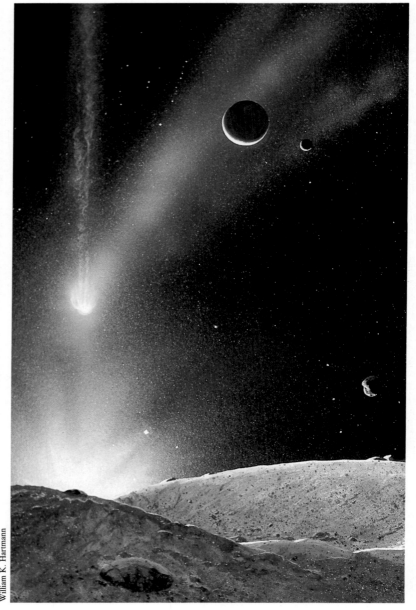

William K. Hartmann

Left: Here we are standing on a crater rim of a one-kilometer Apollo asteroid that is passing by the Earth-moon system (upper left). The sun has just set below the rim, and the pearly corona and zodiacal light glow prominently. This asteroid happens to be crossing Earth's orbit at a time when a major comet is passing through the inner solar system. The comet is seen directly above the sunset, with its gas and dust trails pointing away from the sun. Earth and the moon are silhouetted against the comet's tail.

The asteroid we're on is one of a rare, hypothetical class; these asteroids have minor satellites of their own. Evidence for them includes some double impact craters on Earth. The satellite is above the horizon to the right. Venus is prominent in the coronal glow of the sun, and part of Orion is visible in the lower sky.

other asteroids that venture into the inner solar system are likely to end their days within 10 or 100 million years by colliding with one of the planets, creating large craters on the surfaces of Mars, Earth, the moon, or some other world.

Apollo asteroids, related to Amor asteroids, differ in that they drop far enough into the inner solar system to cross over the orbit of Earth. Their closest approach to the sun (typically 0.5 to 0.9 astronomical units) is inside Earth's orbit, and their farthest from the sun (typically 2 to 4 AUs) is usually in the asteroid belt. Apollo asteroids, like Amors, are named after the classic example of their group, 1862 Apollo, a tiny, 1.5-kilometer (1-mile) asteroid. They are sometimes called Earth-crossers, or, more ominously, Earth-grazers; just as some Amor Mars-crossers come close to Mars, some Apollo Earth-crossers can come very close to Earth.

Apollo asteroids tie in with another phenomenon: meteorites. Apollo asteroids are, essentially, giant meteoroids. Of the many dozen Apollo asteroids now known, the biggest are about 8 to 10 kilometers (5 to 6 miles) across, and nearly all are bigger than 1 kilometer. Many smaller ones also exist, all too tiny to detect with telescopes, but they are so numerous that many hit Earth each year, breaking into pieces in the atmosphere and hitting the ground as meteorites.

Although spectroscopic studies of Apollo asteroids reveal many different rock types among them, all these rock types are similar to those of main-belt asteroids and also to those of various meteorites. Some of them almost perfectly match the spectroscopic properties of certain common meteorite types. This means that some of the meteorites in our museums are probably fragments of Apollo asteroids—or at least fragments of the same parent body that the Apollo asteroids are themselves part of.

Some of the Apollo asteroids are probably fragments of asteroids from the asteroid belt, perturbed into Earth-crossing orbits by gravitational disturbances from Jupiter or Mars, the planets on either side of the belt. Other Apollo asteroids may have a quite different origin. They may be the burnt-out, rocky remnants of comets. Fresh comets are believed to be mostly ice and to contain a certain proportion of rocky material. But often, comets get perturbed by planets into orbits in the inner solar system where the ices eventually evaporate or sublime into space, leaving the rocky material in a loosely consolidated clump. Some Apollos may be such clumps.

Apollo asteroids occasionally crash into Earth, causing monstrous explosions like the atom bomb-sized one in Siberia in 1908. That blast flattened trees in an 18-mile circle, knocked a man off a porch 38 miles away, and was heard more than 600 miles away. Statistics suggest that such impacts may occur every century or so—but they usually take place in the ocean and leave little or no historical record.

Because Apollo asteroids have the potential of crashing into Earth, interest in them has increased in recent years. Several moderately large telescopes have been dedicated to search for them, and NASA engineers have begun to consider schemes for modifying their orbits, if one should be discovered on a

Ron Miller

Above: Venus is seen in the far distance from the asteroid Apollo, one of the rare asteroids that crosses the orbit of that planet. Apollo is influenced by the gravitational fields of both Earth and Venus, and in time will probably fall onto one or the other of the two planets. Apollo's elliptical orbit will take it beyond the orbit of Mars before it begins its swing back toward the sun.

collision course with Earth. Newspapers and television have given unprecedented coverage to asteroids as a result of international meetings in the United States and Russia about the asteroid threat.

Despite the media blitz about asteroids' threat to civilization, there may be a bright side to near-Earth asteroids that has received less attention. Asteroids' danger to our civilization may be less than the more predictable instabilities that will arise from the anticipated shortages of raw materials and energy sources in the next century. Thus, a more

positive response to asteroids is to note that some of them are made from pure nickel-iron alloy and other metal-bearing materials; if we pursue ways of detecting asteroids and changing the orbits to avoid the rare threat of collision, we will at the same time be developing the technology to utilize their materials in a stable, *inter*planetary economy. This could not only remove the threat of random-impact explosions but, more importantly, also allow Earth's biosphere to relax back toward its preindustrial, natural state, as we transfer heavy mining and smelting operations into space, a virtually unpollutable environment with 24 hours a day of free solar energy to power industrial activities. (See our companion book, *Out of the Cradle*, which discusses these issues in more detail.)

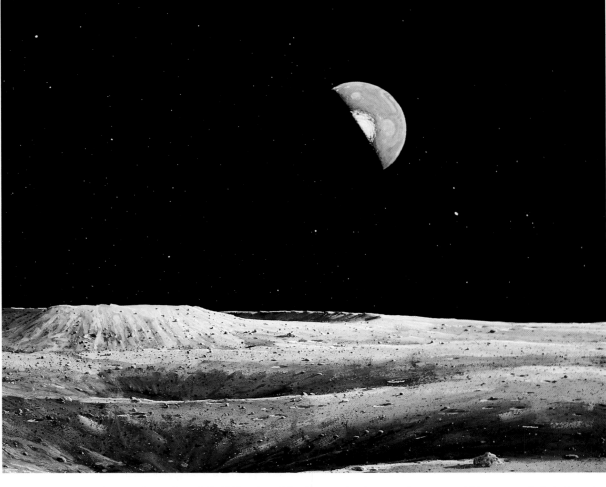

William K. Hartmann

Above: We are standing on the surface of a five-kilometer (three-mile) Amor asteroid that is making a close approach to Mars at a distance of some 55,000 kilometers (34,100 miles). We have an unusual view of Mars, because the asteroid happens to be passing "under" the south pole. Mars's south polar ice cap shows up as a white ice field at the center of the Martian disk, half illuminated by the sun. In the background is the northern constellation of the Big Dipper, which seems to have two new, bright stars. Above the handle (upper left), nearly 7 Martian radii out from Mars, is Mars's satellite Deimos, shining about as bright as the brightest star, Sirius. To the lower right of Mars, at about 2.7 radii, is Phobos, still brighter. The surface of our asteroid is composed of dark, rocky material and the pulverized dust of many impacts. Two eroded craters are in front of us, and a fresher, larger crater is seen on the nearby horizon. Gravity is so weak that if you picked up a rock and threw it hard, you could put it into orbit around the asteroid. But it would be wise to duck before it returns.

194

4769 CASTALIA AND 4179 TOUTATIS

APOLLO ASTEROIDS OF CURIOUS SHAPE

As astronomers discover more Apollo asteroids, they add to the list of bizarre objects in the solar system. An interesting new radar technique allows amazing images of the ones that pass closest to Earth—without using expensive space probes! This technique involves bouncing radar waves off the interlopers. The leader in this field is Cal Tech astronomer Steven Ostro, who has bounced radar signals off several asteroids and found bizarre shapes among them.

Ostro's first striking result came from an Earth-passing asteroid initially cataloged as 1989 PB (a code indicating discovery date) and later named 4769 Castalia. When Ostro bounced radar signals off it, he got double return, indicating a dumbbell-like body. As shown in the accompanying photo, his technique allowed him to make a crude image of the rotating dumbbell. Castalia consists of two roughly spheroidal bodies just touching each other. It is

William K. Hartmann

Above: *According to analysis of radar signals bounced off the small, Earth-approaching asteroid 1989 PB, it is a dumbell-shaped object consisting of two spheroidal lumps just linked by a narrow neck. It was observed while passing Earth in 1989 and would make an extraordinary target for future space explorers.*

about 1.7 by 1.0 kilometers in size (1,900 by 1,100 yards) and rotates in about five hours.

By 1992, Ostro's technique had improved and the close pass of Apollo asteroid 4179 Toutatis enabled him to make a photo-like radar image of the object. The astonishing result, released in January 1993, shows that Toutatis resembles two lumpy, cratered rocks stuck together. Roughly 4 by 7 kilometers

(2.5 by 4 miles) in size, it is the slowest-rotating asteroid known, taking about 10 or 11 Earth-days to make one turn. Spectra show a rocky composition.

These surprising radar observations confirm theoretical research from the late 1970s, including some by the author (Hartmann), predicting that many asteroids are loose assemblages of fragments, created when larger bodies were smashed but not totally disrupted. During chaotic fragmentation of a Vesta-sized parent, for instance, two neighboring kilometer-scale fragments flying out of the explosion might find themselves on parallel courses and could fall together by their own gravity. This would produce a compound double body like Castalia or Toutatis.

In addition, occasional disruption of objects like Castalia or Toutatis, perhaps by impact, might produce co-orbiting pairs of asteroids, i.e., asteroids with satellites. This could explain sporadic but unconfirmed claims by observational astronomers that a few asteroids have satellites.

Finally, Ostro's discoveries may explain double craters on Earth and other planets. Arizona scientists Jay Melosh and J.A. Stansberry emphasized in a 1991 article that of 28 known impact craters on Earth, at least three are double, formed by simultaneous impact of two main masses. If objects like Castalia or Toutatis are sometimes pulled apart by impacts or during collision with Earth's atmosphere, this could explain double craters.

Below: *Compound asteroid 4769 Castalia passing the Earth-moon system in 1989. Radar waves bounced off the asteroid from radio telescopes on Earth revealed its dumbbell shape.*

NASA

1991 BA
THE SMALLEST KNOWN ASTEROID

With asteroid searches increasing, astronomers are discovering smaller and smaller objects each year. One of the most interesting search projects is that of Dutch-American astronomer Tom Gehrels and his colleagues at the University of Arizona. They added ultrasensitive detectors to a moderate-size 0.9-meter (36-inch) telescope, dating from 1919, and started a semi-automated search program named Spacewatch. They began observing in September 1990 and quickly netted the smallest known interplantary object yet observed from Earth.

Provisionally designated 1991 BA, it was spotted in January 1991 as it passed unusually close to Earth while pursuing its own orbit around the sun. Its orbit takes it from beyond the asteroid belt to a point close to Venus's orbit. In 1991, it passed within 171,000 kilometers (106,000 miles) of Earth—less than half the distance to the moon. This is the closest known asteroidal approach (not counting the bodies that actually hit Earth).

Here is testimony once again, as if any were needed, that Earth moves in a cosmic shooting gallery where random, if rare, bullets are being fired all the time.

Such close encounters, fortunately, most often involve only small objects, because tiny asteroids vastly outnumber big ones. 1991 BA was no exception. Calculations based on its brightness placed it at only 9 meters (about 30 feet) in diameter—a bus-sized object.

Interestingly, another similarly small object, 1991 VG, was discovered by Spacewatch some months later, but some scientists believe that it is not an asteroid but a burnt-out rocket booster that launched a sun-orbiting solar probe in 1974. What is the origin and destiny of 1991 BA? It seems to be a true asteroid fragment. Probably, its parent asteroid suffered a collision in the asteroid belt, broke apart, and sent fragments hurtling into new orbits, which (with a little help from the gravity of Jupiter and Mars) eventually intersected Earth's orbit. 1991 BA will orbit around the sun many times, and occasionally will encounter Earth at close range again. If it hits Earth, it will break up explosively in the atmosphere, with an energy equivalent to about 40 kilotons of TNT, or about three times the energy of the Hiroshima A-bomb. With a probability of about six chances

Ron Miller

Above: *Tiny asteroid 1991 BA may look not much different than a large boulder that tumbled from a mountain cliff. Its origin is not so different—it is a fragment of a larger rock mass. A few craters testify that it has been exposed to the random "meteoritic bullets" of interplanetary space. 1991 BA may have been blasted free from its parent asteroid only a few hundred million years ago, and may not have had time to accrue a large population of craters.*

out of seven, such a blast would occur over an ocean or polar region.

Another possibility is that 1991 BA will miss Earth, but pass so close that its orbit will be radically changed. Perhaps in this new orbit it might hit Mars or Venus.

A third possibility exists. Perhaps as it approaches Earth in the next century it will find itself visited by an artificial metal "asteroid"—a spaceship containing inquisitive creatures from planet Earth. They might be voyaging farther from Earth than any of their species have ever gone before. Encased in their metal ship and their helmeted suits, they might have as their mission to deflect 1991 BA into a safe trajectory, make scientific measurements of its ancient materials, and begin the reconnaissance of its resources. They would make the first tests to confirm whether 1991 BA was made of lava-like rock from a parent asteroid's crust, or perhaps nickel-iron from a parent's core.

But the results of the expedition would be less important than the fact of the expedition itself. In a marvel of life's adaptability, these explorers would be carrying their own planetary environment with them into the empty depths of interplanetary space, and they would be extending human consciousness and human civilization for the first time beyond our finite Earth-moon system into the larger, richer realm of the solar system.

GLOSSARY

APOGEE
Point in an orbit farthest from Earth (*apolune:* farthest from the moon; *aphelion:* farthest from the sun; *apapsis:* farthest from any object, general term.) See PERIGEE

CONJUNCTION
When two or more planets appear close together in the sky

CRUST
Outermost solid layer of a planet

DENSITY
The proportion of mass to volume: a pound of lead is more dense than a pound of air

Knowing how *dense* an object is can give you a good idea of what it is made of. Different substances have different densities. Gases have very low densities, liquids have higher densities, and solids like rocks and metals usually have even higher densities. Water is used as the standard for all densities and is given a value of 1. Saturn has a very low density, less than 1, so that we know that it is made of something very light. In fact, it is made up mostly of gases. Earth has a density of 5.5, indicating that it is made of some very heavy substances. If an object has a density of 3, we know that is more than water (1) but less than rock (say, 5). A good guess would be that it is a

mixture of rock and water or ice. Adding rock to ice would raise the water's average density, while the ice would lower the rock's, giving us a density halfway between the two.

ECLIPSE
When one body passes into the shadow of another

ECLIPTIC
Plane of Earth's orbit; approximate plane of the solar system

GALILEAN SATELLITES
Jupiter's four largest moons (Io, Europa, Ganymede, and Callisto); named as a group for Galileo Galilei, who discovered them in 1610

LATIN PLACE-NAMES
To avoid international confusion, or favoritism of any one language, "neutral" Latin is used to describe features on the planets and satellites, just as Latin names are used in biology and botany. This has been standardized so that "mountain" on one map is "mountain" on another. Following is a list of these descriptive terms:

DORSA:	Scarps
MARIA:	"Seas" (singular: MARE)
MONTE:	Mountains (singular: MONS)
PATERA:	Shallow, dish-shaped depression
PLANITIA:	Plains or basins
RUPES:	Ridges
RILLE:	Narrow, linear valley
VALLES:	Valleys

LIMN
Apparent edge of an object

LITHOSPHERE
Solid rocky layer in partially molten planet

MANTLE
A region of intermediate density around the core of a planet

MASS
The amount of material in an object

METEOR
A "shooting star," the streak of light made by an object burning up as it enters atmosphere

METEORITE
A meteoroid when it is on the ground

METEOROID
Any small rocky, metallic, or carbonaceous object in space, usually smaller than the size of a pea

METRIC MEASUREMENTS

$$\text{meters} \times 3.281 = \text{feet}$$
$$\text{kilometers} \times 0.621 = \text{miles}$$
$$\text{degrees Celsius} \times 9/5$$
$$(\text{now add }32) = \text{degrees Fahrenheit}$$
$$\text{feet} \times 0.305 = \text{meters}$$
$$\text{miles} \times 1.609 = \text{meters}$$
$$\text{degrees Fahrenheit}$$
$$(\text{now subtract }32)$$
$$\times 5/9 = \text{degrees Celsius}$$

MILLIBAR
A unit of atmospheric pressure; the average pressure at Earth's surface is 1,000 millibars

OCCULTATION
When a smaller body passes behind a larger one

ORGANIC MOLECULE
A molecule based on carbon, usually large and complex

PERIGEE
Point in an orbit nearest Earth (*perilune:* nearest the moon; *perihelion:*

GLOSSARY

nearest the sun; *periapsis:* nearest any object, general term) See APOGEE

PHASES

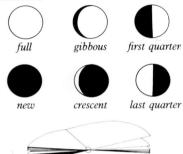

full gibbous first quarter

new crescent last quarter

PLANE OF THE SOLAR SYSTEM
The plane of Earth's orbit around the sun. With few exceptions, all the other planets orbit in or near this same plane

PLANETESIMAL
Another (and more accurate) name for an asteroid; also often used is *minor planet*

retrograde

prograde

RETROGRADE and PROGRADE
When describing the rotation of a planet or its movement in its orbit, *retrograde* means clockwise (east to west), when seen from above the planet's north pole,

and *prograde* means counterclockwise (west to east), when seen from above its north pole

REVOLUTION and

ROTATION
Revolution describes the movement of one body around another; *rotation* describes the movement of an object around its own axis

ROCHE'S LIMIT
Distance from a planet within which tidal forces would disrupt a large enough satellite

SATELLITE
Any small body orbiting a larger one

SUBLIME
When a substance, like ice, goes directly from a solid to a gaseous state without first becoming a liquid; dry ice (frozen carbon dioxide) does this on Earth

SUNSPOT
A magnetic disturbance on the sun; it is cooler than the surrounding area and, consequently, appears darker

TERMINATOR
Dawn or dusk line separating night from day

TERRESTRIAL PLANETS
Planets resembling Earth in that they are made primarily of rocky material

TRANSIT
When a smaller body passes in front of a larger one

VISUAL ANGLES
In order to help our readers visualize what they would see were they to

actually visit any of the places described in this book, we have included *visual angles* in the captions of many of the paintings. The horizon in front of you, if you are outdoors, covers 180 degrees from your right to your left. Normal vision, as you stare straight ahead, covers about 90 or 100 degrees of this area, although you are visually aware of—and mainly using—only about 40 degrees of that. (Forty degrees is the angle covered by a picture taken by an ordinary snapshot camera.)

A few of the scenes in the book cover a larger width, 90 degrees or even more. These are *wide-angle* views, the kind that you could take with a wide-angle camera lens. This lens has the effect of making any object appear relatively *smaller* than it would in a normal-angle picture. Our moon, for example, covers half a degree in the sky. It follows that it would thus be twice as large in a 40-degree-wide picture as it would be in an 80-degree-wide picture. Since they have the effect of shrinking distant objects, wide-angle views are used only when they are necessary to show some feature in the landscape or foreground that is too large or extensive to see completely otherwise. In the book, if a view deviates substantially from the everyday snapshot angle, or a visual angle of 30 to 45 degrees, we have pointed this out.

ZODIACAL LIGHT
Faint glow caused by dust in the ecliptic

VITAL STATISTICS

OBJECT	DISCOVERY	ORBITAL PERIOD (r = retrograde)	DISTANCE From Sun (au) or Planet (1,000's km)	DIAMETER (km)	SURFACE GRAVITY* (Earth = 1)	SURFACE MATERIAL	ATMOSPHERE
MERCURY	Prehistory	86.0 d	0.39 AU	4,880	.39	Basaltic dust & rock	Essentially none
VENUS	Prehistory	225.0 d	0.72 AU	12,100	.91	Basaltic & granitic rock	Thick, CO_2, + H_2SO_4 clouds
EARTH	~500 B.C.	1 yr	1.00 AU	12,756	1.00	Water, granitic soil	N_2, O_2, H_2O
Moon	Prehistory	27.3 d	384	3,476	.16	Basaltic dust & rock	None
MARS	Prehistory	1.88 yr	1.52 AU	6,787	.38	Basaltic dust & rock	Thin, CO_2
Phobos	1877	7.7 h	9.4	27x21x19	.0009	Carbonaceous rock	None
Deimos	1877	30.3 h	23.5	15x12x11	.0004	Carbonaceous rock	None
CERES	1801	4.6 yr	2.77 AU	914	.04	Carbonaceous rock	None
PALLAS	1802	3.63 yr	2.77 AU	522	.02	Meteoric rock	None
JUNO	1804	4.61 yr	2.67 AU	244	.01	Rock & iron	None
VESTA	1807	5.59 yr	2.36 AU	500	.02	Basaltic, meteoritic rock	None
JUPITER	Prehistory	11.9 yr	5.2 AU	142,984	2.6	—	H_2, He, NH_3, CH_4
Metis	1980	7.1 h	126	40	.002	Rock (?)	None
Adrastea	1979	7.1 h	128	24x16	.001	Rock (?)	None
Amalthea	1892	12.0 h	182	270x170x155	.009	Sulfur layer over rock (?)	None
Thebe	1980	16.2 h	223	100	.003	Rock (?)	None
Io	1610	1.8 d	422	3,630	.18	Sulfur compounds	Very thin SO_2, S, Na
Europa	1610	3.6 d	671	3,130	.14	H_2O ice	None
Ganymede	1610	7.2 d	1,071	5,280	.15	H_2O ice & dust	None
Callisto	1610	16.8 d	1,884	4,840	.12	Rocky dust & some ice	None
Leda	1974	240.0 d	1,110	16	.0003	Carbonaceous rock (?)	None
Himalia	1904	251.0 d	11,470	180	.004	Carbonaceous rock (?)	None
Lysithea	1938	260.0 d	11,710	40	.001	Carbonaceous rock (?)	None

* Multiplying your weight by this number will tell you what you would weigh on a particular world.

OBJECT	DISCOVERY	ORBITAL PERIOD (r = retrograde)	DISTANCE From Sun (au) or Planet (1,000's km)	DIAMETER (km)	SURFACE GRAVITY* (Earth = 1)	SURFACE MATERIAL	ATMOSPHERE
Elara	1904	260.1 d	11,740	80	.002	Carbonaceous rock (?)	None
Ananke	1951	r 1.72 yr	20,700	30	.0005	Carbonaceous rock (?)	None
Carme	1938	1.89 yr	22,350	44	.0008	Carbonaceous rock (?)	None
Pasiphae	1908	2.02 yr	23,300	35	.0009	Carbonaceous rock (?)	None
Sinope	1914	r 2.07 yr	23,700	20	.0008	Carbonaceous rock (?)	None
SATURN	Prehistory	29.5 yr	9.5 AU	120,660	1.1	—	H_2, He, NH_3, CH_4
Pan	1990	13.8 h	134	20 (?)	.0006	Mostly H_2O ice (?)	None
Atlas	1980	14.4 h	138	50x30x20	.0008	Mostly H_2O ice (?)	None
Prometheus	1980	14.7 h	139	140x80	.006	Mostly H_2O ice (?)	None
Pandora	1980	15.0 h	142	110x70	.005	Mostly H_2O ice (?)	None
Epimetheus	1980	16.7 h	151	140x100	.004	Mostly H_2O ice (?)	None
Janus	1980	6.7 h	151	220x180x160	.005	Mostly H_2O ice (?)	None
Mimas	1789	22.6 h	186	390	.007	Mostly H_2O ice	None
Enceladus	1789	1.4 d	238	500	.008	Mostly H_2O ice	None
Tethys	1684	1.9 d	295	1,050	.015	Mostly H_2O ice	None
Telesto**	1981	1.9 d	295	34x26	.0003	(?)	None
Calypso**	1981	1.9 d	295	34x22	.0004	(?)	None
Dione	1684	2.7 d	377	1,120	.022	Mostly H_2O ice	None
Helene**	1980	2.7 d	377	36x30	.004	Mostly H_2O ice	None
Rhea	1672	4.5 d	527	1,530	.028	Mostly H_2O ice	None
Titan	1655	15.9 d	1,222	5,140	.14	Ices; liquid NH_3 & CH_4	Thick N_2, CH_4
Hyperion	1848	21.3 d	1,484	290	.006	Ices (?)	None
Iapetus	1671	79.3 d	3,562	1,440	.02	Ice & rock	None
Phoebe	1898	r 550.0 d	12,960	220	.005	Carbonaceous soil	None

** Telesto and Calypso are both in the same orbit as Tethys; Telesto is about 60° ahead of Tethys and Calypso about 60° behind. Helene is about 60° ahead of Dione and in the same orbit.

OBJECT	DISCOVERY	ORBITAL PERIOD (r = retrograde)	DISTANCE From Sun (au) or Planet (1,000's km)	DIAMETER (km)	SURFACE GRAVITY* (Earth = 1)	SURFACE MATERIAL	ATMOSPHERE
CHIRON	1977	51.0 yr	13.7 AU	250	.005	Carbonaceous soil over ice (?)	None
URANUS	1781	84.0 yr	19.16 AU	51,120	.88	(?)	H_2, He, CH_4
Cordelia	1986	8.0 h	50	30 (?)	.0009	Dark soil & ice (?)	None
Ophelia	1986	9.0 h	54	30 (?)	.0009	Dark soil & ice (?)	None
Bianca	1986	10.2 h	59	40 (?)	.001	Dark soil & ice (?)	None
Cressida	1986	11.1 h	62	70 (?))	.002	Dark soil & ice (?)	None
Desdemona	1986	11.4 h	63	60 (?)	.002	Dark soil & ice (?)	None
Juliet	1986	11.8 h	64	80 (?)	.002	Dark soil & ice (?)	None
Portia	1986	12.3 h	66	110 (?)	.003	Dark soil & ice (?)	None
Rosalind	1986	13.4 h	70	60 (?)	.002	Dark soil & ice (?)	None
Belinda	1986	15.0 h	75	70 (?)	.002	Dark soil & ice (?)	None
Puck	1985	18.3	86	150	.004	Dark soil & ice (?)	None
Miranda	1948	1.4 d	130	470	.004	H_2O ice, rock	None
Ariel	1851	2.5 d	191	1,160	.01	H_2O ice, rock	None
Umbriel	1851	4.1 d	266	1,170	.008	H_2O ice, rock	None
Titania	1787	8.7 d	436	1,580	.02	H_2O ice, rock	None
Oberon	1787	13.5 d	583	1,520	.01	H_2O ice, rock	None
NEPTUNE	1846	164.0 yr	30.0 AU	49,530	1.14	(?)	H_2, He, CH_4
Naiad	1989	7.1 h	48	50 (?)	.001	Dark soil & ice (?)	None
Thalassa	1989	7.5 h	50	80 (?)	.002	Dark soil & ice (?)	None
Despina	1989	8.0 h	52	180 (?)	.005	Dark soil & ice (?)	None
Galatea	1989	10.3 h	62	150 (?)	.004	Dark soil & ice (?)	None
Larissa	1989	13.3 h	74	190 (?)	.005	Dark soil & ice (?)	None
Proteus	1989	1.1 d	118	400	.01	Dark soil & ice (?)	None
Triton	1846	r 5.9 d	356	2,700	.06	CH_4 ice	Thin N_2, CH_4
Nereid	1949	360.0 d	5,567	340	.004	CH_4 ice (?)	None
PLUTO	1930	247.0 yr	39.4 AU	2,300	.05	N_2 ice, CH_4 ice, CO ice	Very thin N_2
Charon	1978	6.4 d	19	1,190	.02	N_2 ice, H_2O ice, CO ice	None

CH_4	Methane	N_2	Nitrogen
CO	Carbon monoxide	Na	Sodium
CO_2	Carbon dioxide	NH_3	Ammonia
He	Helium	O_2	Oxygen
H_2	Hydrogen	S	Sulfur
H_2O	Water	SO_2	Sulfur dioxide
H_2SO_4	Sulfuric acid		

FURTHER READING

Solar System, Ludek Pesek and Peter Ryan. Viking (N.Y.), 1980

In the Stream of Stars: The Soviet/American Space Art Book, eds. William K. Hartmann, Andrei Sokolov, Ron Miller, and Vitaly Myagkov; Workman Publishing (N.Y.), 1990.

Pioneering the Space Frontier: The Report of the National Commission on Space. Bantam Books (N.Y.), 1986.

The New Solar System, eds. J. Beatty and A. Chaiken. Sky Publishing (Cambridge, Mass.), 3rd ed., 1990

Cycles of Fire: Stars, Galaxies and the Wonder of Deep Space, William K. Hartmann and Ron Miller. Workman Publishing Co. (N.Y.), 1987.

Astronomy: The Cosmic Journey, W.K. Hartmann. Wadsworth (Belmont, Calif.), 4th ed., updated, 1991

Moons and Planets, W.K. Hartmann. Wadsworth (Belmont, Calif.), 3rd ed., 1993.

The History of Earth, William K. Hartmann and Ron Miller. Workman Publishing (N.Y.),1991.

Out of the Cradle: Exploring the Frontiers Beyond Earth, William K. Hartmann, Ron Miller, and Pamela Lee. Workman Publishing (N.Y.), 1984.

The Conquest of Space, Willy Ley and Chesley Bonestell. Viking (N.Y.), 1949. (Historic predictions of solar system exploration, with pioneering space paintings by Chesley Bonestell; see our dedication at the front of this volume.)

Solar System Evolution: A New View, S. Ross Taylor. Cambridge University Press (Cambridge, Mass.), 1992

Visions of Space: Artists' Journey through the Cosmos, David A. Hardy. Paper Tiger (N.Y.), 1989.

NASA Special Publications covering the results and photos of all lunar planetary missions are available from NASA Head-quarters, Washington, D.C., and from regional bookstores of the U.S. Government Printing Office. For *Voyager* mission results, see *Voyage to Jupiter*, by David Morrison and Jane Samz, NASA Special Publication SP-439, 1980; and *Voyages to Saturn* by David Morrison, NASA Special Publication SP-451, 1982.

INDEX

ABOUT THE AUTHORS

RON MILLER is widely known for his astronomical and science-fiction paintings. The author of several novels, he has translated and illustrated new versions of Jules Verne's *20,000 Leagues under the Sea* and *Journey to the Center of the Earth*; he was production illustrator for the movies *Dune* and *Total Recall* and has designed postage stamps. Ron Miller is a fellow of the British Interplanetary Society, a member of the International Academy of Astronautics and a faculty member at the International Space University. He lives in Fredericksburg, Virginia.

WILLIAM K. HARTMANN is internationally known as a planetary scientist and also as an astronomical painter and writer. In recognition of his work on the evolution of planetary systems, asteriod #3341 was named after him. He was invited to participate in NASA's Mariner 9 and Mars Observer missions to Mars and will also take part in Russia's planned Mars-94 mission. Dr. Hartmann has authored two college textbooks—*Astronomy: The Cosmic Journey* and *Moons and Planets*. In addition to his doctorate in astronomy, he holds an M.S. in geology and has done extensive research on planetary surfaces. He lives in Tuscon, Arizona, where he is a senior editor at the Planetary Science Institute.

Other books by William K. Hartmann and Ron Miller are *Out of the Cradle, Cycles of Fire* and *The History of Earth*. They also edited *In the Stream of Stars: The Soviet/American Space Art Book*.